Mastering Nature Ph

hooting
and Selling
in the Digital Age

John Kieffer

**ALLWORTH
PRESS**
NEW YORK

08 07 06 05 04 5 4 3 2 1

Published by Allworth Press
An imprint of Allworth Communications, Inc.
10 East 23rd Street, New York, NY 10010

Cover design by Derek Bacchus
Cover photograph by John Kieffer
Page composition/typography by SR Desktop Services, Ridge, NY

ISBN: 1-58115-389-9

Library of Congress Cataloging-in-Publication Data
 Kieffer, John.
 Mastering nature photography : shooting and selling in the
digital age / John Kieffer.
 p. cm.
 Includes index.
 1. Nature photography. 2. Photography—Business methods.
I. Title.
TR721.K52 2004
778.9'3—dc22 2004018473

Printed in Canada

Contents

PART ONE: A Solid Foundation

PART TWO: Photographic Equipment

PART THREE: Photographing Nature

Acknowledgments

I'd like to thank my wife, Beth, for her expertise with many computer-related endeavors, including this CD-ROM and to my entire family for their patience and support of my photographic career. Finally, to the people at Allworth Press, particularly Tad Crawford for his support of this book project; Nicole Potter's help with making sure things make sense and are well organized; Monica Rodriguez for a thorough editorial review; photographer David Weintraub for his catching photographic insight; and Derek Bacchus for a great cover design.

About the Author

John Kieffer is a leading authority on nature photography. A professional outdoors photographer for nearly twenty years, he has traveled throughout the American West, regularly spent up to eighty days per year living in a camper, and risked his life more than once while capturing the natural landscape. In 1997, he established Kieffer Nature Stock, one of the first stock photo agencies to fully integrate digital media in CD-ROMs, Web sites, and image fulfillment. He has a master's degree in entomology and is the author of *The Photographer's Assistant* (Allworth Press). He lives in Boulder, Colorado.

The accompanying CD-ROM contains 650 captioned photos and is an integral companion to this book. However, there's more. Organized by subject and geography, the imagery is a visual road map to the best photo sites in the American West. Specific locations, dates, and times are given to help you plan your visit and maximize your photography—an invaluable resource.

An image and caption can be printed out to assist your photo journey, but can't be used in any commercial endeavor without my express written permission. All images Copyright John Kieffer, 2004 and protected by Digimarc. The easy to navigate CD-ROM uses the same software as your Internet (Web) browser, and runs on both Mac and PC computers.

A Solid Foundation

So You Want to be a Nature Photographer

When you use a 4 × 5 inch view camera, you tend to attract all sorts of curious people. Most have never seen a view camera before, and sometimes it's as interesting as the scenery. Often one of their first questions is, "Do you do this for a living?" When I tell them I do, the usual response is, "That sure must be fun," or, "I'd really like to be a professional nature photographer, too." Usually I think, if you only knew.

In writing this book, I have two basic goals. First, **t**o give you an idea of what the real life and times of a nature photographer are all about. And second, to bring to your attention some of the diverse skills that will make you a better, more productive photographer, while increasing your enjoyment in the field. If you dream of selling your work, you'll get a good sense of what it really takes to make it in this very demanding and somewhat crazy profession. There are many different markets for your work, from advertising and magazines to calendars and fine-art prints. However, there are subtle differences as to how you approach these markets and the kind of photography they buy.

Even after nearly twenty years of being a professional photographer, I'll often take in a great view and think, am I really doing this? But, it's not only when I feel exhilarated after getting a great shot. Just as often, it's when I've been on the road for a week or two or three, and I miss my family. It might also be when I'm struggling to pay all the bills and have doubts. Is this going to get my kids through college? Oh hell, being a nature photographer is so much fun, who needs to retire anyway? All I have to continue to do is to

carry fifty pounds of gear throughout the high and wild places of the great American West.

So what does it take to be a professional nature photographer or just shoot like one? Perhaps the most obvious response is you have to be a damn good photographer. You must be able to go into an unfamiliar environment and pull enough tricks out of your bag to consistently produce good work—work that sells. However, the actual photography is just part of it. After all, during a full day's work, my total exposure time is measured in mere seconds. I often look at nature photography as having two parts. There's one part photography and one part everything else, and it's that everything else that's so important.

In trying to become good at anything, it can be helpful to list all the variables that you will encounter as you strive to achieve your goal, and then see what you can do to maximize your control of each of these.

BE A NATURALIST

When I started college, I met with a counselor and said what I really wanted to be was a naturalist. It probably sounded like wanting to be a mountain man or explorer, which was true, but I knew I was a hundred years too late for that. I admit to being a bit naive, but what can I say, I was young. It was suggested that I try biology. So having a greater affinity to animals than plants, I graduated from the zoology department and ultimately received a masters degree in entomology—yes, the study of insects. However by becoming a nature photographer, I think I've come full circle and have become a modern-day naturalist.

It takes being a naturalist to enjoy this line of work. You have to love being out on the land. You have to know when an environment is at its best, and then be there at that time. I've learned this the hard way. When your job is to produce high quality photography consistently, your task is much easier when the scenery is at its peak. It's just like people photography: It's much easier to take a successful photo of a beautiful person. And the best people photographers tend to shoot the most beautiful people.

BE AN ATHLETIC AND ADVENTUROUS OUTDOORSPERSON

Most people don't appreciate how physically and mentally demanding this job can be. Physically, you've got to prepare yourself

for some long, hard days. Mentally, you've got to familiarize yourself with the landscape and the environment, so that you can travel safely and photograph effectively. With many years of solo travel, I've found that most dangerous situations come about through a combination of seemingly small errors—many of which could have been circumvented with a little preparation and conservative behavior—that slowly conspire to lead one into a desperate situation.

I can also feel like a professional pack animal and a solitary one at that. Often I'm the first out of the parking lot or the last one back; either way I'm usually alone and in the dark. The day might begin with a two- or three-hour uphill push on an unfamiliar trail. For efficiency and safety, gear is confined to one backpack, with the ever-present tripod strapped on. The load consistently weighs forty plus pounds, more if I want a jacket or a drink of water.

Nearing my destination, I get energized and anxious, fearing I might miss something; so the sooner I get there the better. If shooting conditions are good, there's no rest. I've come to appreciate that conditions are ever changing and you've got to shoot when the shooting is good. Who's to say a jet trail won't appear at any moment or that someone won't pop out of the woods and jump in front of the camera? One of the best feelings is packing up and heading back, knowing you've captured something special. Arriving at the trailhead, I might camp right in the parking lot. If need be, I'll drive to the next morning's shoot, searching for that lone radio station trying to reach me.

When I get too busy to exercise, I think of Toroweap, a classic spot along the Grand Canyon's north rim. From an intersection ten miles from nowhere, you head south for sixty miles on a very lonely dirt road. Two different nature photographers had warned me about this road; each had flat tires along its desolate stretches. So warned, I carried an extra spare, one which I regularly lifted in and out of my pop-up camper. By the end of the trip, my shoulder was shot. Lesson learned? Stay in shape by combining aerobics and weight training.

By the way, I didn't get any flats and it's a reasonable two-wheel-drive road; just don't drive like a maniac. The photography, however, was hair-raising. There are few places where the drop-offs are so intense. One misstep and you'd plunge 2,000 feet, right into the river. And the camping? Three primitive sites perched 100 feet from the edge—it was heaven! (See CD-ROM: Canyons > Grand Canyon> Toroweap)

BE A BUSINESS PERSON

After college, I looked at my choices and felt ill prepared to enter the real world. I got a job in sales. I can remember commuting to Denver with the book *The Photographer's Market* by my side. It didn't do me much good at the time because I didn't even know where to begin. I mean, who ever saw a classified ad that read, Wanted: Nature Photographer?

Due to my science background, I was selling electronic research equipment. Considering I was better suited to having my head buried in a book, this was a real challenge and it lasted seven years. You never know where an experience will lead, but a foundation in business, particularly sales, was a great factor in my success as a photographer. When I take pictures alongside a group of fellow photographers, I find that amateur photographers tend to discuss photo gear, while the pros discuss business and making a living.

Photography is like any other small business. It can be useful to look at your photos as your *product line,* and you have to develop a fine eye toward making a product that people want. Then, you have to start selling. You may not need a cash register and retail space, but you do need a work area and a number of essentials, such as a desk and computer equipment. To succeed, you need to bring everything together with an *entrepreneurial spirit* and self-motivation. The alarm clock will probably be the only thing prodding you to get up early. You've got to want success and want it bad, plus have the skills to go out and get it.

Whether photographing in the field or working at my stock photo agency, I regularly talk with people who want to sell their photography. There's something tremendously satisfying about seeing your photography in use. It's a dream with which I readily identify. Therefore, I have integrated this aspect of photography throughout the book. For want of a more common term, I often refer to selling photography. I want to clarify. In general, photographers do not sell their photography, but rather license images to buyers, usually for a specific purpose and length of time. Even when a photographer sells a print, the photographer still owns the copyright to the image (more on this in chapter 23).

WHAT ABOUT EQUIPMENT?

I tend to be a minimalist regarding camera equipment and this seems unlikely to change, because a growing part of my budget goes for

ever-changing technology, not to mention outdoor gear, a vehicle, and travel expenses. When I first began to make a real go of this in 1986, I put my equipment together and had a total of one 35mm SLR camera, four lenses, and a tripod. I thought it looked pretty professional—at least it was a good start. My next big decision was to start shooting a 4 × 5 inch view camera. For years I studied the black-and-white photography of Ansel Adams and Edward Weston, then the contemporary color photography of Larry Ulrich, David Muench, and Carr Clifton. I figured if my future competitors all shot a view camera, so should I. On many trips, I rarely took my 35mm SLR out of its case.

In the mid- to late-nineties, with the changing marketplace and digital technology, using a 35mm SLR made much more sense. It's inexpensive to shoot and then scan 35mm film. Nowadays, relatively few photo buyers want to see film because they're reviewing images online. When they do "buy" something, they want a digital file. Frankly, the quality of digital prints coming from many 35mm slides is astounding. I'm finding that the only markets that prefer 4 × 5 inch film are calendar companies and firms associated with large display prints. Even calendar companies will be forced into reviewing digital submissions; it's just a matter of time. Will the view camera and the traditional 35mm SLR eventually fall by the wayside of the technological superhighway? I'll get into that later. Just remember that your equipment does not determine your success. It's the images you produce that really matter.

Good Photography: A Deliberate Approach

One thought that keeps me excited about photography is that even when I revisit some of my favorite haunts, there's real potential to capture new and unique imagery. Consider all the changes in light and weather as just one day progresses. Then imagine the four seasons, passing year after year. Enter the photographer, capturing perhaps only a sixtieth of a second of this endless change with each exposure. However, it's not chance or luck that most often yields a great photo. This is achieved through a deliberate and integrated approach.

PREPARATION

When I began, I often went into an area without much regard to planning. I looked at it as an adventure and if it was off-season so much the better. There'd be fewer people and I'd have the place to myself. There's something to be said for this philosophy, but not when it comes to making the most of your time and producing good photography. You'll see why some solid preparation before you begin your journey can pay big dividends. Upon arriving, spend some time *location scouting* so you can return to predetermined spots when conditions are at their best.

In some ways, preparation adds to the excitement of photography, even when shooting near home. Rather than just carrying around the camera and wondering if there's a view up ahead, I'm more anxious and motivated when I have some specific shots already worked out. Hopefully, really good shots. Anticipating what's in store, I wonder, are the skies going to stay clear? Did the flowers survive

last night's wind? Once you've done your homework, you're so much closer to getting a great image. (See chapter 11, Planning a Successful Photo Trip; chapter 12, Location Scouting Basics)

A COMMON THREAD IN GOOD PHOTOGRAPHY
Whether e-mailing snapshots or sending images to magazines, all photographers enjoy showing their photos and getting some positive feedback in return. Whatever your objective, there are some common traits that tend to make a photo appealing. Usually it's a combination of powerful elements, or *icons*, which convey something in and of themselves. However when these objects are arranged in an effective *composition*, the image comes together as a whole. Icons and composition often work together on a subconscious level, with a result that's more powerful than the sum of its parts. That's why you might not know exactly why you like a particular image—you just do. (See chapter 3, Elements of an Image)

WHERE AND WHAT TO PHOTOGRAPH

The great thing about nature photography is that there are literally an infinite number of places to set your tripod, and a whole range of conditions under which to do so. On the downside, this can seem overwhelming at first glance, especially when visiting a new area. Just where do you start? One way the early biologists made sense of nature's diversity was to break things down into categories. It's the basic approach I've taken here. When you start exploring a new landscape, you can ask yourself what kind of environment is it: Canyon? Desert? Mountains? Seashore? What are its most prominent elements—flowers, skies, or streams? By reading the appropriate chapter, you can utilize some time-tested techniques to come away with better images.

WHO'S YOUR AUDIENCE?
In photography, there's a difference between shooting for your own satisfaction and shooting to sell. In one sense, it's the level of commitment: if you want to be a pro, you really need to kick it up a notch or three. But going pro also entails a more refined approach to what you decide to photograph. Looking at it from a strictly marketing point of view, you're developing a product line, and you always have to remember the buyer. You've heard the old saying, the buyer is always right. This should give some direction to your shooting.

When I began shooting seriously, I tended to avoid some of the classic places, preferring quieter, less traveled areas. Slowly I came to the realization that I was making photography hard on myself, and taking excellent photos was already hard enough. Frankly, nobody cares if you struggled for five miles or shot it from the front seat of your car while enjoying a donut and coffee. They just want an image that works for them.

After about three years of hard work, I showed my photography to the owner of local stock house. After reviewing my work he remarked, "So, where's Maroon Bells?" Maroon Bells are majestic twin peaks forming a dramatic backdrop to an equally beautiful lake in Colorado. Not wanting to be among the masses of other photographers, I hadn't shot there, not yet anyway. This was a mistake. I also realized that this area has real magic. For whatever reason—geologic, weather, cosmic, I don't know—it's special. The lesson learned? I had worked hard for a few great mountain photos, but people still wanted to buy Maroon Bells. Give the customers what they want. (See CD-ROM: Maroon Bells)

Elements of an Image 3

Telling someone how to compose a pleasing photograph is difficult. It's like the old saying, "I can't tell you what art is, but I know it when I see it." However, much of the mystery is removed if you consider three basic elements when making a photograph: the subject, composition, and lighting. (See CD-ROM: Composition)

SYMBOLS AND ICONS: THE STARS OF YOUR PICTURE

Placing elements in your photograph that have mass familiarity and readily convey an idea or message helps people relate to the image. These icons or symbols are so integrated into our society and mass psyche that they have a profound and subconscious effect on us. That's why certain subjects and places are seen over and over in landscape paintings and scenic photographs. These eventually make their way into calendars, books, magazines, and advertising. As I write this, and for several years prior, it seems every national television ad is based on an old rock song. It's hoped that in just a few seconds, the music will get the advertiser's message across to millions of people. Try to do this with your photography.

Can some of these be considered clichés? Have they been shot before? Guilty on all charges. But you're missing the point if you want to be an accomplished nature photographer. I know, because I made the mistake of not visiting popular areas sooner and photographing subjects with universal symbolism. Ask what defines the place you're visiting. If you go to Paris, you want a picture of the Eiffel Tower, but a successful image will also convey something more generic, like romance.

Here are some time-tested icons:

1. *Saguaro* (sa-WAR-o) *cactus* of the Sonoran desert. What better says, "This is the American Southwest"? A silhouette at sunset and voilà, you have a classic.

2. *Monument Valley* along the Arizona-Utah border is the American West to people worldwide. It's seen over and over in calendars, car ads, John Wayne westerns, even fashion shoots. The towering buttes denote strength, adventure, the last frontier. Plus, the campground is the best.

3. The *Grand Canyon* denotes eternity, raw nature, solitude, one of a kind. It also has international appeal.

4. *Water* is life. It's found everywhere—lakes, oceans, streams, waterfalls, reflections, raindrops, rainbows, and snowfields. Even an arid canyon is the manifestation of water's work on rock. Wherever you go, look for water.

5. *Pointed peaks and rocky ridges* convey adventure, overcoming obstacles, reaching new heights, success. From my home, Longs Peak (14,255 ft.) dominates the skyline. As your eyes ascend its rocky ridges, you're met with disappointment. The summit is a quarter mile of flat and quite anticlimactic ground, nothing like, say, the Grand Tetons.

6. *Redwood trees* stand for stability, longevity, strength. For an insurance company, they convey, "We'll always be there for you."

7. *Bald eagles* represent independence, wildness, freedom, made in America. Their popularity rises and falls with the tides of patriotism.

8. *Sunbursts.* Few elements can spice up a photo better. Sunbursts symbolize rebirth, energy, excitement, cutting edge. They add warmth to a winter scene or make a desert feel blistering hot.

9. *Colors* convey many feelings. Green is the color of nature; a "green" product is environmentally friendly. Yellow demands attention, and yellow flowers pop out above all others. Red can be viewed as warm, but also exciting, energized. Although blue is thought of as cool, there's nothing better than a blue sky.

Above all, be positive and upbeat. Life is better than death; a green juniper framing a canyon is far better than its deceased counterpart. Blue skies are more appealing than somber clouds. (See CD-ROM: Composition > Icons)

GENERAL RULES OF COMPOSITION

When a beautiful scene stops you in your tracks, your first impulse is to get your camera and take a picture, but often the result is a disappointment. One way to become more discriminating in your picture taking is to ask yourself the five questions of journalism: who, what, when, where, and why:

- *Who* are you taking this picture for—an art director, a magazine, or yourself?
- *What* are you trying to convey—a mere visual record or nature's power?
- *When* is the best time to photograph it—a mid-July morning?
- *Where* is the best vantage point?
- *How* can you select and compose key elements to express what you want to convey?

One challenge in photography is successfully translating a three-dimensional, multisensory experience into two dimensions. Using basic rules of composition can help. You're often not consciously aware of them, but they're at work in most good photos and are worth knowing. The old adage, "rules are meant to be broken" is probably more applicable once you've acquired the basic compositional skills and you're consistently taking successful photos.

A valuable exercise is to test these rules, or visual theories, with your images. Try flipping over, or "flopping," a transparency or scan and seeing the effect. Also, crop your images several ways, to see if they can be made better. Next time you're in the field, you might take the better photo first.

The Subject and Its Supporting Cast

One reason images fail is because they don't have a powerful subject. That's why I began this discussion with examples of common symbols and icons, and the innate message or power they bring to a photo. However, subjects don't exist in a vacuum, but are part of a more complex environment. A good photographer usually employs several rules of composition to organize the subject and its supporting cast into a pleasing arrangement. Unfortunately, unlike a painter, we can't rearrange these elements with the stroke of a brush; we can only choose the right camera position and lighting.

To appreciate how small changes in camera position impacts your composition, try this simple exercise: Stand still and note exactly where major objects intersect with other elements in your environment. Exactly where does a fence post intersect with the tree behind it? Now slowly move to your right and left, then bob up and down. The juxtaposition of these objects changes dramatically as you change position. If your not making note of these changes when positioning your camera, you're rushing the shot.

Rule of Thirds

A common guideline is the *rule of thirds*: Divide the camera frame into thirds, both top to bottom and left to right, so you have nine regions. (See CD-ROM: Composition > Rule of Thirds)

THE HORIZON LINE

Generally the *horizon line* is placed either near the top one-third or bottom one-third of the photo. When you want to emphasize the vast sky, place the horizon line nearer the bottom third of the frame. Conversely, to emphasize the land, place the horizon near the top third of the frame. This is based on the belief that symmetry tends to be predictable and boring, whereas asymmetry is viewed as exciting. Therefore, a horizon line splitting your photo in equal halves, like positioning your subject right in the middle of the frame, is considered boring. When the actual horizon isn't quite level, it's often better to adjust the camera to make the horizon appear level. Otherwise, it can look like a mistake.

LEFT AND RIGHT BORDERS

Like the horizon, a subject is best placed off-center, near the right or left third of the picture. Furthermore, some feel having the subject on the left side is more powerful, whereas positioning it on the right side makes it a secondary part of the composition. This might be because we read left to right. Most magazine cover photographs seem to have prominent objects on the left side along the spine of the cover.

FRAMING

You can place secondary elements well off to the sides of the picture. This is called *framing* the picture. Tree branches can contain a vast sky, an endless ocean, or frame your subject. When incorporating vertical lines as a frame, make them appear vertical. When using a

wide-angle lens, unless the camera is parallel to your subject, you're bound to see some convergence, like tree trunks curving inward. If objectionable, convergence can be reduced by moving back from the subject, keeping the camera parallel to the subject, and using a longer focal length lens. (See CD-ROM: Composition > Frames; Man Made > Miscellaneous > Lighthouses2.jpg)

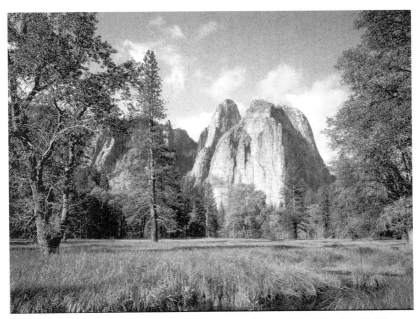

CATHEDRAL SPIRES IN YOSEMITE NATIONAL PARK, CA. MAY 23, 8:00 A.M. *Trees are the most common way to frame a scene; just be certain the main subjects aren't hidden. Yosemite Valley offers more photographic diversity than any area its size.*

Vertical and Horizontal Formats

One of a photographer's most basic decisions is to choose between a vertical (portrait) or a horizontal (landscape) format. We view the world in a horizontal or slightly panoramic format, and this is generally considered normal and calming. Most nature photos are horizontal format, as are most calendars and prints. I've learned to appreciate that a horizontal can be cropped into a vertical, but it's not easy to create a horizontal from a vertical image.

Before you capture the image, view it in both formats. Often this provides exciting ideas. Vertical format is perceived as active or unusual and can emphasize a vertical subject, like trees. Verticals also

have plenty of space for foreground, which helps increase the feeling of depth. I love to photograph streams, but much to my dismay, I've noticed that most of my images are verticals. (See CD-ROM: Streams)

Adding Depth to a Two-Dimensional Image

A photograph is a flat, two-dimensional object. But one characteristic of a good photo is that it has a feeling of depth, or three dimensions, thereby pulling the viewer into and through the image. It does so by effectively incorporating the foreground, middle area, and background. Try placing the main subject nearer the middle area, with the foreground and background framing or complementing the main subject. Also try positioning a stunning subject (like flowers) in the foreground and in front of a grand backdrop (like mountains). This is a good way to convey a sense of scale and depth. (See CD-ROM: Flowers > Colorado > Colorado7.jpg) Lighting and shadows are also used to convey depth and are discussed in a following section.

Also, because we are dealing with depth and dimension, avoid having the subject blend into or conflict with the surroundings. Basically, make sure a telephone pole isn't growing out of someone's head.

Lines and Curves

Lines and curves are another way to carry the viewer through an image and convey depth. We read from upper left to lower right, and this supposedly influences how we interpret a photograph. It's felt that diagonal lines and s-shaped curves running in this "reading" direction are more appealing. For instance, a fence or stream going from upper left to lower right gives the impression it is coming toward us, whereas lines running from upper right to lower left are interpreted as receding. Flop some of your photos and come to your own conclusions. (See CD-ROM: Composition > Lines)

LIGHTING

Lighting plays such a critical role in photography that it's hard to overestimate its importance. Unfortunately, nature photographers can't change the light; we have to work with the cards we're dealt. Become familiar with many different lighting conditions and what's best photographed under each. Then match the lighting with the

appropriate subject. This is why location scouting is so critical. You find good shots beforehand, then return when the lighting is best. The quality of light is controlled by the sun's movement and the sky, especially clouds. (See chapter 18, Photographing the Sky)

The Sun's Movements

To simplify things, assume that the sky remains cloudless all day and that it's generally better to photograph with the sun somewhat at your back or side. Imagine facing your subject with both arms spread out, forming a straight line through your body. Keep the sun behind this line.

Throughout the day, the sun predictably moves from east to west. This movement effects the sunlight's brightness and color, but more importantly the shadows. I admit it; I'm not a big fan of shadows, especially dense, color-robbing shadows. In many ways, I look at color photography as managing shadows. That's why most scenes are best photographed at certain times of the day, so your subject catches the light while minimizing the shadows. That's why good backlit scenics are so difficult to pull off. You're shooting directly into the sun and everything is in shadow, thus showing very little color. (See CD-ROM: Sunsets > Sunset > Sunset6.jpg)

SUNRISE

At sunrise, the light's color is at its warmest or most golden, but we also get our longest shadows. This is one reason to keep the sun more toward your back. However, as the sun rises, even within an hour or so, the light has "cooled" considerably, to become much more blue in color. For everyone who loves a sunrise, don't pack up the camera too soon. The hour or so after sunrise is one of the very best times to photograph. The sky becomes a darker blue and most valleys have filled with light. What shadows there are often help to define the contours of the land rather than hide them. Also, the light isn't nearly as "contrasty" or harsh as later in the morning and early afternoon. (See CD-ROM: Sunsets > Sunrise > Sunrise3.jpg)

MIDDAY

As the sun rises high in the sky the light becomes brighter and bluer while the shadows become blacker, but smaller. Many photographers feel it's the time to pack it in until later in the afternoon, but first review your options. If you haven't changed where you're pointing

the camera, the sun has now moved in front of you, making the scene backlit, generally a no-no.

Now it's time to consider changing locations, or at least changing the direction the camera's pointed. Remember, we want the sun behind our spread-out arms. Another major consideration is the sky. A great looking sky can really make shooting worthwhile, especially if you can use a polarizing filter. During midday, the sky is often a rich, deep blue and contrary to has other opportunities. When photographing a deep, narrow canyon or valley, it's often nice to be able to see into its very depths, especially if there's a nice river, like the Colorado Black Canyon of the Gunnison. When all these options fail, scout another location so you're ready for later in the afternoon.

LATE AFTERNOON TO SUNSET

Mid afternoon blends to late afternoon and ends in sunset. The lighting conditions reverse themselves by slowly becoming less contrasty, gradually a little warmer, and with shadows progressively longer. Although the shadows become longer, they can be managed in two ways. Generally, position yourself to keep the setting sun behind your spread-out arms. In this way, most of the shadows won't dominate your composition. As the day gets later, the contrast range lessens and the shadows begin to show more detail and color, a big improvement over dense black.

POLARIZERS AND LENS SHADES

As the sun moves higher into the sky and shadows diminish, the light becomes harsher (higher contrast). Keep the sun behind your spread-out arms and consider using a polarizing filter and a lens shade. A polarizing filter produces a rich blue sky and increases the color by reducing haze. A lens shade prevents stray light, which would degrade the image, from entering the lens. (See chapter 7, under Polarizing Filters)

A Day in the Life of a Nature Photographer 4

Few of us have an unlimited amount of time in the field. So when we have the opportunity to shoot, we want to make the most of it. What I've learned over the years allows me to be far more productive in the field, while depending less on the fickle hands of nature for success. Once believing that sunrises and sunsets were the holy grail of nature photography, I've learned how to photograph throughout the day and under various lighting conditions. Finally, I'm thinking of the photo buyer. I have to sell this stuff and imagery tucked away in a file cabinet is of little value me.

THE MAROON BELLS

I'd been shooting stock for a number of years before visiting Maroon Bells, Colorado. I knew plenty of people had photographed them and that the area was a tourist trap. I also figured the farther you hiked or worked for a photo, the more inherent value it had. Wrong. To give you a sense about how my photographic approach has evolved over the years, I'm going to describe revisiting the same area over the years. (See CD-ROM: Maroon Bells)

Round One: It's a Sunrise Shot

On my first visit, I spoke with a friend of one of my favorite nature photographers, Larry Ulrich. He mentioned how Larry had enough energy to photograph here all day. At the time, I didn't know quite what to think. Wasn't the best shot along the lake at sunrise? What was he shooting during the rest of the day? I don't think it was energy or enthusiasm I was lacking, it was skill. The classic Maroon

Bells photograph is thought to be an early morning shot, especially in the fall. It's common to see the photographers arrive in droves by 5:00 A.M. and leave a few hours later. I did the same.

Round Two: Later Is Often Better

On my second autumn trip, I had a nearby campsite and little incentive to leave. The morning began with a soft breeze and a hazy sky. Like everyone, I shot a mediocre sunrise and exhausted my limited supply of film holders for my Sinar view camera. With nowhere to go, I stayed along the lake and shot my 35mm SLR.

By about 11:00 A.M., well past the golden hours, the skies had turned a brilliant blue and sported great cumulus clouds. Plus the lake's surface was finally calm, showing its highly prized reflection. I felt lucky. Afterwards, I was thrilled at just how vivid these photos looked. Many times I've thought, I'd love to have this on 4 × 5 inch film. But I learned two valuable lessons: Don't pull up stakes too soon, and there is nothing better than a great blue sky.

Round Three: A Little Patience Goes a Long Way

Several years later, while shooting my favorite autumn area—the Sneffels Range in the southwestern part of Colorado—there was word of fresh snow on the Bells. The recent storm had produced disappointingly little where I was, so I left. The Denver media treats the aspens' foliage change as a major event, so quite a few hopeful photographers were shuffling patiently along Maroon Lake's shore.

Unfortunately, the morning arrived with wind and drizzle. By 9:00 A.M., one fellow diehard and myself had the only tripods left standing. One aspect of photography that confounds me to this day is, when do you give up on a shot? I mean, who hasn't just thrown their camera gear into the car, only to have the sun finally come out? Every now and then we queried each other as to whether it made any sense to keep on hoping. I've learned over and over to be patient. So, there we stood.

I've come to appreciate that some locations have an unexplainable magic. The weather can change rapidly, and if you're prepared, you're rewarded with some heart-pounding shooting. Maroon Bells is such a place, Yosemite Valley another. I was positioned at the east end of the lake, so a large group of spruce trees framed the left side. Unfortunately, it's a breezy spot.

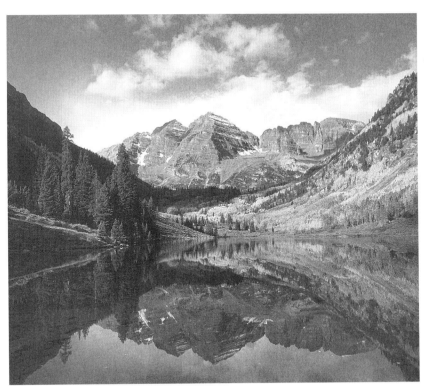

Maroon Bells near Aspen, CO. September 26, 8:45 a.m.
This is the classic view of the Bells and the shot everyone wants. Don't avoid the popular areas just because they've been photographed.

Slowly the clouds parted, revealing a few patches of pastel blue. The twin peaks remained hidden in the clouds, but now there was hope. My pacing around the tripod was replaced with rechecking that everything was ready, just in case. The wind had eased a bit and the reflection everyone comes to see was slowly coming to life.

Over the next hour the skies were transformed to a cloudless blue, without a hint of wind. Every now and then I shot another Polaroid and some film. I'm one of the few nature photographers who uses Polaroid instant film. The immediate feedback eliminates stupid mistakes—most of the time anyway. I was introduced to it when I was a photographer's assistant. It was a staple among the pros, until digital anyway. I packed up my gear, assured I'd gotten the classic shot I'd always wanted. (See CD-ROM: Maroon Bells > Lake1.jpg)

Final Round: Learning to Look Beyond the Obvious

After traveling throughout much of the American West, methodically expanding my stock files, I revisited the Maroon Bells. Not having a reserved campsite, I left home after dinner to arrive in time for bed. This let me sleep right in the parking lot, with little chance of being hassled. I could monitor weather conditions and have a short hike to the lake. Nature photographer's need to be near the action. I was looking forward to a relaxing time, because I already had some good images. However, since my last visits, I'd become a better and more productive photographer. Here are some the ways I improved.

DAY ONE: SUNRISE AND COFFEE ALONG THE LAKE

Most photographers set up right at the lakeshore. What can I say, you can't help but be blown away by the view, no matter how many times you've see it. After shooting sunrise, most are heading to their cars. Unless there's a spectacular sunrise, the best fall shooting is at 9:27 A.M. This is when the sun finally fills the valley floor with light. Until then, the prominent spruces and the most colorful aspens are shaded.

The morning dawned breezy, so I photographed where Maroon Creek exits the lake. With the low water flow in autumn, the creek formed a small pool about five feet wide. I've learned it takes very little area to yield a big reflection. Plus, small pools of water are often tucked away from the wind, and even if disturbed, the reflection in them returns quickly.

I positioned the camera a couple of feet from the water's surface. It took several years to feel confident getting close to my subject, down on my knees close, but it's had a major impact on the quality of my images. However, from this vantage point, the relationship between foreground and background is much more complex. Now, small changes in camera position have a dramatic impact on composition. So I use a tripod and take my time.

I like to elicit a feeling of wildness in my photos, but there's a trail running along the edge of the creek bed, so I reduced its impact by laying logs on it. This also kept people from standing there. While everyone else was waiting for the wind to die down, I photographed this protected spot to my heart's content. The wind finally relented at about 10:30 A.M. and the Bells formed their trademark reflection. Unfortunately, only a couple of photographers were left to enjoy it. (See CD-ROM: Maroon Bells > Creek2.jpg)

It's really worth getting some of the classic shots, but afterwards try something different. I invest considerable time looking for a beautiful foreground to complement a stunning backdrop. Years earlier my hard work paid off. I'd found a great spot, but never got the shot. It's along Maroon Creek, upstream from the lake. When I arrived at noon, it was about time to stop shooting toward the Bells. The sun was almost in front of the lens and the scene was becoming backlit, so color saturation decreased markedly. Since I'd figured out the exact composition, I shot it quickly. It was nice, but it could have been better. I've learned that one great image is worth more than many nice images, so I decided to return the next day, only earlier. (See CD-ROM: Streams)

DAY TWO: IF AT FIRST YOU DON'T SUCCEED

The next day there was no need to return to Maroon Creek too early. It's at a low point and stays well shaded until about 9:00 A.M. Everything went as planned, but as I was leaving, a cloud appeared. Mountain clouds usually don't blow in, but are formed by the peaks themselves. A good photographer lets the clouds build to an esthetic balance, about 60 percent blue sky to 40 percent clouds. This is a short-lived moment and worth capturing. I've learned it's not luck or an unpredictable moment that gives me a great image. It's planning, location scouting, and coming back at the best time. (See CD-ROM: Maroon Bells > Creek1.jpg)

Being a naturalist and monitoring conditions is critical. By talking with other photographers, I learned that most of the state's aspens had a fungus from a wet summer. The leaves got black spots and fell off. Armed with this knowledge, I decided to stay put. Anyway, I produce my best imagery by exploring an area and photo-graphing it under varied conditions.

I've climbed high above the lake before, but never found any-thing to shoot. I lost the trail and so I arrived as clouds filled the sky. Plans changed from picture taking to location scouting. Later, as I headed down, I had little to show for considerable effort. I'd never seen a good sunset at Maroon Bells, but planned to descend to the lake just in case. I'd go nuts being stranded in the forest with the sky on fire.

I sensed the light was changing and picked up my pace. A view camera can seem interminably slow when setting up under fast-changing conditions, so I used a wide-angle lens. It would be far

more forgiving of stupid mistakes and would encompass both the reflection and a large part of the sky. By now the Bells were nearly black, but their rugged silhouette overcame the lack of detail and their faces were punctuated with snowfields. The lake remained calm, so I got a reflection and reasonable color—good but not great. (See CD-ROM: Maroon Bells > Sunset013.jpg)

Alone in the parking lot, I checked my shot list and found a surprise. I'd noted that the road was freshly paved and painted. It also runs through a beautiful valley right toward the Maroon Bells; it seemed perfect. I'd begin the next day shooting the road.

DAY THREE: WORKING THE ROAD, TIME WELL SPENT

I've always had requests for roads and cityscapes, so I shoot them. The next morning dawned clear, so, with little chance of a spectacular sunrise, I ruled out the lake and headed down the road. Since I hadn't scouted it yet, I left before sunrise. I think of roads the same way as streams. I find locations where the road winds through the frame to infinity or goes straight as an arrow to a great backdrop. (See CD-ROM: Roads > Mountains > Aspen6.jpg)

While scouting the road, I spotted several potential sites. One was a rocky ridge that climbed high above the valley and might be perfect from sunrise to about 11:00 A.M. (See CD-ROM: Maroon Bells > Expore1.jpg)

The other was a small pond tucked in a meadow. I thought it was a morning shot, because of its open view of the Bells. On closer inspection, I noticed the trees behind the lake were dead, so I decided against that view.

You often have to fight tunnel vision when visiting an area renowned for an icon, like redwoods or saguaro cactus. I circled the pond several times and found another spot. Having the luxury to casually scout a location is like playing with a zoom lens or comparing vertical versus horizontal formats. It expands your creativity.

The pond held a reflection of the mountains that lined the lower valley. From my previous day's hike above the lake, I knew these peaks would catch the last light. The rounded summits weren't as rugged as I prefer, but a colorful reflection surrounded by tall grasses might make it all work. I'd finally found an afternoon shot along the valley. (See CD-ROM: Maroon Bells > Pond.jpg)

Solid planning and preparation before you begin shooting will increase your chances immeasurably. Visit a few great locations,

hopefully during the best seasons. Upon arrival, check out the vantage points you've learned about and scout for new ones. Determine when it's best to photograph by learning the sun's movements. Stay a couple of days and then head to your next well-chosen locale. Most nature photographers need to fight the urge to keep on driving. Besides yielding more and better imagery, this strategy also makes traveling with companions less stressful.

PART

2

Equipment

Cameras

I have my equipment preferences, but I know successful nature photographers using every kind and make of professional gear. They've all made the equipment work for them, because they know how to use it. Here is information about technical aspects that apply to just about any camera format or lens, and about how you might use this knowledge to produce better imagery. (Lenses are covered in detail in chapter 6, Lenses and the Creative Process)

35MM SLR CAMERA SYSTEMS

The 35mm SLR, with its incomparable selection of lenses and accessories, is undoubtedly the most versatile camera system, and the only logical choice when photographing wildlife or people. A valid case can be made that you shouldn't shoot anything else. Even the digital camera option has to be weighed against the ever-increasing affordability of high quality 35mm film scanners. Even if you intend to buy a larger format camera system, it makes sense to explore and perfect your photographic skills with this economical system. If and when you switch to digital, you should be able to use your lenses on your new digital body.

35mm SLR Camera Bodies

Most camera bodies provide more than you need for nature photography, and it's the selection of lenses, accessories, and/or price that will sway your decision. Basic features are motor drive, electronic flash, and exposure system. The biggest variation is the type of light metering, but it shouldn't take long to adjust to a new system.

Most 35mm SLRs have both *automatic* and *manual* modes. In automatic mode, the camera meters the light and then selects the exposure by adjusting shutter speed and/or aperture (f/stop). It's a great feature for changing light and action photography. However, you still want to know how to use the camera's manual mode. Here, the camera meters the light, but you adjust the shutter speed and aperture (f/stop) to set the exposure.

Built-in Electronic Flash

A built-in flash unit is a big advantage and increases your camera's usefulness. Because of the flash's relatively low power, it can't light up a landscape, but it's useful for still-lifes, close-ups (macro), some wildlife, and family photos. You may still want the ability to attach a flash unit (strobe), either directly to the camera body or via a synch cord. This capability is particularly important if you expand into sports or people photography. Here, artificial lighting is critical to freeze the action or pleasantly light your subject. To excel at photography using artificial lighting, become familiar with professional lighting techniques and light modifiers such as diffusion material, gels, fill cards, reflectors, soft boxes, and umbrellas.

Size and Weight

Some of today's cameras are like SUVs—they've grown to include every bell and whistle. But let's face it, all we photographers really have to do is focus the lens, then adjust the aperture (f/stop) and shutter speed to set the exposure. It's not all that complicated. Recently I replaced a camera body with a used, non-automatic camera. I wasn't sure if it was worth spending the money for another expensive body, especially with the arrival of digital. I quickly appreciated its shear simplicity, compact size, and lightweight. When combined with a 24mm-70mm zoom, a polarizer, and a few rolls of film, it's perfect for location scouting.

35MM SLR LENSES

The 35mm SLR camera system has lenses from wide angle (short focal length) to telephoto (long focal length), to zooms (adjustable focal length). The advent of autofocus, along with automatic and digital features, has made compatibility an issue. Make sure new equipment will work on your older gear, and find out whether it's compatible with newer digital cameras. This chapter presents some

of the features important to nature photographers. However, because all lenses obey the basic laws of optics, their effect on picture taking is discussed in next chapter, Lenses and the Creative Process.

Wide-angle Lenses

Wide-angle lenses (commonly 18mm to 35mm) are some of the most useful lenses for capturing the grand landscape. They're easy to handhold and provide a great deal of depth of field, so you can get very close to a stunning foreground, while keeping distant mountains razor sharp. This technique yields powerful imagery.

Normal to Short Telephotos Lenses

So-called normal lenses (50mm) give the approximate field of view and perspective of human vision. They're great for landscape and people photography. Slightly longer lenses (70mm to 105mm) are called portrait lenses because they isolate a person and put distance between the subject and photographer, thereby creating a pleasing perspective. Consider a 50mm or 100mm Macro (Micro) lens for close-up photography. A macro lens in the normal focal-length range can also double as a standard lens, with the bonus of letting you photograph close-up images of, say, water drops or leaf patterns.

Telephoto Lenses

Telephoto lenses are what make the 35mm SLR camera system out perform all others. Medium and large format cameras also have telephoto lenses, but not the variety and magnification available to the 35mm user. Telephoto lenses are more difficult to successfully use than wide angle or normal lenses, so it's important to understand the relationships between focal length, depth of field, focusing, and shutter speeds. (This is discussed in detail in chapter 6.)

Telephotos are a necessity for wildlife and sports photographers, and range from 200mm to 500mm. These are expensive, so evaluate your interests. When your primary goal is landscape photography, you might be better off beginning with a few zoom lenses, covering the range from 24mm to 200mm. (Few photographers realize the difficulty and expense associated with producing top-notch wildlife photography. See chapter 21.)

Telephotos have several drawbacks. Besides cost and weight, telephotos require a sturdy tripod and tripod head combination, along with a substantial protective case. Also, each increase in maximum

aperture, such as going from a 300mm f/4.5 to a 300mm f/2.8, adds weight, bulk, and cost. Once you know what kind of photography you want to pursue, then consider the investment. You might also consider a 1.4X or a 2X extender, or tele-converter, to economically increase the lens's focal length.

Zoom Lenses

Zoom lenses allow you to adjust the lens's focal length within a specified range. Zooms save weight and bulk, while increasing your creative options. They give you the advantage of exploring different crops and compositions without changing lenses. Generally wide angle and shorter telephoto zooms are most likely to provide maximum sharpness. A common set of 35mm SLR zooms is a 24–70mm zoom and a 70–210mm zoom. Beyond this range, it is best to use fixed focal length lenses, such as a 300mm or a 400mm, possibly with an extender.

WHY USE A LARGER FORMAT CAMERA?

Some photographers want to capture an image of the highest quality, and they think a larger film size is the solution—but it's not that simple. Yes, medium format film is about three times bigger than 35mm film, and 4×5 inch film is about fifteen times bigger. However, there's more to the equation than film size. You have to evaluate your goals, even your personality.

Advantages

Larger film is an advantage when you are making larger reproductions. It also gives the option to crop, or only use part of the film, and then enlarge without sacrificing image quality. The question becomes, is it worth buying a second system for the occasional need for larger film? And, if you're going to make the investment, why not bypass medium format and go directly to a 4×5 inch view camera, since both cameras are heavy and require a solid tripod.

A 4×5 inch view camera is immanently practical. Imagine standing in front of the perfect panoramic mountain range. A wide-angle lens will capture the breadth of the scene, but the real advantage to 4×5 film is that there's still plenty of film above and below the mountain range that can be cropped. You never know if the designer wants more sky or more foreground. Placing the mountain range dead center may not be the best aesthetic decision,

but it may be the best economic decision. The ability to crop a big piece of film is a tremendous asset. (See CD-ROM: Marketing > Subjects > Pano2.jpg)

Medium format and 4 × 5 inch view cameras are very different, so I'll discuss their workings and advantages separately.

Disadvantages

Now, I'll play the devil's advocate. First, it's worth developing your skills to a moderate level on a 35mm SLR or comparable digital camera. A mediocre image that's bigger isn't better. You should learn which images are special and warrant bringing out the big guns. Whether you see it as an advantage or a disadvantage, tripod-mounted cameras slow down the photographic process. You must think more about composition, because moving a heavy camera and a tripod is strenuous work. If a medium format camera takes twice the effort of a 35mm SLR to use, a 4 × 5 view camera takes four times the effort, because it also has film holders and camera movements.

Like it or not, you're going to miss some good shots, especially when conditions are changing and you're fumbling. Basically, you've got to have the right temperament: someone who likes the technical aspects of photography, prefers quality over quantity, and doesn't mind working a little harder.

Another reason larger format cameras are more demanding than a 35mm SLR is because lens magnification decreases as film size increases. Thus a longer lens is needed to magnify the scene onto the larger film. Here's an example: A 50mm lens is considered normal for a 35mm SLR, whereas a 150mm lens is considered normal for a 4 × 5 inch view camera. There are a host of issues that come into play as focal length increases, such as less depth of field and a greater need for stability. (See chapter 6)

Expense

Larger format systems are expensive, with fewer accessories and fewer third-party manufacturers of less-expensive lenses. Plus, you'll still probably want to use, maintain, and even expand your 35mm SLR or digital camera. Larger format systems complement, rather than replace, your other camera systems.

Medium format roll film is reasonably priced, but one sheet of 4 × 5 inch color transparency film costs about $3.25 to buy and

process. A roll of 35mm film costs $15 to buy and process. Also consider the added expense to scan the film. A high-resolution scanner for 35mm slides is affordable. Adding a new film format to your avocation may require you to buy a different scanner or pay to have it scanned.

Stock Value

Stock value is an image's economic value in the marketplace. You'll learn there are many markets for your photography, but each goes about business differently. Is the same image shot on 4 × 5 inch film inherently more valuable than a 35mm slide or digital file? Maybe, but maybe not. Today most photo buyers in the advertising and editorial markets review digital images, either on CD-ROM, via e-mail, or at a Web site. This is the great equalizer, as far as film size goes. Ultimately, if the client chooses your image, you'll usually provide a digital file.

On the other hand, there are instances where larger format film is preferred, such as when the use is large display prints for ads or trade show booths. Larger format film certainly has more impact compared to a slide, when viewed on a light box. Fine-art prints, quality books, and calendars all benefit from larger film. (The stock value of specific subjects is discussed in chapters 13 to 22.)

MEDIUM FORMAT CAMERAS

In many ways, a medium format camera is a larger version of a 35mm SLR, ideally retaining many desirable attributes of its smaller relative, while providing a larger film size. Both utilize roll film, a built-in light meter, interchangeable lenses, and possibly a motor drive. Realize that all medium format cameras are heavy enough to require a tripod, especially with slower films.

Many nature photographers use the Pentax camera, perhaps because it looks like a giant 35mm SLR. I've used the Hasselblad and Mamiya extensively, which go about things a little differently. Hasselblad has a square format (6 × 6 cm), the logic being you crop the image as needed. The Mamiya (6 × 7 cm) is a bit large for the field, but it is a real workhorse.

Film, Magazines, and Polaroid

There are two standard sizes of medium format roll film, designated 120 or 220. Both have the same width (6 cm), but the 220 has twice

as many exposures. A roll of 120 provides ten to twelve exposures. What's nice about Hasselblad and Mamiya is they use interchangeable film backs, or magazines. You can change the film back, hence film type, in mid roll. They're also designed to accept a Polaroid film back, something that is very useful.

THE VIEW CAMERA

To the uninitiated, the view camera is mysterious, but it's really the most basic of cameras. The lens and film are held in a front and rear standard, respectively. The two standards are supported on a rail or base plate, and are connected via the accordion-shaped bellows.

Focusing is accomplished by moving the front standard (lens) or the rear standard (film) back and forth, until the image is sharp. The photographer views an upside-down and backwards image on a focusing screen, called the ground glass. A magnifying loupe helps fine-tune the focus, and a dark cloth keeps out extraneous light. Imagine standing on the edge of a windy cliff, with a dark cloth over your head, focusing a disorientating upside down and backwards image. (See CD-ROM: Equipment > View Camera)

Two Kinds of View Cameras

There are two kinds of view cameras, *field* and *studio*. Both can be use with excellent results. Field cameras are specially designed for landscape photography, and are what most people envision when they think of nature photographers. Even newer models are often made of wood and look rather antiquated. Their advantage lies in their collapsible, compact design.

Studio cameras have a modular and are bulkier, but both styles weigh about six to seven pounds. I've used the Sinar F1 and F2 extensively since 1987. They're light, affordable, and very durable. (Visit *www.sinarbron.com*, *www.bhphotvideo.com*, and *www.calumetphoto.com*)

Lenses and Filters for View Cameras

View cameras have relatively few lenses. Wide-angle lenses for a 4×5 inch camera range in focal length from 70mm to 90mm. The normal lens is 150mm and longer lenses of 210mm to 360mm round out most camera bags. A 600mm view camera lens is about the maximum. There are no zoom lenses for the view camera.

Generally, multiply a 35mm lens's focal length by three to determine the comparable 4×5 inch view camera lens.

Begin by purchasing wider-angle lenses like a 90mm and a 135mm or a 150mm. Wide-angle lenses capture the grand landscape better and are easier to use. I feel the unique strength of the view camera is to get close to your subject and still hold focus in the distance, through the proper use of the camera movements.

Both UV (haze) and polarizing filters can be mounted onto the exterior lens element. However, it's common to attach a filter and filter frame (holder) to the inside lens element, the end inside the bellows. This allows you to use smaller, less expensive filters than those that mount on the exterior lens element. This also eliminates light reflecting off the filter, which may cause glare and flare. (See chapter 7)

View Camera Movements

Most people think the big advantage to a view camera is large film. What really separates the view camera from the 35mm SLR and medium format camera are the *camera movements*, the ability to adjust both the film plane and lens plane in almost any direction. These movements allow the photographer to control both the plain of sharp focus and perspective. A landscape photographer commonly adjusts the plane of sharp focus by tilting the front standard, with lens attached, forward. The effect is that the foreground (for example, flowers) and the background (for example, distant peaks) are both in focus. This lets the photographer get very close to the foreground and still keep everything to the background sharp. (See CD-ROM: Deserts > Flowers > Flowers1.jpg)

Perspective can be adjusted to keep tree trunks or buildings looking vertical, so they don't converge or slant inward. When a 35mm SLR is pointed upwards to photograph a nearby building, the film plane is tilted back relative to the building. The buildings sides appear to lean inward toward each other. To keep vertical lines vertical when using a view camera, the photographer tilts the rear standard, which holds the film, forward to the vertical position. The film is now parallel to the building and the building's sides appear vertical.

Sheet Film and Film Holders

The view camera exposes an individual sheet of film, which can measure 4×5 inches, 5×7 inches, or 8×10 inches, with 4×5

inches being the most common size used for nature photography. Two sheets of film are held in one sheet film holder. If you intend to shoot a lot of film, you either need plenty of film holders, or plan on unloading and reloading frequently. Twenty film holders is a minimum. You can use individually packaged sheets of film, like Fuji Quick-Loads® or Kodak Easy-Loads®. They're also great for long trips because they're compact and far lighter than film in conventional holders. (The CD-ROM has three files that show the cleaning and loading of sheet film holders. See Equipment > Film Holders)

An advantage to sheet film is that you can process (run) one sheet of film at a time. This allows you to alter the development based on the results. For example, if the film looks dark (under-exposed), the next sheet can be pushed, or developed longer, to make it lighter. (See chapter 8, under Pushing and Pulling Film)

Learning the View Camera

The view camera takes some time to get used to, so a book demonstrating its use will help. Begin in your living room or backyard. Practice by photographing simpler scenes that require few movements, with the camera focused at infinity. A nice sunny day is best, because the bright light will make focusing easier and getting the exposure correct won't be a problem. Shoot Polaroid Instant Film. It's also worth sacrificing a sheet of film or two to practice loading a film holder in the dark.

PANORAMIC CAMERAS

Panoramic cameras produce unique images, but I've always wondered about the practicality of such an extreme format, often 6 × 17 cm or wider. Concern one: I don't see the panorama format being used in print very often. I need to sell this stuff. Two, it really restricts the subjects you can photograph. Finding the right scene to fill its expansive width is difficult. (See CD-ROM: Mountains > Colorado > San Juan Mtns > Pano3.jpg)

DIGITAL CAMERAS

I must say, when my Nikon digital camera arrived, I was a little worried. It looked familiar enough—unless I looked at its electronic display glowing with technical information—but the manual is nearly 200 pages long. I've worked with various computers and scanners, but it's often a battle getting started. So I procrastinated.

However, when I finally got started, the learning process was surprisingly pleasant. The manual just might be the best I've ever used. It took about four hours from opening the box to seeing my images on the computer. This included a fair amount of experimentation, but never wondering if I would make it. Not bad at all.

Some photographers equate the arrival of digital with the plight of the characters in the movie *Invasion of the Body Snatchers*; something to be avoided at all costs. I firmly believe you can use either film or digital cameras to capture great imagery and sell it, but digital will eventually win you over and you'll like it. Digital cameras are increasing in resolution (file size) at a vigorous pace, and today's professional cameras even exceed most commercial needs. Whether film or digital, there's usually a computer involved, because most film is scanned. Therefore, digital photography is discussed in detail in part four, The Business of Selling Your Photography.

The big question is, if you're going to scan the film, why not go with digital capture and save all the time and money? The simple answer is, when you find a digital camera that produces a file size big enough for your needs, make the switch. You really need to review both photography and computer-oriented magazines to keep up with the newest offerings, if you're considering a purchase of a digital camera. (Visit *www.digitalimagingmag.com*, *www.digitalcapture.net*, *www.peimag.com*, *www.imaginginfo.com*, and *www.edigitalphoto.com*)

Pros and Cons of Digital Cameras

A computer is an integral part of the digital photography process. Most of us are familiar with computer memory and file size. Instead of film, a digital camera uses electronic media, in the form of memory cards or miniature hard drives, to store images as electronic files. After capturing the images with the digital camera, you download the files to your computer by connecting the camera to your computer's CPU. The high-resolution files that nature photographers want require considerable memory, usually many megabytes (MB). Today, four GB (gigabytes) cards and forty GB iPods are available.

A digital camera allows you to preview each image and playback previous exposures on its small monitor. This can be a real advantage in helping photographers succeed, especially those entering the market. First, it speeds up the learning process tremendously by letting you review different settings immediately. It's analogous to using Polaroid Instant Film to check composition and exposure

before exposing film. Second, when you calculate film and processing costs, you might be shocked at how much you spend. Reducing costs is a good way to increase profit.

Eliminating the need to scan film is another big savings because producing high-resolution files is very time consuming. Technology has already dramatically reduced my shipping costs. More often than not, I e-mail images or upload them to our Web site, at just the size the photo buyer needed and paid for. This is not only quick and easy, but also demanded by the marketplace. Plus, the time, effort, and anxiety spent on getting film back from the client safe and undamaged, and then refiling it, is eliminated.

A laptop computer is useful for traveling photographers to download files from the camera. This allows you to edit your images on a (relatively) large screen, saving only the best on the computer's hard drive. Plan on investing in several memory cards and also in a spare rechargeable battery for the camera. This dependence on electrical power becomes more problematic for adventurous nature photographers, who are often far from a power source. On the other hand, commercial airline security has made film a real liability. We do have the right to have our film hand-checked, but it's usually a hassle and it's easy to overlook some errant rolls.

Resolution and File Size

Resolution is the most common specification of image quality, and is given in megapixels (MP). The higher the megapixels, the larger the file size that is produced. Generally, the greater the resolution (or the larger the file size), the larger the image can be reproduced, like for large display advertisements or fine-art prints. Equipment is still evolving rapidly; today's fourteen-megapixel cameras have a file measuring 3000×4500 pixels, enough for a double-page magazine spread or a 16×20 inch fine-art print.

Nature photographers often make a considerable investment to capture an image, not knowing beforehand if it will be special. So why not capture it at the highest resolution, just in case? A 35mm slide will still outperform a fourteen-megapixel file, but just barely. Many nature photographers are anxiously waiting for a slightly larger file. I use a Nikon D100 digital camera. It produces a maximum file measuring 2000×3000 pixels, which is six megapixels. This is the same size as the maximum resolution files on a Kodak Photo-CD, which have served me well for many years. As you'll learn later, the

vast majority of commercial stock sales don't require large files and six megapixels are just enough for a full-page ad or a calendar page.

The original file format captured by the camera is referred to as a *RAW format*, and it's the manufacturer's proprietary file format. For example, NEF is Nikon's Electronic Image Format, and you need the manufacturer's software to view the images. (Film scanners also have their own RAW format.) When saved in this uncompressed file format, which preserves all the image information, a six-megapixel file is seventeen megabytes in size. Digital cameras can also save files in TIFF or JPEG (JAY-peg) file format to reduce file size. The JPEG file dimensions are still 2000 × 3000 pixels, but the file is compressed to only two megabytes in size. The loss of quality depends on the amount of compression. (See chapter 24, under File Formats)

Basic Considerations for Digital Cameras

Choosing a digital camera is much easier if you already have a quality 35mm SLR, with a selection of relatively new lenses and accessories. Sticking with the same manufacturer is probably the safest solution. My newer Nikkor zoom lenses work fine, and even my thirty-year old lenses work, but only in manual mode—still pretty amazing. Manual mode is just like a traditional camera and feels very comfortable. Compatibility with flash units (strobe) must also be considered.

It's important to realize that a lens's magnification may not remain the same from a film camera to a digital camera. Lenses often increase in magnification (focal length) when used on a digital camera. A little backyard experimentation revealed that my 24 mm lens becomes the equivalent of a 34mm lens on my digital camera—quite a difference. This means you may need to invest in a new ultra wide-angle lens, because they're so useful for landscape photography. On the opposite end of the focal-length scale, my 300 mm telephoto becomes the equivalent of a more expensive 400mm lens.

If your current equipment doesn't restrict your choice, consider visiting a professional camera store for a hands-on evaluation. Compare whether some menus and dials seem more intuitive than others. Check the monitor's size and how it looks, especially in bright sun and when it's tilted.

For action photographers, the capture rate, or frames per second (fps), may be important. The Nikon D100 has a three-frames-per-

second rate, which is very good. At this time, both faster capture rates and higher resolution cost substantially more. Check the manufacture's reputation and how many conventional accessories can be used on its digital cameras, including flash units (strobe).

Finally, there are many amateur point-and-shoot digital camera models, some at very low prices. These are less sophisticated than the professional models, and most offer only a built-in zoom lens. File size can be quite large, up to five megapixels, but my main concern with these cameras is the quality of their lenses and the lack of available accessories.

Following are some terms that you should be familiar with when using digital cameras:

- *Image Size* and *Quality*. As mentioned above, resolution and file size determine image quality and how large it can be reproduced. Digital cameras have settings for image size (dimensions), such as 2000 × 3000 pixels or 1000 × 1500 pixels. There are also settings for quality. The best quality and largest files are RAW format and TIFF. Various levels of JPEG compression can be used to balance files size and quality. (See chapter 24, Digital Files)

43

- *Noise*, or randomly spaced bright pixels, is the digital equivalent of film grain. Noise, which degrades image quality, can occur at shutter speeds longer than half a second.
- *Sensitivity*. This is the digital equivalent of film speed (ISO or ISO rating). Like using faster speed film, a higher sensitivity setting lets you use a faster shutter speed or a smaller lens aperture (f/stop). Settings range from about ISO 200 to ISO 1600.
- *White Balance*. Digital cameras can analyze the light's color temperature and adjust the information from its image sensor (CCD, charge-coupled device) to produce the best image. In auto mode, the camera selects the white balance for you. Other white balance settings are: Direct Sunlight, Cloudy, Shade, Incandescent, Flash, and Fluorescent. Briefly, yellowish tungsten light has a color temperature of 3300 degrees Kelvin, while bluish daylight is 5000 degrees Kelvin.

GENERAL PHOTOGRAPHIC EQUIPMENT CHECKLIST
To summarize the information discussed in this chapter, I have devised a general checklist of essential items:

- Two camera bodies, ideally one of which is relatively compact and light.
- Selection of lenses from 24mm to 300mm, longer if you want to seriously pursue wildlife photography. UV (haze) and polarizing filters with lens shade for each lens is minimal.
- Tripod, monopod, beanbag to lay the camera on for support.
- Flash unit (strobe).
- Film or memory cards (storage device) for digital camera.
- Spare batteries for cameras, light meter, flash unit (strobe).
- Any special cases, like a hip-belt case, for location scouting (See chapter 10, under Camera cases and Photo Vests).
- Cable release. If you forget this item, you can also use the camera's exposure timer or the mirror lock-up mode, if available, to reduce vibration.
- Lens cloth, canned air, zipper-locking bags, and spare lens caps.
- Tools and supplies, such as small screwdrivers, Allen wrenches, duct tape, computer cables.

- Notebook for your shot list, and to record dates and locations.
- Maps, guidebooks, watch, compass, GPS unit.
- Polarized sunglasses.
- Outdoor studio gear like green wire, scissors/pruning shears, spray bottle, eye dropper, glycerin, reflectors/fill cards, clamps, stand, or spare tripod.
- Clothing specific to the environment.

Also see chapter 12, under Checklist for Hitting the Road and Survival Gear: The Basics.

Lenses and the Creative Process

Many of the images I review have a fatal flaw, a big enough mistake that takes them out of the running. The most common is having part of the image out of focus—that shouldn't be. You can successfully push the limits of your equipment by understanding some basics about your camera and especially about lenses. Common lenses for use with 35mm SLRs and 4 × 5 view cameras were described in the previous chapter on cameras. This chapter discusses the principals and concepts that pertain to all lenses and profoundly influence the process of transforming your creative vision into a quality image.

FOCAL LENGTH

Focal length is an indication of a lens's magnification and its angle of view. The longer the focal length, the greater the magnification and the narrower the angle of view. In practical terms, a 50mm lens gives the approximate magnification (1×) and angle of view of human vision, and thus is often called a normal focal length. A 24mm lens is considered wide angle and a 300mm is a telephoto.

APERTURE

Maximum lens *aperture* is the other common specification listed with focal length. If a lens is described as 50mm f/2.8, it means the largest aperture, or opening, for the lens is f/2.8. Lenses with large maximum apertures let in more light than those with smaller maximum apertures, a fact which gives rise to a number of consequences: 1) the ability to expose film in low light; 2) the ability to use a faster

shutter speed to capture motion and possibly avoid using a tripod; 3) a brighter viewfinder, so it's especially valuable in longer focal length (telephoto) lenses where focusing is more critical. Also, most of the big lenses use small filters inserted in the light path, rather than a large one on the front, but this makes them more expensive. Most landscape photographers don't use the biggest aperture (like f/2.8), but rely on f/8 to f/16, which provide more depth of field.

Adjusting the lens aperture (f/stop) is one of the photographer's most important creative actions. To the beginner, f/stops are confusing because of their inverse relationship with aperture: the bigger the f/stop number, the smaller the opening. A lens set at f/16 makes a smaller opening than one set at f/11. Each f/stop lets in either twice as much light (from f/8 to f/5.6) or half as much light (from f/8 to f/11). I'll discuss shutter speeds shortly, but each shutter speed setting is equal in amount of light to an f/stop setting. Lengthening the shutter from 1/30 second to 1/15 second lets in twice as much light, just like changing the aperture from f/8 to f/5.6.

DEPTH OF FIELD

Depth of field is the distance from the nearest point that is in focus, or sharp, to the farthest point that is in focus. There is a direct relationship between depth of field and aperture (f/stop). Small apertures, such as f/11, provide greater depth of field (a larger area in focus) than larger apertures, such as f/5.6. Therefore, regularly use f/8 to f/16 to keep your photos sharp. One reason tripods are so valuable is that they let you use a slow shutter speed, so you can stop down the lens to a small aperture, and thus increase depth of field.

Depth of Field and Lens Focal Length

As focal length increases, depth of field decreases. A 28mm wide-angle lens provides far more depth of field than a 100mm lens, when both are set at the same f/stop and focused on the same subject. In fact, when using a wide-angle lens, it is difficult to get the background out of focus, unless you're focused on a very close subject. This is why such lenses are found on most point-and-shoot cameras.

Telephoto lenses, on the other hand, provide relatively little depth of field and let you isolate the subject from an out-of-focus background. This effect increases when you use a large aperture. Wildlife and sports photographers invest more money for telephoto lenses with a large maximum aperture, such as a 300mm f/2.8

instead of a 300mm f/4.5. In addition to the creative possibilities, f/2.8 allows for higher shutter speeds and lessens the dependence on a tripod.

Depth of Field and Distance

The nearer your subject, and therefore the closer you focus the camera, the less depth of field you have. This relationship becomes particularly important when photographing a still-life, and it's even more critical when doing any macro photography, like a close-up of a flower. Therefore, if you're concerned about holding focus, move back, even if you'll have to crop the film later. (See CD-ROM: Flowers > Colorado > Colorado010.jpg)

Plane of Sharp Focus

When focusing on a subject that's only a foot or two away, it's important to understand the *plain of sharp focus*. This concept says that the depth of field extends outward from the camera and is parallel to the film plane. This means if you have one foot of depth of field, it's going to fill a box-like area one foot deep, and this area is parallel to the film plane. (For practical applications, see chapter 16, Photographing Flowers, Forests, and Still-Lifes)

47

Depth of Field Preview Button and Scale

Many cameras have a button that closes down the lens to the working aperture. This allows you to look through the viewfinder and see what's in focus. However, when the lens is stopped down, the viewfinder is quite dark. Another aid is the depth of field scale engraved on the lens barrel. It can be represented several ways. Commonly, there are several pairs of identical f/stop numbers or lines. Their colors are associated with particular f/stops. Focus on your subject, and the scale indicates your depth of field. It's worth digging out your lens's manual, so you can use this feature.

Depth of Field and Focusing the Lens

As you use longer lenses or require greater control over depth of field, focusing becomes more critical. Many photographers simply focus on their subject and hope that everything in the foreground and background is in focus. However, you can be more precise.

For example, imagine focusing on someone fifteen feet in front of you, using a 100mm lens set at f/8, with a depth of field of nine

feet. About six feet (2/3) of your depth of field is behind the subject and three feet (1/3) lies in front of the subject. As the subject or focus point moves closer to the camera, the ratio approaches 50:50. Therefore, when you want to be certain that both the person and the foreground remain sharp, focus about one foot in front of the person's face.

Review of Depth of Field

- Greater depth of field means a larger area is in focus, or sharp.
- A small aperture, or opening (f/16), provides more depth of field.
- A big aperture, or opening (f/5.6), provides less depth of field.
- Wide-angle lenses provide more depth of field.
- Telephoto lenses provide less depth of field.
- When focusing on a near object, there's less depth of field.
- When worried about holding focus, step back from your subject.
- Understand the plane of sharp focus.
- Use your camera's depth of field preview button and the lens's depth of field scale, if available.
- Faster film (higher ISO) allows for an f/stop setting with greater depth of field.

SHUTTER SPEED

The relationship between f/stop and shutter speed means that as you maximize one, you minimize the other. For example, to photograph a landscape so the image is sharp from foreground to infinity, you want maximum depth of field, such as f/16. Unfortunately, this means a long shutter speed, which makes it difficult to hold the camera steady, especially if it is windy. Your decision is often a compromise between your creative goals and the environmental conditions. There's a list of common shutter speeds and exposures in chapter 9, Exposure and Contrast Range. Examples of the creative use of shutter speeds are found throughout the chapters on photographing specific subjects, such as sunsets and streams.

Handholding the Camera

The best rule of thumb for deciding whether handholding will yield a sharp image is: the shutter speed should be at least the inverse of the lens's focal length. Put simply, a 28mm lens can be handheld at

1/30 of a second; a 250mm lens can be handheld at 1/250 of a second.

Here's another rule of thumb: Realize that clicking the shutter is the moment of truth and requires all your concentration. First, slow down and compose a shot. Then note exactly where one corner of the frame is positioned as a reference point. This lets you return to your exact composition. The same is true for focusing. Once you've decided to focus on a branch, go back to it to recheck.

Next, get a stable stance, hold your breath, and gently depress the shutter. When you're pushing the limits without a tripod, consider a shorter lens, faster film, removing filters that diminish light, such as polarizers, sitting on the ground, or leaning against a tree. (See chapter 10, under Specialized Camera Supports)

Mirror Lock-up and Mirror Slap

An SLR camera contains a mirror positioned to divert the image from the film plane to the viewfinder. Pressing the shutter first moves the mirror out of the way. Then the shutter opens to expose film. The mirror's movement may produce enough vibration, or mirror slap, to reduce sharpness. This is a greater concern when using telephoto lenses or older cameras. Shutter speeds of 1/8 and 1/15 of a second are most susceptible. At faster shutter speeds, the exposure time is so short that little vibration registers. At longer exposures, like one second, the vibration is relatively short compared to the total exposure.

When sharpness is a top priority, use the camera's exposure timer and a tripod. When clicking the shutter button, the first noise is the mirror moving out of the way—now you can't see through the viewfinder. The camera is very stable when the shutter finally opens. Some cameras have a mirror lock-up mode, which keeps the mirror up.

Filters selectively eliminate certain wavelengths of light or add a color. Thus, they are used for color correction, color compensation, as a polarizer to adjust saturation/intensity, to eliminate haze and UV light, and as lens protection. Except for the lens protection and polarizing benefits, I'm not a big user of filters and have become even less as the years go by. This started because the diameter of view camera lenses varies, so filters get expensive and bulky. Before digital, I also made many duplicate images, or dupes, and it was relatively easy to add color to an unaltered original.

Today, Photoshop software lets you selectively add color, increase saturation, and adjust the brightness of any part of an image. More than ever, it may be a limitation to filter too heavily. Just recently, I received a submission from a wildlife photographer. There were some excellent images, but most had been photographed using a red filter. Adding a permanent colorcast to an entire image often limits future creativity, and you may become thoroughly bored with its look over time. Most good images are not filtered very much. Plus, art directors and graphic designers are both capable and very interested in adding their own creative vision to the image.

EXPOSURE COMPENSATION

A consequence of using filters is that they reduce the light reaching the film. Therefore, you often have to increase the exposure. Fortunately almost all cameras, except view cameras, have through-the-lens metering systems, reducing the need to worry about determining the correct exposure. Still, it's worth knowing how much you need to

increase the exposure, to determine if you can still handhold the camera or stop motion. Check the manufacturer's specification sheet, or use a light meter and take a measurement with and without the filter.

FILTER FRAMES AND HOLDERS

The most common way to attach a filter is to screw it onto the lens, but a filter frame, or holder, offers some advantages. A filter frame attaches to the lens and holds a square plastic filter, usually measuring 3×3 or 4×4 inches. There's a seemingly endless assortment of colored, graduated, and special-effect filters. Some even integrate a lens shade, a useful feature.

ULTRAVIOLET (UV), SKYLIGHT (1A), AND HAZE FILTERS

One of these should be standard equipment on every lens to protect it from scratches. They filter ultraviolet light, which appears as a bluish haze on color film. They're particularly helpful at higher elevations and on cloudy days. They look like clear glass and don't require any exposure compensation.

POLARIZING FILTERS

You should have a polarizing filter for just about every lens. Since it's such a useful and at times overused filter, it gets plenty of attention when discussing how to photograph specific subjects. A polarizer is most commonly used to make a good sky even better by making the blue more saturated. It also cuts glare and reflections, as a pair of polarized sunglasses does, thus increasing color saturation. Circular polarizers, a special type of polarizing filter, are required for beam-splitting, light-metering systems, commonly found on autofocus cameras.

Using Polarizing Filters

There are several things to know about polarizing filters. Ideally, you'll want the sun at your side and slightly behind you. Polarizers have the greatest effect on the sky when the scene you are photographing is lit from the side, or when the sun is about 90 degrees to the camera. They have reduced effect when the scene is backlit or lit directly from the front. Once the filter is screwed onto the lens, a blue sky slowly shifts from light blue to dark blue as the filter is rotated 90 degrees (¼ turn). Polarizing filters are relatively dark

and you'll need to increase exposure by at least two stops. This could cause problems when handholding a camera or photograph moving objects.

Warning!

Polarizing filters are useful, but not infallible. Don't overpolarize an already dark blue sky. It can become nearly black, especially with today's very saturated films. Care must be taken when using a polarizer with a wide-angle lens. Remember that polarization is maximized when the sun to the side of the camera (about 90 degrees) and then tapers off. Wide-angle lenses cover so much area that part of the sky becomes dark blue, while some parts are light blue, creating an uneven blue and an unnatural looking sky.

ENHANCING AND WARMING FILTERS

Enhancing filters are shades of orange, magenta (red plus blue), and peach. Warming filters tend toward a very light yellow color, which makes them ideal for flesh tones. The 81A is a classic warming filter and requires 1/3-stop more light. When pleasant flesh tones are a priority, select a more neutral portrait film, not the supersaturated film favored by most nature photographers.

GRADUATED FILTERS

Graduated filters are made so that the top and bottom of the filters are of different color and/or density. The top half of the filter is colored or of neutral density. The filtering gradually blends into the clear part of the filter, making the effect more realistic. For example, you might position a red graduated filter to add color to the sky at sunset, while not coloring or darkening the foreground. Most graduated filters are square and held in a filter frame, so they can be precisely positioned.

You can use a graduated, neutral density filter to photograph a scene that varies greatly in brightness. For example, at sunrise a distant summit is in sunlight, while the foreground remains in shadow. The contrast range is so great that when exposing properly for the sunlit area, the shadows are almost black. A graduated, neutral density filter will darken the sky by several f/stops, so you can expose more for the foreground. You'll get the most natural looking results when the horizon line is fairly straight and aligned with the middle of the filter.

DIGITAL FILTERS

There is a digital solution to overcoming contrast range. Make a series of exposures and then combine the best two. Use a tripod, so that you have the exact composition from frame to frame. Bracket your exposures to make sure you can work with the best combination of exposures. Expose the first set of frames for the highlights, like a peak catching the morning sun. Increase the exposure on the second set of frames to lighten the shadow area (which will overexpose the highlights). Afterwards, scan the best two film images, or select the best two digital files, and combine them into one file.

NEUTRAL DENSITY (ND) FILTERS

These filters decrease the light reaching the film, thus increasing the exposure required, but without altering color. Most nature photographers use such slow film that making it even slower isn't necessary. Nature photographers might use neutral density filters to increase the exposure time when photographing waterfalls and streams, or when they want to blur the image. Neutral density filters are available in one f/stop increments. ND.3 requires one more f/stop; ND.6 requires two more f/stops; ND.9 requires three more f/stops.

WRATTEN GELS OR COLOR COMPENSATING (CC) FILTERS

Although somewhat fragile, Wratten gels (colored, translucent material) are relatively inexpensive. They come in the three primary and secondary colors: red, green, blue (RGB); and cyan, magenta, yellow (CMY). Color saturation ranges in precise increments from 025 (light) to 50 (dark). A 05M or a 10R adds just a hint of magenta or red to the scene, while a 35B is a dark blue. You can stack a couple of gels to create almost any color. These useful filters are held in a 3 × 3 or a 4 × 4 inch filter frame.

SPECIALTY FILTERS

There are a whole range of specialty filters like fog, sepia, and close-up. You might experiment with a star filter, which produces sunrays or star-like patterns from the sun and highlights, a valuable accent to some stock images. There are also soft focus and diffusion filters that soften or blur the image to varying degrees. When used judiciously, they are very useful for environmental portraits. (Companies advertising in *Outdoor Photographer* and *Petersen's Photographic* magazines offer a whole range of specialty filters. For filters on the Internet, see *www.tiffen.com*)

Film

The debate between film and digital is alive and well, and both sides are doing very nicely. I discuss film versus digital throughout the book. Here, I'll to stick to film. It's still a tremendous medium because of the amount of information it contains. Besides, once an image has been captured on film, it can always be scanned and, as technology improves, rescanned.

Film is also fairly inexpensive, with the exception of 4×5 inch sheet film. I still shoot film, but I shoot less of it and make very few dupes, since scanning is so practical. Differences in cameras and film sizes are discussed in chapter 5. What follows applies to all.

KEEPING TRACK OF YOUR FILM

It's good to know what's on a roll of film, even if you take a day trip. Number the rolls sequentially or make a brief note about the location using an indelible pen. For example, if I shoot two rolls during sunrise and early morning at a lake, I feel better knowing the two rolls won't be processed, or run, at the same time. Perhaps one roll is better than the other. I'll save the best roll for the later run. If the first roll was consistently a little dark, I can overdevelop, or push, the second roll +1/3 or +1/2 stop.

On longer trips, especially to new areas, it's important to collect enough information to caption your photos. Again, date and number each roll, so you can correlate it with information in a notebook. It's also helpful to photograph informational signs. These provide useful information and concrete reference points. (See CD-ROM: Man Made > Miscellaneous > Adobe) Use caption-writing software to

print your name and address on a page of labels. Fix one to each film cassette (and also to all your camera gear). Be warned: Many automated cameras read a code found on the film's cassette to determine film speed (ISO) and set the light meter. If so, don't place the label over the code until the film has been exposed.

KINDS OF FILM

There are three common kinds of film: *color negative* (print, C-41), *black and white* (B+W), and *color transparency* (also referred to as slide, positive, or E-6). In this book, I'm referring to color transparency (slide) film unless stated otherwise.

Color transparency film has always been the industry standard, from advertising to calendars. You can evaluate the film directly with a loupe for sharpness and color, without the need to make a print. However, color transparency film is the most difficult of all to expose properly. That's why color negative (print) film is commonly used in point-and-shoot cameras—it offers far more latitude in exposure and handles a high range of contrast better than transparency film.

High-end or professional scanners are optimized for color transparency film, especially those specifically for 35mm film. However, there's good news for images shot on color negative film. Many markets prefer digital files to film, and once the film is scanned, no one really cares about the original film.

Regarding black-and-white film, since color imagery is in far greater demand, it's more practical to convert a digital file from color to black and white. In Photoshop, go to *Image > Mode > Grayscale*. If your goal is an archival fine-art print, then shooting black-and-white film makes sense. If you are trying to make a living selling black-and-white prints, it does not.

FILM SPEED (ISO)

Other than the type of film, the speed (ISO, formerly ASA rating) is the film's most important characteristic. It refers to the film's sensitivity to light. Film speeds range from ISO 50 (low sensitivity) to ISO 3200 (very high sensitivity). ISO 100 film is twice as sensitive, or fast, as ISO 50, meaning you can use a shutter speed that's twice as fast or can decrease the aperture by one f/stop. In digital cameras, the term *sensitivity* is analogous to film speed.

Slower films provide the best resolution and are referred to as fine-grain films. Faster films (ISO 200 and above) will show increasing graininess when enlarged. Most landscape photographers

use Fuji or Kodak ISO 50 or 100 color transparency film. Wildlife photographers use these slower films, but also need faster films.

There's a setting on the camera body to set the light meter to the film speed (ISO). This should be checked and rechecked. For example, you might switch from ISO 100 film to ISO 50 film, but forget to change the setting. You'll underexpose the roll by one f/stop and the film will be very dark. However, if you catch this mistake before processing, the lab can overdevelop, or push, the film one stop to lighten it. Labs call this a "one-stop push," or "plus one" processing.

Know Your Film's True Speed

When trying a new film, it's important to shoot and process a test roll to determine its true film speed. When an ISO 50 transparency film acts like ISO 40, you'll underexpose the film and the slides will look a little dark. To test the film, find consistent light, like full sun and then even shade. Expose at the correct setting for the film's ISO rating, and then bracket exposures. Bracketing means you make a series of lighter and then darker exposures. Be sure to take notes. You can also ask the technicians at the lab; they usually know the film's reputation.

COLOR AND SATURATION

When you photograph a scene with two different films, it's easy to tell them apart because the colors are different. However, deciding which is better isn't as clear cut. Honestly, they both might be fine, if not for the side-by-side comparison. I've come to worry less about a film's color palette, because the color will shift the moment I make a dupe or scan. It's amazing that two quality scans (expensive anyway) can look quite different, even today. Plus there's another color shift when the file is printed on a digital printer or an offset printing press.

Saturation refers to how much color is there. Is it plain red, or an eye-popping red? Most landscape photographers use saturated films, such as Fuji Velvia or Kodak E100VS (very saturated), but I think these films have finally gone far enough. When you need more saturation, try the Photoshop command: *Image > Adjustments > Hue/Saturation*. (See CD-ROM: Autumn > San Juans > Wilson2.jpg)

PUSHING AND PULLING FILM

Pushing and pulling film are ways to alter the film's processing time to lighten or darken the images. When the color transparency film is

underexposed (too dark) by half a stop, you want to push the film. Instruct the lab to "Push +1/2 stops." This will lighten the film. When film is overexposed (too light) by half a stop, you write "Pull -1/2 stops." (Although it is redundant, write "push" and "+" as well as "pull" and "-" when giving your instructions to lab technicians.) It's better to underexpose transparency film and then push it, rather than the other way around. Pushing does increase contrast, but most film can be pushed up to one stop. Conversely, pulling film reduces contrast range.

Finally, never give a lab all your valuable film at one time. That way you won't lose all your film in case of human errors or equipment problems.

Clip Test

If you're not sure whether you need to alter the processing, do a clip test, also called a snip test. The lab cuts a small piece of film from the front or rear of the roll, and then develops it. You review a few exposures and then adjust the processing, if needed.

Exposure and Contrast Range 9

Getting the right exposure is a key ingredient in making a successful photo. Even now, I breathe a sigh of relief when I first check my film or see a high resolution file pop up on my monitor. There are only two variables when determining your exposure: f/stop (lens aperture) and shutter speed. Remember that one f/stop equals one shutter speed setting. Opening the aperture from f/16 to f/11 has the same effect as doubling the exposure time, say from 1/30 to 1/15 second. However, a proper exposure isn't your only consideration. You must consider a scene's contrast range versus the film's—and even a digital camera's—capabilities. (See CD-ROM: Contrast Range)

LIGHT METERS AND MEASURING LIGHT

Meters are either reflective or incident. The key to proper exposure is correctly measuring the light, using the camera's meter or a handheld meter. The in-camera reflective meter is perfect for almost everything. It has the advantage of metering through the lens, so it compensates for filters.

Reflective Light Meters

These are found in cameras and in many handheld meters. Point the camera or meter at your subject, and it measures the light reflected from it. Realize that a meter doesn't know what it's pointed at. It could be a black wall or white snow, but the meter is calibrated to assume it's neutral gray. Therefore, it gives an exposure reading that will reproduce any object as neutral gray. This is a fairly accurate method, unless the surface is well out of this range, like snow or large

shadows. You can also confirm you reading by using an 18 percent neutral gray card. Here, you point the meter at this standardized gray surface and take your meter reading from it. It's about the same color gray as the default color of many computer monitors.

Spot meters isolate a small area of the scene, rather that averaging the light from a large area. For example, when a distant mountaintop is the only part of the scene getting direct light, you want to meter and expose for that area, if it's the most important part of the composition. A 35mm SLR with a telephoto lens functions as a spot meter.

Incident Light Meters

Incident meters measure the light falling on the scene, not reflected from it. To use one, stand in the scene you're photographing and point the incident meter toward the camera. Now the meter receives the light falling on the scene. Shadows and white areas don't influence an incident meter, because it's not designed to measure reflected light. Incident meters measure a very large area of light, so they're good with consistent lighting like clear skies or overcast conditions. Most handheld reflective meters convert to an incident meter by sliding a translucent dome over the light receptor.

SUCCESSFUL METERING AND EXPOSURES

- Make sure the handheld meter or camera's ISO setting is set to the film's ISO rating (film speed).
- Generally, expose for the middle to brighter parts (highlights) of the scene, and let the shadows fall where they may. If you expose for the shadows, the highlights become overexposed and lose detail. That's fine, if the highlights aren't important.
- Meter the lighter and darker parts of the image to determine the contrast range and take an average, so you're exposing in the middle range. Then bracket up and down plus and minus 2/3 stops.
- Decide what's most important. Meter and expose for it. When using color transparency film, realize that during the middle part of a sunny day shadows will be fairly black, so don't let them become major parts of your composition.
- Landscape compositions often include much bright sky, and the meter may interpret the scene as brighter than it is. Tilt the

camera or handheld reflective meter to include more foreground. Usually, this will increase exposure, either by opening the aperture or slowing the shutter).

- When the subject lies next to large areas of bright snow or dark shadow, use a longer focal length lens or a spot meter to isolate the subject. Incident meters are most effective here.
- Avoid pointing a reflective meter directly at the sun, even when photographing backlit scenes. Shield the meter or point it to one side. Incident meters are pointed at the camera, and consequently often at the sun.
- When you point a reflective meter at a white wall, the meter assumes it's middle gray. It's reading produces a gray wall, so open up one stop to lighten the wall. Incident meters pointed at the sun will yield a better reading.
- While learning, standardize on one shutter speed and adjust only the f/stop. This simplifies things, and it's easier to memorize exposures for common scenes. This technique is like the Sunny 16 Rule (see next page), where you stick to one shutter speed.
- If you find metering confusing, use only one meter. That's if it's calibrated and working properly.
- Try an 18 percent neutral gray card when using a reflective light meter.

CONTRAST RANGE

Contrast range is one of the most important concepts to understand if you want to produce good photography—whether you use film or digital capture. Contrast range is the range in brightness from light to dark in a scene. The question is, how much of that contrast range can your film, or image sensor (CCD), record? Realize that film and digital cameras can't handle high-contrast scenes nearly as well as the human eye.

A sunlit snow scene containing areas of deep shadow is high contrast. The range in brightness from shadows to sunlit snow is very great. Conversely, an overcast sky produces very diffuse light and a scene without shadows. It's low contrast because the range from brightest area to darkest is small. Color transparency film is most difficult to expose properly for two reasons. First, there's little margin for error regarding exposure. When you're off by half a stop, you'll see it. Equally important, it has less contrast range. This means if

exposed properly for the highlights, the shadows are likely to be black. Consequently, you must be concerned about shadows in your composition. (See CD-ROM: Contrast Range)

SUNNY 16 RULE

It's useful to memorize some basic exposures, so if you don't have a meter or don't know whether to believe it, you can refer to a reliable exposure. When using the Sunny 16 Rule, the shutter speed is set to the film's ISO rating and the f/stop is set to a predetermined setting. For example, when using ISO 125 film under sunny skies, you use f/16 and a shutter speed of 1/125. In the examples that follow, notice that most lighting conditions fall within a three stop range.

Set Shutter Speed to the Film's ISO Rating

Bright sun on snow: f/22 (Sunny 16 plus one stop)

Sunny day with dark shadows: f/16 (Sunny 16))

Hazy day producing distinct, but soft shadows: f/11 (Sunny 16 minus one stop)

Cloudy bright, with very light shadows: f/8 (Sunny 16 minus two stops)

Heavy overcast, no shadows: f/5.6 (Sunny 16 minus three stops)

Suggested Exposures for Unusual Scenes

City skyline at night: ISO 400 film, f/8 for 3 seconds.

City skyline just after sunset: ISO 400 film, f/8 for 1/30 second.

Fireworks: ISO 400 film, at f/8 to f/11. Leave shutter open to accumulate multiple fireworks.

Full moon: ISO 50 film, f/8 for 1/125 second.

Landscapes illuminated by full moon: ISO 400 film, f/8 for 2 seconds.

Lightning: ISO 400 film, f/16. Leave the shutter open when the sky is dark.

Rainbow: ISO 50 film, f/11 to f/16 for 1/30 second (no polarizing filter).

Tripods, Supports, and Cases

You should be able to buy only one tripod, if you make the right choice. Over the years, I've learned that tripods don't have to cost a small fortune. I've owned and abused both Gitzo and Manfretto brands, and my tripod heads have ranged from $35 to over $700. They've all worked. You can also use relatively light tripods, but because they have less mass, make sure they're level and let them settle down after any adjustment. Here are some considerations that are based more on functionality than price. (See CD-ROM: Equipment > Tripods)

TRIPOD FEATURES

A six- to seven-foot tripod is very serviceable, measured with its center post extended and a tripod head attached. When the legs are in four telescoping sections, it becomes fairly compact. This may seem tall, but you can rise above ugly foregrounds, and it also lets you work on steeper slopes at a comfortable level. All tripods have telescoping legs, but the mechanism to tighten and loosen the connection varies. Find a compact design that doesn't use big knobs or levers. They catch on everything.

Getting low to the ground is sometimes important, such as when incorporating foregrounds like flowers or doing close-up photography. The lower the better, but eighteen inches from the ground to the top of your tripod head is a good goal.

There are two limitations to getting low. First, the tripod legs must extend almost parallel to the ground, a useful and common feature. The next problem is the center post; it runs into the ground.

Besides digging a hole, there are several options. You might reverse the center post, so the camera hangs upside down between the legs. Awkward, but manageable. You can get a shorter center post or eliminate it. Some center posts are designed in sections, so they can be shortened.

TRIPOD HEADS

A tripod head connects the camera to the tripod. There are two basic styles, and most are rated to support a certain camera format or hold up to a specific weight.

Pan-Tilt Head

The pan-tilt head has three separate knobs to precisely adjust camera position. One knob controls panning left to right, another adjusts the horizon line, and a third adjusts tilt front to back. It's a great system for landscape photography, and for those on a budget, it's the best choice for a rock-solid support. Look for a compact head without long handles. A nice time-saver is a quick-release system. A plate screws into the camera body and is left there. The plate quickly clips to the tripod, no screwing around.

Ball Heads

A ball-style tripod head works by attaching the camera to a big ball joint. To move the camera in any plane, a knob is loosened or a trigger pressed. Tightening the knob locks the camera in place. Ball-style heads are standard equipment for wildlife and sports photographers because you can quickly recompose. Quality ball-style heads for heavy telephoto lenses are expensive, but worth the investment. (See CD-ROM: Equipment > View Camera)

USING A TRIPOD

The best way to be sure you use a tripod is do some planning before you go, then keep it handy. For short hauls, just grab it and go. However, it's more comfortable if a leg or two has a foam covering, like the tubing used to insulate water pipes. This provides a warm grip and softens the load when laying the tripod over your shoulder. After fifteen minutes, carrying a tripod starts to feel like a bad idea. If you like to hike, find an efficient way to carry it. Find a way to quickly and securely attach it to your pack. It's more energy efficient and safer to have your hands free.

Stuff Sacks

Bring a waterproof stuff sack that covers the tripod head and camera with your longest lens attached. This lets you keep your camera/ tripod rig set up, while driving or hiking from spot to spot. The tightened drawstring ensures you don't lose a filter or a cable release. Constantly taking out and putting away your gear takes time and drains your energy. If you spontaneously leave your car to check out a view, the camera and lens stay hidden, inside what looks like a beat up stuff sack. When waiting for a shot, the sack protects from the dust and rain. I still pile rocks over the tripod leg for added security, but here's a better solution. Carry a small stuff sack to fill with rocks. Ideally, suspend it from the tripod's center post, but you can also drape it over a leg as a counterweight. (See CD-ROM: Equipment > Tripods > Tripods2.jpg)

Setting Up a Tripod

Knowing where you want the camera, before you set-up the tripod, reduces your frustration level substantially. Keeping the tripod level lessens the need to re-adjust the horizon line after panning the camera. It also reduces the likelihood of tipping it over, especially with heavier lenses.

On hillsides, extend two legs to the max and position them downhill, so the tripod is level side to side. Then extend the third, uphill leg until the tripod is almost level, but tilting back slightly, for safety. If you bump the tripod, it will fall backwards, not topple downhill. On more dangerous terrain like cliffs, note exactly where the tripod legs are and where you must place your feet when working. One wrong move could be your last.

Tripods and Snow

When the snow is several feet deep, begin by packing down a small workspace. Snowshoes are better than cross-country skis for this and are more maneuverable around a tripod. Compacted snow isn't as likely to be kicked into your camera bag, and it's easier to find dropped equipment. Filters readily slice through powder snow, never to be seen again.

Start by extending the first leg to its fullest. Then force it through the snow, at an angle that leaves the tripod head fairly level. Next, extend the second leg as you're forcing it into the snow, then the third. Afterwards, compact the snow around each leg. Do *not*

extend all three legs at once and then try to force the tripod into the snow, by pushing down on the tripod head. The legs bow out, causing the tripod to act like a giant spring, bobbing up and down (See chapter 15, Photographing Snow and Cold).

SPECIALIZED CAMERA SUPPORTS

There are a variety of specialized camera supports. Monopods have one telescoping leg, usually fitted with a ball-style tripod head. These provide great mobility and allow for quick composition, and are popular with wildlife and sports photographers.

There are supports to attach the camera to a car window, so you can photograph wildlife from the comfort of your front seat. These might be of value in some national parks and wildlife refuges where you can approach animals in your car, but supports resembling a rifle stock are more sensible. You literally point and shoot. Before you invest in something you may rarely use, fill a cloth bag with rice or dried beans. This pillow can be draped over a car's doorframe or rock, and the camera is cradled on top.

CAMERA CASES AND PHOTO VESTS

Photographers have a choice of almost every kind of camera case imaginable. It's an important decision, because carrying it around and then working out of it is strenuous. You want one that's easy to carry and provides ready access to organized gear. Cases also afford protection from the elements and rough handling, more important than ever for sensitive electronic gear.

Major Considerations

Examine your style of photography, equipment, and future needs to make the best choice. First question, how much equipment do you regularly use, and do you plan to expand? The more gear, the bigger the camera case. Consider keeping your most-used gear in one case and always ready to go. Keep spare equipment in another case. Do you hike or prefer to photograph near the car? This often leads you to choose one style over another.

Whatever style of camera case you buy, a good brand name will usually guarantee high quality throughout, meaning better protection and a more comfortable way of carrying it. Look for a modular design, which lets you customize the interior using adjustable dividers. Flexibility is important when adding equipment or if you

find an easier way to organize things. Have a specific place for everything: it's easier to find things, and when something is missing, it'll be obvious. Also, check the weight. Today's camera cases and backpacks often have so many pockets and features that they're too heavy.

Shoulder Strap/Photojournalist Style

This is the style associated with photojournalists: a box-like bag draped over a shoulder with a strap. This style provides quick and easy access, and is great when you're constantly getting in and out of the car. It's a good design when you want to photograph while staying mobile. You can follow wildlife and sports action, and have access to gear without setting the bag down. However, these bags tend to flop around and may be uncomfortable with large loads, because all the weight bears down on one shoulder. You're in for some hard work if you carry much weight with one of these bags over any distance.

Backpacks

Backpacks are probably the best choice for active photographers. You can carry considerable weight and hike more safely on difficult terrain. Evaluate the harness system for good padding and adjustability. It should have two shoulder straps, a lumbar pad, and a padded hip-belt. Try it on, filled with some weight. Remember you may carry more than just camera gear. There's food, water, extra clothing, and an unwieldy tripod.

One problem with a heavy pack is that once you get walking, you can't bear to take it off to grab a quick photo—probably because it's never quick. Over the course of a day, you can walk by some good opportunities. Design a way to suspend the camera from the backpack's internal frame, so it's available, but doesn't hang from your neck. A camera with a zoom lens (about 24 to 70mm) and ISO 100 film is easy to handhold and covers most of your needs.

Hip-Belt Packs and Photo Vests

Hip-belt packs (fanny packs) are designed like shoulder-strap style bags, only they're attached to a hip belt. They're ideal for photographing while remaining mobile, and they don't flop around. Many wildlife and sports photographers use a telephoto lens mounted to a tripod or monopod. A hip-belt pack holds a few other lenses and extra film. This is a good solution for many photographers. Most

hip-belt packs are reasonably priced and make a nice complement to your primary pack. They're also great for location scouting. You can carry a camera with a zoom lens and some survival gear. A photo vest lets you carry the camera while your gear resides in countless pockets, hopefully eliminating a cumbersome case. Be sure your vest fits comfortably under your rain gear.

Photographing Nature

Planning a Successful Photo Trip 11

One thing that hasn't changed over the years—I still get excited and anxious when I see a great image. I want to go there. Maybe it's because I like to travel, but it could be my competitive side. I feel challenged to capture something special, too. However, seeing an inspiring photo is just the beginning of the journey. It's a three-step process, beginning with solid pre-trip planning. Upon arrival, you immediately start step two: serious location scouting.

A common misconception about nature photography is that you sit around hoping for great conditions, and if you're lucky, you're rewarded. I've certainly become more patient waiting to capture a special moment, but when I'm not shooting, I'm location scouting. Effective location scouting blends outdoor savvy with photographic skills to safely find new and exciting photo opportunities. Scouting can be as simple as a short hike to a popular overlook, so you don't have any sunrise surprises, or your goal might be to develop a shot list for a national park. When all the forces of nature finally come together, you need the skills to get the shot.

RESOURCES FOR FINDING LOCATIONS

There's a wealth of information about, and photography from, just about everywhere. Check out calendars, postcards, books, magazines, maps, trail guides, tourism brochures, Web sites, and government agencies. Even cable TV has travel, survival, natural history, photography, and weather channels.

Before you get too far along in planning, have a notebook to record vital details like phone numbers and Web addresses. The

71

accompanying CD-ROM will help you find new places and plan a rewarding photo trip. Three Web sites that are filled with general information about great natural locations, outdoor travel equipment, and nature photography are *www.bpbasecamp.com* (*Backpacker* magazine); *www.AdventureSports.com*; and *www.gorp.com*.

Use this information to begin a shot list—a record of possible locations and different kinds of shots. Keep it handy and update it throughout the trip. Be sure to check out the "Photograph America" series by Robert Hitchman *(www.photographamerica.com)*. It has over eighty issues describing how to photograph popular destinations. There's also the *California Photographer* newsletter by Carol Leigh (*www.calphoto.com*).

Local Resources

Local sources are bookstores, libraries, and outdoor equipment stores. The amount of material depends on the area's popularity and whether it is nearby. Since you never can figure out exactly where a useful book might be, check these sections: travel, natural history, outdoor sports, photography, and maps. Libraries are especially good for browsing back issues of popular magazines like *Outdoor Photographer*, *Outside*, *Backpacker*, *Sierra*, *Petersen's Photographic*, and *National Geographic Adventure*. Many states also publish their own magazines. One of the very best is *Arizona Highways*. Larger libraries (or *www.amazon.com*) offer a selection of video/DVD recordings and even books on tape/CD-ROM, a real treat while on the road.

State Tourism Offices

Tourism plays an important role in every state nowadays, and many states make a substantial investment in promotional material, most of it free for the asking. Usually there's an annual tourism guide, state map, and official Web site. Since they're required to highlight the entire state, you'll find some worthwhile, out-of-the-way areas. States with unique or well-known offerings, like festivals or spectacular fall foliage, often have dedicated phone lines and Web sites to keep you abreast of current conditions.

The state highway map still can't be beat for its overall detail. It's easy to just put the pedal to the metal on the interstate. Instead, see if you can find designated scenic highways or byways. Periodically exiting the interstate to take the "road less traveled" can be a welcome respite from a tedious drive.

Maps

The state highway map is a great start, but as you become interested in specific areas, you need more detailed maps. An invaluable resource is the *DeLorme Atlas & Gazetteer*. Each book provides a complete collection of topographic maps (scale 1:125,000) for an entire state, including lists of scenic drives, historical sites, parks, geological features, and more. Consider bringing a magnifying glass to see every nuance regarding contours, dirt roads, and hiking trails. Along with their selection of trail guides, some outdoor equipment stores offer customized maps for almost any area. You design your map from a database and it's printed on demand right in the store.

MapQuest *(www.mapquest.com)* seems to give the quickest route from point A to B, whereas the American Auto Association (*www.AAA.com*) is tourist orientated and provides its members free maps and travel guides. Don't overlook the National Park Service (*www.nps.gov*), U.S. Geological Survey (*www.usgs.gov*), National Forest Service (*www.fs.fed.us*), and National Geographic (*www.nationalgeographic.com*) for maps and guides. Although useful, many national forest maps are outdated, especially regarding trails and four-wheel-drive (4WD) roads.

The Internet

I've already listed some valuable Web sites, and I'll continue to provide more in following sections. Here, I'd like to give some ideas for searching the Web for information. One of the best Web sites to get started is *www.refdesk.com.* From there you can search for Grand Canyon National Park and get links to the Arizona Office of Tourism. It also provides links to many resources such as the Old Farmer's Almanac (*www.almanac.com*) and Astronomical Applications Department at the U.S. Naval Observatory (*http://aa.usno.navy.mil*); both provide information on sun and moon cycles.

Go to *www.google.com* and search for specific geographic locations. This can lead you to imagery, photographers, chat rooms, stock photo agencies, and private companies of all sorts. If you find an interesting site and have questions, send an e-mail and see what happens. Another tactic is to search for workshops and photo tours. The resulting Web sites often describe specific locations and photo subjects, and you can determine from the workshop and tour schedules when are the best times to photograph certain sites.

PUBLIC LANDS

I've called many of the agencies listed below and have found the people to be friendly and willing to help. Unfortunately, they're available only during regular business hours, so get your questions answered before leaving and bring contact information with you. Realize that asking if the autumn foliage is at its peak is very subjective, so speak with several individuals. Many public lands have a park naturalist, who might be your best bet.

When you plan on visiting a popular park during the peak season, make arrangements early. For a variety of reservations for public lands go to *www.reserveusa.com*. Although the lands are public, the campgrounds and lodgings are handled by private companies. Some campgrounds are "first come, first served," but structuring your precious time around getting a site is stressful. I recently hiked down to the bottom of the Grand Canyon and stayed at Phantom Ranch. I called two years in advance, to ensure I got the dates I wanted. These areas can be busy and booked well in advance because they have international appeal.

National Parks and Monuments

Public lands are probably the best places to photograph nature, and the national parks are usually the very best. Yes, they can be crowded, but they offer truly spectacular scenery and often very accessible wildlife. This also means there's greater demand for images from these locations. Since they're designed with the car in mind, roadside pull-offs yield good photography without working too hard, and great photography if you do it right. When you need quiet time, a short hike can dramatically change your surroundings and attitude. Contact the parks and request free maps and visitor/backcountry guides. National monuments are one level below parks in status and regulations, but many offer outstanding opportunities for photography. The White Sands National Monument in New Mexico comes to mind. (See CD-ROM: Sand Dunes > White Sands)

Start with the National Park Service (*www.nps.gov*) and follow the links to specific national parks and monuments. For instance, go to *www.nps.gov/yose* for Yosemite National Park and *www.nps.gov/deva* for Death Valley National Park. National Park Web sites provide information and links on camping, live video, photos, average temperatures, tide tables, and when the sun rises.

Every national park and nearby tourist town offer material unique to the area. Budgeting for some books and maps upon your arrival is a good investment, and they make nice souvenirs. Photo books with informative captions can be particularly helpful. These resources may also *buy* photography on a regular basis. Jot down some contact information if you want to submit photography.

National Forests

The U.S. Forest Service oversees almost all forested federal lands (*www.fs.fed.us*). National forests don't have the name recognition of national parks, so you have to dig a little harder to learn what they offer. Fortunately, the Forest Service Web site is one of the very best ways to get started for all national forests and grasslands, plus some state forests. Links will take you to every state's official Web site, and also tell you how to buy forest maps and obtain weather information, road conditions, and even photos (*www.fs.fed.us/photovideo*).

National forests have fewer amenities than national parks, but they also have far fewer restrictions. Roads ranging from paved to rugged four-wheel-drive let you explore the backcountry, and you can often camp just about anywhere. A nearby town usually houses a forest service office, so you can ask about local conditions during regular business hours.

Wilderness Areas

Wilderness areas encompass some of the most beautiful and wild terrain left standing. However, official wilderness-area designation means the road stops at its boundary, and travel into the area is by foot, horse, or llama. This makes wilderness areas less crowded than other federal lands, but much more difficult to explore and photograph. The more popular wilderness areas also require backcountry permits for backpacking (a real pain). Don't just expect to show up at the trailhead and get one. You usually have to go into a nearby town. Wilderness areas are found within national forests, so begin your search for them there.

Bureau of Land Management (BLM)

The BLM is similar to the forest service, except it oversees the arid landscape that defines so much of the West. Instead of forests, the land is covered with sagebrush, slick rock, oil derricks, and cows. When you want some real solitude, this is wonderfully open terrain to explore. It's like the Old West (*www.blm.gov*). (See CD-ROM: Canyons > Utah > Arches > Arches4.jpg)

BE A NATURALIST

Good nature photographers are good naturalists. Plants and animals don't occur randomly. You find them in specific habitats, at certain times of the year. So, make sure you are going to the right place, at the right time.

This was quite evident when I was shooting in southern Arizona's Organ Pipe Cactus National Monument. Its one-way road might be the best way to experience the Sonoran Desert. After a few laps, it became apparent that the bright Mexican golden poppies were only blooming in abundance at the middle elevations. Out of this zone, the flowers had already bloomed or were poised to bloom in a few days. I also learned that these flowers open their yellow petals only in the cool of morning. As the heat of late morning builds, they fold up to conserve water. (See CD-ROM: Deserts > Flowers > Flowers3.jpg)

CAN PREPARATION VERGE ON STEALING?

Some photographers wonder whether they're infringing on someone's creative work if they see a photo and try to copy it. The copyright law protects the *tangible expression* of an idea, not the idea itself. For example, you and a different photographer take nearly indistinguishable pictures of El Capitan in Yosemite on the same day, at around the same time. No matter how identical they look, it is merely "coincidental similarity"—a byproduct of free expression. If you create your own expression from the same scene, it's *not* infringement.

I have returned to some of my favorite spots a dozen times and have found that everyday is different, so it's difficult to copy someone too closely. One time, I arrived at a fall classic: a log fence zigzagging through aspen groves right to the Sneffels Range. You park at Dallas Divide and it's a ten-minute walk. (See CD-ROM: Composition > Lines > Lines6.jpg) That morning I saw a photographer comparing his composition to one in a book. He got his shot and left. However, he was so busy worrying about getting it exactly right, he didn't have time for the basics. You need to wait for the prominent foreground shadows to diminish, while not snagging a jet's contrail over the peaks—he got both. Using resources to maximize your time is helpful, but if you aren't willing to explore and experience the disappointment of a fruitless hike to an alpine lake, you probably don't have what it takes to produce a good, personal body of work.

Location Scouting Basics 12

Now that you've decided exactly where you are going, a brief word of caution—location scouting can be dangerous. Keep in mind that you're often alone, off trail, and in unfamiliar territory, with no one expecting to hear from you for days. The often-quoted saying about mountaineers applies here, "There are bold nature photographers, and there are old nature photographers, but no old and bold nature photographers." You've been warned.

This chapter covers basic location scouting. However, there are specific considerations for location scouting in the four major environments: canyons, deserts, mountains, and coastlines. Since location scouting and photography are so intertwined, I cover these in detail in their respective chapters (See Photographing Canyons, Deserts, and Dunes; Photographing Mountains; and Photographing Water).

BEFORE YOU SET OUT

Before you head out to that ideal location, develop a shot list as you plan your trip, by recording both subjects and locations. It takes some of the pressure off, knowing that a certain lake or roadside pull-off is good for your first morning. I'm still fascinated at how different reality looks when compared to a great photograph, so there's still quite a bit of effort determining exactly where and when to set up.

A shot list also reminds you of lesser subjects worth photographing. When an area has *a signature image,* like redwoods and flowering rhododendrons, you can develop tunnel vision searching for these shots and thus tune out other opportunities. (See CD-ROM: Forests > Redwoods) When a site makes it onto your list,

note where it is and when is the best to visit. This can also come in handy when captioning your photos and also if you return to the area years later. Consider using GPS (global positioning system). This is a network of twenty-four global positioning satellites that beam a signal to a handheld receiver (*www.garmin.com*). A GPS receiver can display your route, exact location, and maps.

Monitor the Weather

After deciding on a destination, see if you can monitor the weather before you go. Web sites such as *www.refdesk.com*, *www.AccuWeather.com*, *www.weather.com*, and *www.nws.noaa.gov* are good starts, along with the Weather Channel on Cable TV. For example, when planning a winter trip, it's important to monitor road and avalanche conditions. You can also learn snowfall amounts by checking ski conditions near your destination.

Also, something that's popping up everywhere is live video. You can actually watch what's happening at Yavapi Point, along the South Rim of the Grand Canyon. Denver's local television stations have

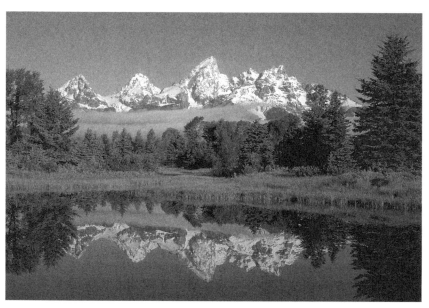

SCHWABACHERS LANDING IN GRAND TETON NATIONAL PARK, WY. JULY 7, 8:00 A.M.
Learn the local weather patterns. This site, near Jackson Hole valley, is known for its morning fog. This day began in heavy fog and cleared to its usual blue sky in a matter of hours.

video cameras throughout the state and are accessible through their Web site. From my computer, I can see the Indian Peaks Wilderness Area to the west. Thanks to a research facility at the University of Colorado, we have video from Niwot Ridge, still one of my favorite out-of-the-way spots. (See CD-ROM: Mountains > Colorado > Northern Ranges > Colorado2.jpg)

If it's been colder than normal, you might benefit from extra clothing, but the weather affects more than your wardrobe. Abnormal cold might signal snow-covered hiking trails and a wildflower season delayed by several weeks. In the Sonora desert of southern Arizona, autumn rains determine the abundance of flowering annuals in March.

WEATHER PATTERNS

Location scouting also means knowing the difference between daily weather patterns and when there's a major change moving in. Along the Pacific coast, a typical May morning begins with fog, which slowly burns-off as the sun gains strength. Conversely, a summer day in the Rockies begins with calm winds and clear skies, but often evolves into afternoon thunderstorms. These daily weather patterns profoundly influence your shooting schedule.

When a weather system brings rain, you may delay a hike into the high country and take advantage of the low-contrast light by heading into the forest. Following inclement weather, after the skies clear, you often get a day or two of really superb shooting. Then the skies invariably get hazier until a new front moves through and cleans the atmosphere. Don't ever take good weather for granted.

Commercial airliners follow a predictable pattern and so do their contrails. Check if the day's jet trails are growing or dissipating in the sky. These intrusions ruin photos, and if they don't immediately dissipate, they often grow in numbers and size. When this happens, it's good to know the area well enough so you can direct your attention elsewhere using your shot list.

CAPTURING THE GRAND VISTA

One compelling aspect of landscape photography is capturing expansive vistas so that the image conveys the same feelings that led the photographer to take the photo. If you feel you have to explain what inspired you, maybe you haven't succeeded. I divide the grand vista into two broad categories. One is the grand vista—what I call a simple composition—such as a view from the edge of a cliff, peering

into the Grand Canyon. Two, is a great view with a stunning foreground in front of it, such as flowers in front of a mountain range. Incorporating a foreground is more complicated and maybe more satisfying, but it sometimes limits the photo's commercial stock value. (See CD-ROM: Flowers > Oregon > Oregon3.jpg)

Here are some photographic principles and ideas to keep in mind when location scouting.

Keep It Simple

Foreground is still a concern in simple compositions, but you're trying to minimize or eliminate it. Carefully examine the entire camera frame. Dull or distracting foreground just subtracts from the image. "But," you might explain, "that can be cropped out." Hey, that's your job when you *take* the picture.

Usually the best way to eliminate unwanted foreground is to get above it. This sends photographers scrambling up open slopes and to the very edge of cliffs. Other places to find unencumbered open views are roads, lakes, meadows, and building tops. Often every inch helps. Buy a tall tripod and consider bringing a cooler or storage crate to stand on. Longer lenses help minimize foreground, and zoom lenses are ideal for perfecting your compositions. (See CD-ROM: Mountains > Colorado > San Juans > Pano3.jpg, and Canyons > Grand Canyon > South Rim > South6.jpg)

The Lighting and Sky

A great sky or lighting makes all the difference between boring and special. Understand the sun's movements to know when a location is best photographed. Grand vistas benefit from the golden light of early morning and late afternoon, but it's rare when you can photograph the same scene at both times. Usually you'll want the sun somewhere behind your spread-out arms.

Learn to appreciate the rich blue sky and vibrant greens that come with cooler (bluer) light. A clean blue sky is very appealing and not too common. A cloudless blue sky can also be a better commercial stock photo. It's easy to crop and you can inset photos and place copy anywhere—very functional. (See CD-ROM: Sunsets > Sunrise > Sunrise3.jpg)

Nice clouds can also turn a simple photo into a great one, but they bring shadows, so be alert to where they fall in the composition. Wide-angle lenses and polarizing filters are wonderful for landscapes,

but be careful when using them together. The filter won't polarize the entire sky. Some sections will become saturated blue, while others remains pale blue. (See CD-ROM: Skies)

The Complete Landscape: Using Foregrounds

When I come across a great vista, I look for foreground subjects to place in front of it. Whatever the foreground, it must be chosen carefully. It becomes the star of your photo. When close to a foreground object, small changes in camera position yield dramatic shifts in composition. Use a tripod and smaller apertures, such as f/16. (See CD-ROM: Reflections > Wyoming > Tetons8.jpg)

TALLER SUBJECTS

Place tall objects—such as trees, saguaro cactus, rocky cliffs, etc.—to one side to frame the picture. When the objects in your photograph are lit from one side, remember that only subjects on one side of the frame will catch sunlight; therefore, include in your photograph the objects that are lit better. This can be particularly important for evergreens, which appear black if shaded. When the foreground is in shadow, objects should make a positive contribution by having a recognizable shape. (See CD-ROM: Deserts > Sunsets > Sunset012.jpg)

81

One composition I've found successful, but still often overlook, is positioning overhanging branches along the top of the frame. It's a great look that can help contain a vast sky or hide one that's too hazy. Perhaps the biggest difficulty is finding branches that either catch the sunlight or have a well-defined shape when silhouetted. (See CD-ROM: Composition > Frames > Frame5.jpg)

SHORTER SUBJECTS

Flowers, a rock ledge, sand dunes, or a pond's reflection follow many of the same rules when using them in the foreground. Most photographers begin by setting up too far back and then inching forward. Get gutsy; get close—on your knees close. Then slowly back up until your composition comes together. Use wide-angle lenses, and be particularly aware how the foreground interacts with the distant landscape. Photograph uphill slopes, which expand the foreground. (See CD-ROM: Flowers > Colorado > Colorado5.jpg)

Stock Value: The Grand Vista

No matter what the environment, the grand vista outsells all other kinds of nature photography. People enjoy pictures that show what

an area looks like and invite them into the scene. It's the "I wish I were there" fantasy. Summer outsells fall, which outsells winter. Place an emphasis on shooting horizontal (landscape) format, which are in greater demand and are more readily cropped to a vertical (portrait) format, when the need arises.

Don't underestimate the value of the classic views you've come to know and love. They sell again and again, that's why you recognize them. For instance, there's "The Flatirons," a classic view in Boulder, Colorado, photographed from Chautauqua Park. Several years ago I made considerable effort to photograph Boulder and these magnificent rock formations from many viewpoints and conditions. As predicted, the classic summer view from Chautauqua Park is the winner, hands down. The buyers all say the same thing, "I want a shot that says Boulder." (Compare CD-ROM images: Marketing > Local > Flatiron1.jpg and Flatiron2.jpg)

TRANSPORTATION

Being in the right place at the right time is the name of the game, so transportation is part of the equation. Briefly, you learn when and where to go with research. Upon arrival, you drive and hike, building a shot list. When conditions are right, you race from spot to spot photographing when each is at its best. Here are some observations and tips to help keep you up and running.

The Lay of the Land

To really get your bearings in a new area, keep a watch, map, compass, and GPS handy, whether hiking or driving. Begin by identifying major landmarks. Is there a river running through the valley, or a prominent east-west ridge that can be used as a reference point or photographed? It's also important to keep track of distances and major pull-offs, so you know how long it will take to return to a particular spot.

Hiking can be a big part of nature photography, and with experience, you develop a sense about how fast you travel over different kinds of terrain. This really helps budget your time. The major variables are distance, vertical rise, and the weight on your back. A good rule of thumb with a twenty-pound load is three miles per hour, plus one hour for every 1,000 feet vertical gain. If a lake is three miles and a thousand vertical feet above the trailhead, give yourself two hours.

Cars, SUVs, and Campers

Let's face it, the car and its relatives make life mighty nice, and it's probably your best friend when it comes to capturing good imagery. Remember, it's not how far you've hiked that matters, it's only that you've got the shot.

I think the most important thing in a vehicle is being able to sleep in it; if it has 4WD so much the better. This allows you to be where the action is 24/7. Going to and from a motel or campground is a serious waste of time, and you can lose touch with nature. Ideally you want to be able to stop anywhere, move things around a bit, and fall asleep. Nature photographers spend a lot of time in beautiful locations, but usually there's no place to pitch a tent. A vehicle lets you come and go more quickly and discretely.

Let's say you want to photograph sunset, then sunrise, from Logan Pass on Going-to-the-Sun Road in Glacier National Park. In summer, the sunset ends at 10:00 P.M.; the sun rises the next day at 5:00 A.M. How do you justify descending to the valley, just to be corralled into a smoke filled campground, even if you're lucky enough to have a reservation?

I began my life as a nature photographer sleeping in a Chevette, then a 4WD Honda hatchback (a car-top carrier was a worthwhile investment). Vans are a nice option, but most don't come with 4WD or a propane heater. An SUV might be the most practical option if you live two lives: a nine-to-fiver and then a weekend warrior/nature photographer.

The best option might be a full-size, 4WD pick-up truck with a small pop-up camper, one that doesn't extend beyond the truck's boundaries. This rig lets you go almost anywhere, then quickly make camp by "popping" the top. Propane provides the comforts of home, and you can stay on the road forever. I've taken my basic F-150, 4WD Ford pick-up on countless rough roads, enough to be terrified many times. There's fear of rolling over, fear of getting stuck, fear that it's too steep and rocky. The truck has exceeded my expectations; it's a beast. The same sized pop-up camper will fit on a mid-sized truck, but will extend over the sides and make the rig top heavy. (See CD-ROM: Transportation >Vehicles)

Four-Wheel-Drive Roads

The West has countless 4WD roads, remnants of a rich mining and timber history. These save lots of hiking and take you to many

remote areas. They're shown on topos and forest service maps. Warning: when a road is listed as 4WD, it is. Unfortunately, they're not rated in difficulty, but they range from a few deep ruts to death defying. Get up-to-date information, especially if it's been unseasonably wet or you're faint at heart. Ask the locals, forest rangers, or the drivers you meet on the road. Plan to drive slowly.

Keep on Truckin': Road Safety

Nothing is finer than waking up at a nice location, getting some great photography, and heading down the road without a care in the world. The best way to keep the dream alive is to drive a dependable vehicle and be alert to some key signals when on the road. You might also start your trips on weekdays, when car problems are much easier to solve.

Before heading to the Sonoran desert, I thought I was ahead of the curve when I noticed my alternator acting up and had it repaired. A few days later I got a 3:00 A.M. start—I love being well into my journey and it's still day one. Unfortunately my exuberance only lasted until midday when my new alternator left me stranded in Gallup, New Mexico. I learned for the umpteenth time just how helpful people are, and that Gallup has over forty (noisy) freight trains running through it every night. A couple of years later, I'd really appreciate my one-night stay in Gallup.

One fine, fall morning I met the excellent Arizona photographer (and now friend) Chuck Lawsen while shooting one of my favorite haunts, the Sneffels Range. Several years later, I again met up with Chuck in Yankee Boy Basin, and it was good I did. You see, I had quite a bit of truck trouble and he saved the day. As we labored up a 4WD road high in the San Juan mountains, my engine began to smoke. Any attempt to pull-off would send me tumbling end over end, but eventually we found a safe spot and assessed the damage.

My serpentine belt, an elaborate fan belt, had come off and wound around lots of stuff. OK, I'm not a car guy. Chuck's mechanical aptitude bested mine, so we tried to fix it. Imagine five skinny rubber bands fused together into one ribbed belt. One of the bands had started to rip and become entangled. Chuck suggested cutting it off and putting the belt back on. Good idea.

Unfortunately we could not figure how to slip it back on; something wasn't right. That's when Gallup came to mind. Long after I had left the gas station where my car had been repaired, I found a

very long wrench along side the engine; one designed to provide lots of leverage. This was used to get the fan belt on after replacing the alternator. Unfortunately, it was in my garage. We began by stripping down my Gitzo tripod and inserted a Crescent wrench into one end of the tripod leg. We had our leverage and attacked the problem from a different angle. We missed a great morning's shoot and I made a safe but nerve-racking descent. Always carry some basic tools in your car, so you have a fighting chance.

FLAT TIRES

The best advice to guard against flat tires is to drive slowly on unpaved roads, especially when freshly graded. Although most punctures seem to be caused by small, sharp rocks, you might encounter a deep pothole that could give you all sorts of trouble. Also buy tires rated as "light truck" (LT).

To make changing a tire easier, come prepared with WD-40 to loosen lug nuts. Invest in a deep socket wrench with a long handle for leverage, so you won't strip the end of the nut. When old lug nuts become worn, it's inexpensive to replace them the next time you buy tires. You can also carry an aerosol spray that inflates and seals the tire, or a small air compressor that plugs into a cigarette lighter. When you stop, always take a moment to check your tires and also to make sure your car is not dripping any fluids.

Checklist for Hitting the Road

- Hide a photocopy of your driver's license, credit card, and medical insurance card in case you lose your wallet.
- Include some basic tools for your car and camera gear. Include jumper cables, duct tape, wire, WD-40, a quart of oil, antifreeze (coolant), and spare bulbs for headlights. Rough roads are tough on bulbs (not to mention that police love to pull you over for having a light out).
- Cash—don't leave home without it. I've needed it to get me pulled out of ditches and fix an engine hose late on a Saturday.
- Lend a hand to others. Once, I was camped high up American Basin, just west of Lake City. It's a favorite Colorado site for wildflowers. After a great morning's shoot, I was lifting my second spare out of the back of my camper, and the person in the first jeep heading down stopped and offered to help change my tire. I didn't have a flat, but it sure was nice to hear.

- Spare car keys. Encase a set in plastic wrap so they won't rust, then duct tape them under the bumper. Put spares in camera cases and daypacks.
- Books on tape or CD-ROM. Some times you've just got to sit and wait.
- A spray bottle is nice to spray on leaves for a still-life, but it can also be a great way to help yourself stay cool (evaporative cooling) and to clean off.
- Carry pillowcases and stuff sacks to hide gear and protect it from dust. When my big view camera case goes on an airline, I stuff it in a green duffel bag. It looks like it ain't worth a cent.
- When photographing along roads, position your car so it affords you some protection from other cars.

Beasts of Burden

I used to think it was rather wimpy to have someone or something carry your gear. Maybe it's age, but I've changed my mind. I've rented llamas on several occasions. After a few hours indoctrination, our family was left to fend for itself, and the trip went very smoothly. We pulled a small horse trailer to get the animals to the trailhead, but in some cases, they can be delivered. Your average llama can carry about eighty pounds, evenly divided into two panniers, or sidesaddles. (See CD-ROM: Transportation > Animals)

I've met people who've had very stubborn llamas, which can spit at you. I'm told it's because of too much human contact when they were very young. They imprint on humans and there can be a fight for dominance from then on. It's also better to use more than one llama, so the dominant llama can be satisfied leading the other llamas and not you. Although llamas look very huggable, resist. Llamas interpret the gesture as a predator going for its neck. Since llamas forage on almost any vegetation, you don't bring food, just corn. By the way, you *never* let go of the lead or you risk losing everything you need to survive. And you *always* carry corn on your body to entice a free llama to come back if the unthinkable happens.

As for mules, during a family trip into the Grand Canyon, we rented space on a mule train to haul most our gear down to Phantom Ranch and then back up. It allowed for a far more enjoyable hike and provided an extra margin of safety, because we weren't overburdened. In 2003, the cost was $53 each way for a thirty-pound duffel.

Getting Around the Old Fashioned Way: Bicycles and Snowshoes

Some parks are beginning to take measures to protect against smog and traffic congestion. As a photographer who often ventures into remote areas of a park, though, the elimination of roads and forced-use of buses are formidable restrictions. This has happened at the Grand Canyon's West Rim and might be coming to a park near you. Your best alternative could be to use a mountain bike; it would be heavenly along the Canyon's West Rim Road.

Snowshoes are simple but effective. They don't require specialized boots and can be mastered in your first 100 yards, especially if you use ski poles. Snowshoes are so compact you can work around the tripod and on uneven terrain. You can walk over rocks, cross roads, and even climb fences without taking them off. The classic Sorel® style boot, those with a rubber base and leather sidewalls, are perfect for snowshoeing (and are also a great all-around boot for general mucky conditions)

TRAILS: EXPLORING THE BACKCOUNTRY

Most areas have a trail system with maps and guidebooks. These are essential because finding a trailhead can be difficult, and trail following or route finding takes skill and intuition. Try to relate the grand landscape to your map and look at it regularly—before you get lost. For instance, if the trail follows a small stream up a valley, you could lose the trail here and there but still get to where you need to go by staying near the stream.

Be alert to staying on trail around popular destinations like lakes. Here, there are often many side trails fanning off in every direction. Check your map and determine where the trail departs from the lake.

One way to confirm you're on a human trail and not a game trail is by checking fallen logs and branches. Sawed off logs and blazes are obviously human trail signs. A subtler sign is found when logs are on the ground. Humans must step on logs, scraping off the bark and gradually wearing them down, whereas deer and elk jump over logs. Also, we humans feel the compulsion to break off branches as we pass; deer and elk don't have hands.

An established trail is almost always the best bet, but sometimes my enthusiasm still gets the best of me. I lose the trail, but because the terrain is relatively open, I keep going. This happened once while hiking high above Yankee Boy Basin. I was headed to Blue Lakes

Pass near Mt. Sneffels, but lost the trail. I kept going because I could see the pass, and the rocky slope looked the same everywhere. Anyway, I was off trail, and the slope got steeper and steeper, finally to the point where I knew I couldn't stop, no matter how tired I was. It was fear, adrenalin, and the sinking feeling that if I lost momentum, I'd lose the battle. When I finally topped out, I quickly counted my blessings and got to work. Fortunately I found an easier way down, but I noticed if I'd fallen I would have tumbled over a twenty-foot cliff—not fun. (See CD-ROM: Mountains > Colorado > San Juan Mtns > Yankee_Boy1.jpg and Yankee_Boy2.jpg)

Open Terrain

When exploring open terrain like deserts and alpine tundra, you may find that trails are sporadic or disintegrate all together. Because it's open, people don't stay on one fixed trail, or it's so rocky that a trail never forms. Make note of major landmarks, trail intersections, and look for rock cairns (piles of rocks) indicating the trail. Check the sun and determine where it will be on your return.

Be particularly leery of scree slopes and all snowfields. Slopes have a nasty habit of getting progressively steeper as you ascend, so they're often steepest right before they top out onto a ridge. Ideally, hike on rock that's covered with lichen; its slow growth is a good sign that the rock is fairly stable.

The most important thing to consider when evaluating any steep route is the run-out. This is where you'll end up, if you take a tumble. A snowfield with boulders at its base makes for a nervous ascent or descent. Remember, it's not the fall that hurts, it's the landing.

SURVIVING THE LANDSCAPE

The most important considerations while location scouting are 1) how far you'll be going and 2) how difficult or remote the terrain. Heading up a well-worn trail to a popular lake is far safer than stopping along a national forest dirt road and bushwhacking up a steep slope to check out an exposed ridge. You never know—you might get lost or twist your ankle. There are bears, mountain lions, ticks, West Nile virus, killer bees, raging streams, falling rocks, lightning, deteriorating weather, hypothermia, approaching darkness, un-explained noises, crop circles, and even Bigfoot. I don't know how I ever get up my nerve to step out of the car.

When location scouting, I like to travel light. Otherwise I don't retain the enthusiasm to keep getting out of the car to amble up and down the hillsides. It's a delicate balancing act between weight and safety, but whatever you decide to carry, keep it handy so you can just grab it and go.

Survival Gear: The Basics

I don't want to look like I just stepped out of an outdoor equipment catalog, and often the locals don't take to it either, but the high-tech fabrics and new designs really make the outdoors more comfortable and survivable. Try to get the best gear available for every part of the body. I never know when I'm going to stop to explore, and I've learned from countless scratches and a few brushes with poison ivy to stay away from shorts and cotton T-shirts. Pants with zip-off legs and cargo pockets really do the job, and you can carry extra items with surprising comfort.

I often wear athletic shoes. They don't trample the terrain like heavy hiking boots, and they quickly dry out after working along water or trudging through morning dew. However, wear a full leather boot and possibly gaiters in rugged terrain, especially deserts. The various spines and barbs go right through fabric. Even when keeping your clothing to a minimum, wear polarized sunglasses and the appropriate hat. These protect against branches as well as the sun.

Have ways to get some protection from the rain, wind, or sun. A high quality rain/wind parka (like those made from GORE-TEX® fabric) often forms the foundation of any survival system. Add rain pants if you anticipate precipitation or plan to visit more remote locales; you'll need a fleece hat and gloves for the cold. Consider a couple of giant garbage bags as emergency shelter to ward off hypothermia or as covers to protect your camera gear. You can tear a hole in the bottom and pull it over your head for protection or slip your legs in like a bivy sack. A space blanket, which is a large piece of plastic with a reflective coating, can make a windbreak, sunshade, or emergency signal. Add a tripod and you can construct an A-frame tent, especially if you've brought along some duct tape (you can store it around a tripod leg).

As mentioned, it's essential to customize your survival kit. Consider a butane lighter, candle, compass, whistle, flashlight, nylon cord, pocket knife, sunscreen, insect repellent, prescription medi-cines, lip balm, protective foam for blisters, Zanfel® for poison ivy,

chemical heat packs, extra clothes, umbrella, first-aid kit, tweezers, binoculars, pepper spray for wildlife, trekking poles, and, most important, spare car keys. On one visit to a wilderness area, I locked my keys in my idling Chevette. Did I mention it was winter, with evening quickly approaching? I was just about to break the window, when I spied a rusty, barbed-wire fence. With repeated bending, I broke the wire and unraveled the two strands. I fashioned a coat hanger and broke in. Now I always have two sets of keys with me, and a third taped under the bumper.

Living with Lightning

Lightning is a common hazard, but its dangers can reduced with a little knowledge and conservative behavior. To determine the distance in miles from you and the lightning, count the seconds between the flash and the thunder, then divide by five. Although the closer the lightning, the greater the risk, there are instances when lightning literally strikes out of the blue, with no indication of a thunderstorm anywhere. Here are some ways to stay safe:

- Avoid the highest areas, such as ridges and summits, and also the lowest open areas, such as valleys.
- Don't seek shelter directly under overhangs, cliffs, a lone tree, or in shallow caves.
- If you're on an open slope like a scree field, stay on your feet and crouch low onto insulated material like a non-metallic pack or pad.
- Don't touch metal objects like tripods and trekking poles. These don't attract lightning, but will conduct it to you.
- When in a group, disperse; if someone is struck, others can help.
- Your car is a safe place, but don't touch the doors.

Keeping in Contact

When visiting a new area, you may get in and out of the car so often that leaving a note on the windshield stating your whereabouts seems impractical. However, for longer hikes, write a short description, including the route, when you plan to return, and a name to contact. It's also good to sign and date any register at the trailhead or summit. A cell phone can be a lifesaver, but make sure you can get reception if it's part of your survival plan. And remember, walkie-talkies and

two-way radios only work if someone is listening to your channel and is relatively nearby.

My first visit to Utah's Canyonlands National Park began with a late afternoon hike. Finally arriving after a 350-mile drive, I took off at an enthusiastic pace looking for a place to setup for sunset. You guessed it, it got dark and finding my way across the trailless, open plateau didn't seem nearly as idyllic, particularly after running into yucca and prickly pear cactus. Fortunately, I wasn't solo that time; my wife began to worry, but she had the insight to turn on the car lights, and even honk the horn. Make sure you are well prepared for when you are alone.

Wildlife: Bears, Mountain Lions, and Coyotes

After many years of solo travel in all kinds of places, at all times of day, both on and off trail, I thought I would have had more close encounters with potentially dangerous wildlife. I've had only three—with a black bear, a rattlesnake, and a pack of coyotes.

I had an encounter with a black bear because I didn't heed the warning signs. I was several miles up the trail heading to Lake Josephine in Glacier National Park, and right in the middle of the trail was a big, fresh greenish mound of bear droppings. I should have turned around, or at least waited a bit, but I didn't, and minutes later I walked right up to the bear. I slowly turned around and headed back down the trail, peering over my shoulder to see if it followed. It didn't.

Black bears are not nearly as large as grizzlies, but they're far more common and still capable of killing you. Most experts agree that if you encounter a black bear, you should raise your arms to appear larger and act as a formidable adversary—above all, don't run, because this will trigger the animal's chase instinct, and you can't outrun a bear. Hopefully you'll scare off the bear. When attacked by a black bear, you're being viewed as prey and you should do everything to fight back. This aggressive behavior is also suggested for mountain lions, a.k.a. cougars or pumas.

Grizzly bears are far larger than black bears; they're rare, though, found only around Yellowstone and Glacier National Park, and in Alaska. Here, a defensive position is suggested, possibly by curling up in the fetal position to protect yourself. When I'm worried, I might get out my bear spray, but I always make lots of noise in bear country. If they know I'm coming, they'll probably get off the trail.

Some hikers rattle pebbles in an empty soda can, bang on pots, or hang "bear bells" from their pack while on the trail. Remember also that bears have a keen sense of smell, so take care at the campsite: keep your camp clean, cook at a place separate from where you sleep, and store food in airtight containers.

After my brief bear encounter, I started carrying pepper spray. It has slowly been relegated from my pants pocket into my pack. Once, after a long day in the high country between Crested Butte and Aspen—a glorious place—I'd left the four-wheel-drive road at Schofield Pass at 3:00 A.M., hiking through forest, then lush alpine meadows, to reach Frigid Air Pass by sunrise. (See CD-ROM: Mountains > Colorado > Elk Mountains > Frigid_Air1.jpg and Frigid_Air2.jpg)

I spent the entire day up there, and after a disappointing sunset, I rushed to leave. To save weight, I had stashed my big flashlight along the trail after sunrise and much to my dismay, my spare was missing. The moon was a few days past full and any light it might offer would come well after midnight, so I made a hasty descent off the ridge. Where the terrain flattens, the trail forks—one returns to the parking lot, and the other ascends West Maroon Pass (another good photography spot). That was tomorrow's destination, so I dumped all my gear and hoofed it down to basecamp.

It was almost pitch dark as I reached treeline, and it took all my route-finding skills to stay on course. I figured it'd be even darker in the trees, but maybe not as easy to wander off the trail. That's when I met my coyotes. I had heard them off in the distance from time to time, and I thought it added the perfect wilderness accent. Now they were up close and personal—twenty, maybe thirty feet away. Not so idyllic.

As they circled me, the darkness and distance conspired to make them seem more like fleeting ghosts than solid beasts. I kept up my pace, for once wishing I was carrying my eight-pound Gitzo tripod. Where was my pepper spray? Where else, but in my pack! They kept up their eerie whines and darting movements. After fifteen minutes, they were off. See—nothing to fear but fear itself. When I do get worried about bears and other wildlife, I just start up a loud conversation with myself—*most* wild animals, given the choice, would prefer to be as far away from humans as possible.

Guns, Self-Preservation, and Theft

Everyone has an opinion about guns. In the most basic of terms, there are three main reasons why some people carry guns: hunting;

protection from wildlife; and protection from people. For all my solo hiking and wandering, I've had so few animal encounters that I don't feel the need. Certainly if you're traveling in the Alaskan bush, you should talk to the locals and ascertain the bear danger. Realistically though, if you're not familiar with firearms you won't have the marksmanship to stop a charging bear.

As for people, just use common courtesy and common sense. You may not like hunters and off-road enthusiasts, but don't make value judgments or think you're the better outdoorsperson because you consider yourself an environmentalist. You're the intruder to many of these people; they have probably been using the area long before you knew it even existed. But I guarantee you that they'd help you out long before the city slickers in their shiny SUVs. During fall hunting season, be more visible, invest in a blaze orange vest, and watch your dog.

When camping, I always try to park my pickup in a "get in and go position." If I feel threatened or leery, I don't want to have to go through any maneuvers to leave. I also remove the lightbulbs in the cab, so I can open the doors without the light coming on. I like to be discrete, especially when it comes to park rangers. I didn't realize it at first, but rangers are very concerned about poaching. That means they may think you're armed and breaking the law, so kiss ass.

National parks are like anywhere else in that you need to be concerned about theft. One key to location scouting is going light; this means you often leave your expensive gear in your vehicle. Don't be conspicuous about being a photographer (like walking around in your photographer's vest; someone could follow you to you car). Make it a point to keep your gear under wraps until it's really needed. When you do head off to shoot, your equipment should be the last thing to come out and should immediately be put away upon return. It doesn't sit around the vehicle. This policy also keeps you from leaving something behind because you don't set it outside to begin with. When staying at a motel, valuable gear can also be left with the front desk.

PRIVATE PROPERTY AND LOCATION SCOUTING

I have a favorite place to shoot flowers and mountains that I found after seeing a picture in a magazine; its brief caption headed me in the general direction. The first year I arrived too late, but I knew I was in the right place. Next year proved perfect. I had just finished

photographing what is still one my favorite photos. While casually working on another shot nearby, a woman walked directly to my previous spot, feverishly set up her tripod and fired away. I figured from her Nikon and well-worn Gitzo tripod that she was a pro, so I gave her some space. As I thought to break the silence with a cordial "hello," she left just as quickly. Several years later, I returned and discovered her need for a quick getaway. It was private property. I didn't have permission and was very rudely thrown off the property. On the way out, I did my best to win back the graces of the foreman to no avail. I was told maybe next year, but for now I was history.

No Trespassing Signs

I can't stand driving by a great view that's just begging for a second look and then seeing "No Trespassing" posted there. Usually it's best to check out the view quickly and discretely, and be done. When conditions are ripe for the taking, shoot it, since, as they say, it's better to ask for forgiveness than for permission.

When it's worth the effort to return, seek out the landowner. However, finding owners is nearly impossible because in many scenic areas absentee owners control private land. Also, I figure most female homeowners are leery of a lone male coming to the door. Cell phones might prove helpful: Get a name off a mailbox, call information, and proceed from there.

Hopping the Fence

When you decide to take the plunge, wear low-key clothes and try to park away from no trespassing signs, so you can plead ignorance ("What sign?"). Park away from where you'll be working. If your vehicle draws attention, you'll be discretely tucked some distance away. Ranchers and farmers, the original stewards of the land, are good people to deal with. What they want most is for you to be respectful of the land, so close all gates and don't disturb livestock or damage fences.

I've run into a number of landowners and caretakers this way and haven't had any real problems—just defer to their wishes. If you feel you have to offer something to get off the hook or get permission from the owner, ask if they'd like a print. When the owner has some commercial interest, like a land developer, ask if you can continue to shoot and provide some photography as a trade out.

NETWORKING

One of the best ways to find locations is to talk with and observe other photographers in the field. Early in my career I was more sensitive to this and missed shots because I was afraid of butting in or stealing someone's creativity. I still respect other's photography and privacy, but on the other hand, I've got to bring home the bacon. I've learned to appreciate the value of talking to other photographers and sharing advice, with the emphasis on sharing. I bring this up because there are certain high-level pros who rearrange (trample) things a bit afterwards, to make sure no one else gets their shot.

BASECAMP: TRIPS AS FAMILY VACATIONS

If your photo trip is doubling as a family vacation, you can often ward off problems by setting up a basecamp in a motel or campground. You can come and go at all hours and not drag everyone along. Plus most kids find a swimming pool and eating out a real treat. It's also important to schedule visits to the nearby tourist town or do things without a camera. When you travel with children, you must slow your pace and lower your expectations. It's easier when they're very young because you're their entire world; if they're with you, they're happy. As they get older, they need to be entertained both on long drives and during long waits. A TV/DVD for your car is a real sanity saver.

One of the biggest mistakes less-experienced photographers make is trying to accomplish way too much in a week's vacation. It's far better to spend more time in a carefully selected area and really get to know it. This also let's you spend time away from the camera without having an anxiety attack.

Your Basecamp Pantry

Life on the road can be so much sweeter and cheaper with a little preparation, especially regarding food and drink. Most of my efforts revolve around keeping things good and simple, with little effort. Divide your supplies into camp food and what you'll carry on the trail. Bring foods you like; don't plan on becoming a health nut. Start with a good cooler, one you can also stand on to photograph. Solid ice lasts far longer than cubes, so begin your journey with frozen canteens or water bottles; they won't leak like plastic bags.

Freeze foods like spaghetti, soups, sandwich meats, cheeses, and pizza. For everyone's sake stay regular by keeping well-hydrated

and eating bran cereals, fruits, and Metamucil. Get some padded mailers—these are great for packing fruit, eggs, and spare camera gear.

LOCATION SCOUTING CHECKLIST

- Use a watch, map, GPS, and compass to understand the sun's movements. Learn the grand lay of the land and identify major landmarks.
- Note daily weather patterns and be alert to potential changes.
- When hiking, keep track of your time. Memorize unique landmarks, especially how things will look on your way back.
- Be a naturalist if you want to photograph specific subjects like flowers or fall foliage. Learn the habitat where they occur, then find it.
- When you find a potential photo site, establish exactly where to place the tripod and discretely mark it.
- Review your shot list and travel notes to avoid tunnel vision.
- Hide photo gear when not in use. Don't advertise that you're a photographer!
- Network. Accept the crowds and keep an eye out for other photographers. Share information—you might learn something or make a friend.
- Every environment is unique; adapt your survival gear accordingly. Envision one night out, under good conditions. What do you need to survive?
- Every place has natural hazards. Leave any sense of invincibility at home and bring a healthy dose of caution.
- Let someone know your itinerary or leave a note.
- Early morning starts and late returns require a heightened awareness about potentially dangerous wildlife. Make noise to let wildlife know you're coming and give it time to move out of your way—don't jog. Consider bear spray or mace.
- Respect private land. Don't leave gates open or ruin fences.
- The *universal distress signal* is three whistles, horn honks, or whatever.

Photographing in Canyons, Deserts, and Dunes 13

When traveling through the semi-arid landscape of the American West, the canyons, buttes, deserts, and sand dune coexist. Where you find one, you're likely to find the others. However, they have unique characteristics, which influence your photographic approach. For example, canyons and buttes often go together, but a canyon is basically a big hole in the ground. A butte is just the opposite, a rocky monolith towering over relatively flat surroundings.

PHOTOGRAPHING CANYONS

Canyons range from the deep and wide Grand Canyon to the claustrophobically narrow slot canyons, and offer some of the most accessible yet exhilarating landscapes to photograph. (See CD-ROM: Canyons)

LOCATION SCOUTING: CANYONS

The best-known canyons in the United States are found throughout the Colorado Plateau in Utah and northern Arizona, but canyons are found almost everywhere. Colorado's Black Canyon of the Gunnison and Wyoming's Yellowstone Canyon are carved into mountains. On a smaller scale, a stream winding its way through thirty-foot high granite walls presents some of the same lighting issues and risks as the Grand Canyon. (Read *Over the Edge: Death in the Canyon* by Ghiglieri and Myers for a run down of all the ways you can kill yourself while exploring canyons.)

Learn the Lay of the Land

When visiting a canyon, you arrive either at its top, along the rim, or at the bottom, and it's often nearly impossible to get from one to the other because of the cliffs. The drop itself is a sober warning to be careful.

Canyons are unique because they resemble a big hole or fissure in the ground. With clear skies, deep canyons often produce dark shadows. Therefore, it's critical to understand the sun's movements, so shadows won't dominate the image. Where there's a photogenic river, note when the bottom finally gets light. Much of the Grand Canyon runs east to west, and in mid-winter, the Colorado River sees little light. However, by mid-April, when the sun is rising directly to the east, the canyon is filled with light from early morning. (See CD-ROM: Canyons > Grand Canyon > Phantom > Phantom2.jpg)

Exploring the Canyon Rim

Given a choice, I usually prefer working along the rim. It's often level, relatively free of vegetation, and has the best views. It also receives the lion's share of the sunlight. Check your map for parts of the rim that project into the canyon for the best vantage points. The best views at the Grand Canyon have "point" in their names, like Lipan Point. (See CD-ROM: Canyons > Grand Canyon > South Rim > South_Rim4.jpg)

When hiking watch out for loose rock and make sure you can retrace your steps. If you have doubts about making the moves without camera gear, it will be even more dicey loaded down—so why bother? If you descend into the canyon, save plenty of water and time for the climb back up. Or better yet, hide a canteen and energy bar on your way down because the hike up will take at least twice as long and will likely be a lot hotter.

Inside the Canyon's Depth

Hiking along the canyon floor is usually more strenuous, and as dangerous, as hiking along the rim. There's often a river to contend with, plus it's often strewn with unstable boulders of all sizes. As you descend to the canyon floor, hiking partners must avoid hiking directly above one another, to stay out of the way of dislodged rocks.

The bottoms of deeper canyons receive the least amount of light. This is limiting, so be prepared to shoot when that precious light finally reaches you. However, when a canyon opens to the

east or west, you can often take advantage of that golden light found at both ends of the day. Again, know the sun's movements and the canyon's direction.

Rain and Flash Floods

Appreciate the danger of rain in the canyons. Trails become treacherous; the mud, which acts as glue when it is dry, melts away in the rain and down comes the rock. When there are thunderstorms in the vicinity, dry creeks and narrow slot canyons can experience flash flooding. And that dusty road you complained about on the way in quickly becomes an impassible mud hole—twenty miles long.

Important Vantage Points

The road usually determines whether you spend most your time on the rim or along the canyon floor. It's a real advantage working on top, because it catches the first and last light of the day, plus it's usually easier to get around. When along the bottom, incorporating some form of water is your best hope, especially if it has a reflection. (See CD-ROM: Canyons > Utah > Canyonlands > Canyonlands4.jpg)

PANORAMIC POINTS

Rocky outcrops extending into the canyon offer the best vantage points by providing unobstructed views. When you can see in several directions, you can usually photograph at different times of the day, a big advantage. When you want to eliminate the foreground, you and your tripod are usually perched at the very edge, so it's vital to note exactly where to place your feet, especially when moving away from the tripod. You might want to pile up some rocks around each tripod leg for security. (See CD-ROM: Equipment > Tripods)

OPENINGS IN A WALL

Canyons are often fissures in a wall of rock. When it opens to the east, the entire canyon catches morning sun, but it gets a little complicated. For example, in summer, the sun is farthest north, so the southern walls of the canyon get the best light. Therefore, the photographer should stand to the north and shoot toward the southwest. Lesson? Know the sun's movements.

Again, imagine photographing this east-facing canyon on a summer morning. Always check the skies to the east, more precisely,

where the sun is. When cloudy, you'll have boring but consistent light. However scattered clouds give you hope and the light will be best when the sun intermittently peeks out. Location scouting can save your morning's shoot by letting you take advantage of these ephemeral, sunlit moments. By noon, the sun has moved overhead and the shooting is usually over for the day. Conversely, canyons opening to the west are primed for afternoon shooting. (See CD-ROM: Canyons > Monument Valley > Monument1.jpg)

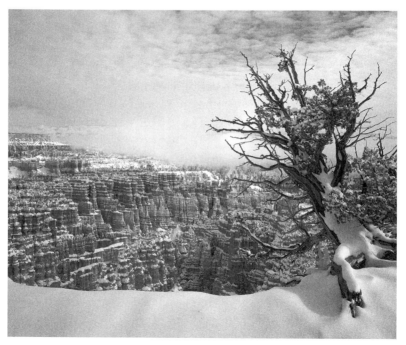

BRYCE CANYON NATIONAL PARK, UT, JANUARY 2.
When incorporating foreground, use a high vantage point so you can still see deep into the canyon. This is Utah's highest (and coldest) national park.

Canyon Compositions

I like pictures that let my eyes roam. I put myself in the image and dream of going from place to place. If the photographer blends natural elements with the proper techniques, the viewer can experience standing on that ledge and taking in the view. Wide-angle lenses are especially useful in capturing a canyon's vastness. However, the enormity can lead to an overwhelming amount of similarly colored rock and a lack of focus—there's no subject.

Incorporate carefully chosen foreground. Vegetation adds a splash of green and contrasting shapes. This also helps contain the expanse by framing the image. Also, try stepping back to include a rock ledge at your feet. This frames the picture and invites the viewer to imagine standing there. Wide-angle lens are perfect, because they provide plenty of depth of field. (See CD-ROM: Canyons > Grand Canyon > South Rim > South_Rim2.jpg)

Position the foreground so you can still see into the canyon's depths. A higher perspective often helps. This integrates the foreground, rather than building a wall in front of the canyon. Take the time to see *exactly* where important elements of the foreground intersect with the background. You don't want to hide prominent feature. (See CD-ROM: Canyons > Utah > Bryce Canyon > Bryce3.jpg)

SLOT CANYONS

These are the hidden treasures of canyon country. From above, a slot canyon is a nondescript crack in a sea of slick rock, giving no hint to the visual marvels below. Unless you're equipped to rappel, you'll enter and photograph from the slot canyon's floor.

Once inside, you're in a different world. Often no more than a couple of feet wide, the smooth walls can rise hundreds of feet overhead. Slot canyons are formed by flash floods on steroids, so you need to be vigilant about rain, especially localized downpours. It's not uncommon to see large trees lodged far above your head. As you hike farther into the canyon, make note of any escape routes from the unthinkable—a rising torrent. (See CD-ROM: Canyons > Slot Canyons)

Slot Canyon Compositions

Most images concentrate on the sensuous textures and colors of the undulating walls. When the sun is lower in the horizon, little light reaches the bottom. Plan to photograph the upper walls using longer lenses (70 to 100mm). As the sun climbs, more light spills into deeper crevasses. This is your best chance to include the canyon floor. If so, look for s-shaped sections and switch to normal (50mm) and shorter lenses (28mm). The low light makes a tripod a necessity.

One of my most memorable shooting experiences came at the infamous Antelope Canyon. This is where eleven adventurous tourists were swept to their deaths in a violent flash flood in August

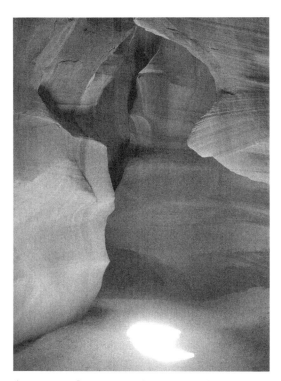

ANTELOPE CANYON IN APRIL NEAR PAGE, AZ.
Slot canyons are formed by flash floods, so be alert for thunderstorms. Bring a tripod; this exposure was twenty seconds at f/32, using a Sinar 4 × 5 inch view camera and a normal lens (150mm).

1997. I'd spent several days photographing the canyon's cousins, Paria Canyon and Buckskin Gulch, northwest of Page, Arizona. A local directed me to Antelope Canyon, just a couple of miles east of Page. I've been on many a wild goose chase, but this was the goose that laid the golden egg. It's a little more restricted now, but that spring I was able to camp right at the entrance to the upper canyon.

It's so narrow and deep that even at 9:00 A.M., there are areas as dark as a cave. Most of the canyon never receives direct sunlight. However, the light is very diffuse and warm from being bounced around the red canyon walls.

Hidden under the dark cloth, I wasn't aware of any change. No, my feet weren't getting wet, but I was being flooded in radiant light. Twenty feet away, a bolt of sunlight struck the canyon floor and the surrounding rock was glowing, and I was panicking.

No matter how good you are with a view camera, it's still slow compared to a 35mm SLR. I frantically moved over and recomposed. Shot some film, a Polaroid, and then more film. The sun's imprint moved across the sand like a speeding sundial. It lasted just a couple of minutes. It's one of those shots where you can't wait to see the film. Shortly after my return, I met with my stock agent and his first and only words were, "You should have thrown some

sand in the air, so you'd see the beam of light." It's a tough business. (See CD-ROM: Canyons > Slot Canyons > Slot1.jpg)

PHOTOGRAPHING BUTTES

The best way to envision buttes is to imagine a John Wayne western or Monument Valley. Buttes intermingle with the canyons, but because their vertical walls rise dramatically above a relatively flat landscape, they often receive unobstructed light. At sunrise, they catch the first rays, or they can provide a powerful silhouette if backlit—very versatile.

The immediate surroundings appear sparse at first, but a little scouting often reveals miniature sand dunes, flowers, and rock patterns. Any of these might make an effective foreground to the towering rock. In winter, when the neighboring canyons are dark and cold, these sandstone spires will prove to be worthy and easy-to-photograph subjects. (See CD-ROM: Canyons > Monument Valley)

STOCK VALUE: CANYON COUNTRY

No matter how much mankind marches over the landscape, these lands stay relatively free of human habitation. Canyon country conveys a sense of wildness, adventure, and the old West. The sandstone buttes and canyons found throughout the American Southwest are used in every kind of visual communication. This is partially due to their commercial accessibility. Most aren't heavily regulated and the landscape is undeveloped.

Monument Valley is an important photographic resource, the land of SUV ads and Western movies, while Utah's slick-rock country is the domain of mountain bikes and adventure trekkers. Canyons like Yellowstone and the Black Canyon of the Gunnison don't have quite the international recognition of the Grand Canyon, but their national park status makes them especially valuable for calendars, books, and tourism.

Slot canyons are some of the most beautiful and sensual forms in nature. Their abstract qualities produce exceptional fine-art prints and calendar photos. For reasons unknown to me, I rarely see them used in advertising.

PHOTOGRAPHING DESERTS

Deserts are lands of expansive vistas and sparse vegetation. The terrain can be as flat as a board and then abruptly give rise to rocky slopes

and cliffs. Nature photographers strive to create images that are so beautiful, they're almost surreal. Deserts must be photographed at the best time in order to look good. At the same time, the desert might be the most fickle environment when it comes to giving you that one precious moment. (See CD-ROM: Deserts)

LOCATION SCOUTING: DESERTS

When you descend from the Colorado Plateau down to the drier Sonora landscape, you enter a true desert—home to saguaro cactus, roadrunners, and rattlers. The sparse terrain, coupled with the potential for heat and harsh midday lighting, puts a premium shooting when the shootin's good. I pride myself on being able to photograph at a variety of times and conditions, but the desert seems to be an exceptional challenge. The light from sunrise to 10:00 A.M., and then again from 5:00 P.M. to sunset, seems best. Knowing where the sun is at these times is critical.

The terrain is likely to range from flat to rocky hills—not intimidating at first glance, but I don't know of any place where you need to keep your vigilance as high. The walking isn't strenuous, but there seem to be spines and barbs everywhere. An unintentional brush against the cholla or "teddy bear" cactus means a body part full of barbs. A good pair of tweezers is indispensable, maybe even pliers (seriously). As you might expect, drink excessive amounts of water, wear light-colored clothes, and plan on hibernating during the hottest part of the day. March and April are best, while July and August are absolute hell.

Rattlesnakes

A rattlesnake, like most wildlife, will do its best to stay out of your way if it knows you're coming. When hiking, look where you put your feet and keep a tripod or trekking pole out in front, especially when off-trail. Leather boots, gaiters, and long pants are standard in serious rattlesnake country.

I wasn't always paranoid, really. It all started one beautiful spring morning. I'd pulled into Organ Pipe Cactus National Monument about 1:00 A.M., so I camped along the road and planned an early start. By 9:00 A.M., I had the shot that was tops on my list: a lush field of golden poppies surrounded by cactus, with the Ajo Mountains forming a rugged background. (See CD-ROM: Deserts > Flowers > Flowers3.jpg)

Satisfied, I put my camera gear away and began location scouting. Rather pleased with my morning success, I was really

enjoying myself. Suddenly, there was a whirling between my feet. I instantly knew what it was. I'd stepped on a rattlesnake and it was rattling and wrapping itself around my leg.

Actually it was probably doing its best to get away and I wasn't helping matters. I made a desperate one-footed leap and landed seven or eight feet away. We exchanged glances, and then we both went our separate ways. This was a good dose of reality. I was about a half mile from the dirt road, which is about ten miles from a paved highway—and from there it's a lot of miles to nowhere. Fortunately, all I got out of it was a good lesson and a bum leg: I had jumped with such force that my thigh muscle was sore for three days.

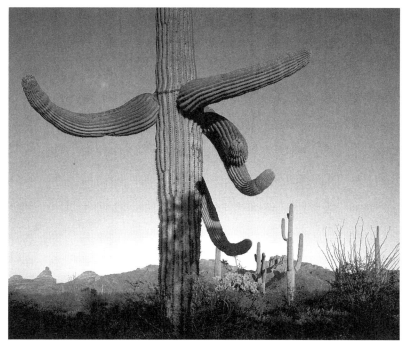

Ajo Mountain Road in Organ Pipe Cactus National Monument, AZ.
Mid-March is the best time for the flowers. When location scouting for saguaro, look for arms that are well defined. Also, the trunk should stand above the surroundings.

Desert Skies

The desert is one place where photographing throughout the day is often unproductive. Except during short rainy seasons, desert

photographers face the challenge of clear skies, all day. This means the light is very high contrast and truly stark. There's also stifling heat by mid-morning.

This places a premium on location scouting and being familiar with the sun's movement. The golden light at both ends of the day is precious and short-lived. On the plus side, the land is usually very open, so there are fewer problems with large shadows stretching across the land. Still, don't quit shooting too soon. The lighting at 10:00 A.M. is excellent. Shadows are small, the skies bluer, and the greens greener. A polarizing filter adds even more color.

The Southwestern U.S. is almost unbearably hot in August, but the monsoon rains produce powerful skies and lightning. This is the time to capture a rainbow over the Grand Canyon. Precipitation in late fall and winter dictate the abundance of spring flowers. (The CD-ROM provides the best times and dates to visit the best areas.)

Desert Sunsets

Deserts are known for good sunrises and great sunsets. Though arid, deserts often have cirrus clouds fanning out over vast distances, which can produce quite a display. Another factor is dust, which can enhance the sunset. The desert is the only place I know where you can get a colorful sunset without clouds, and it occurs well after the sun has gone down, so be patient. The more distant the horizon, the better the color, because there are more particles filtering the sun's rays. The color forms a very even gradient from yellows and reds along the horizon, to purple then black. Though striking, the image is missing something. A silhouette of a Saguaro cactus would be perfect. (See CD-ROM: Deserts > Sunsets > Sunset010.jpg)

TWO CLASSIC DESERT LANDSCAPES: CACTI AND FLOWERS

One of the best ways to make a grand vista better is to carefully position well-chosen foreground. One hurdle is the vegetation—what little there is often lies close to the ground and is very seasonal. This is why some of the desert's prominent inhabitants are so visually compelling—they stand head and shoulders above all others. The main players are the Joshua tree in southern California, and Arizona's saguaro and organ-pipe cacti.

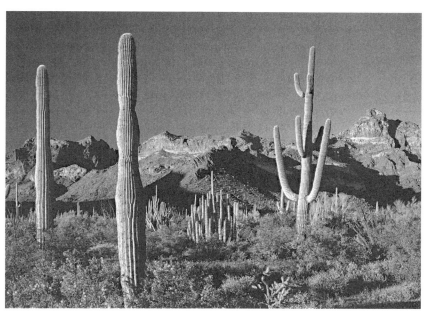

AJO MOUNTAIN ROAD IN ORGAN PIPE CACTUS NATIONAL MONUMENT, AZ.
MARCH 18, 7:00 P.M.
Position major subjects in front of larger shadows. This hides the shadow and accentuates
the subject.

The Saguaro Cactus

The saguaro is the undisputed icon of the Southwestern desert. Its
statuesque form makes it a pleasure to photograph. Saguaros are
often found in large numbers, but you soon find that not all
saguaros are created equal.

Here are some things to consider when photographing larger cactus,
especially saguaro. Find one or a small group of cactus to be your subject.
Pay particular attention to the "arms." Position your camera to keep
them well separated from the main trunk and reaching upwards.

Examine how the arms look from several directions and dis-
cretely mark good vantage points. Try finding a site that can be
photographed from different spots and at different times of the day.
This preparation is a lifesaver under rapidly changing conditions,
like sunsets. As the best color shifts from one part of the sky to
another, you're prepared to move the tripod immediately to pre-
determined spots and still create a tightly composed photograph.
(See CD-ROM: Deserts > Cactus)

ISOLATE

Beside a nice shape, you want to have the saguaro stand out from its surroundings. Try positioning it in front of a rocky slope or large shadow, to keep its olive green color from blending into the background. Experiment with a low camera angle. This basically raises the cactus, so it can be placed against the sky. A low perspective also gives the feeling it's looming over you, especially when photographed with a wide-angle lens.

SILHOUETTES

When shooting an object with the sunset as a backdrop (backlit), the object usually goes black and becomes silhouetted. All you can convey is its shape, so work at making it a strong graphic statement. It's imperative to have the entire saguaro stand above the horizon. Otherwise, the arms look like they're sticking out of the ground and not the saguaro, a fatal flaw. This problem is most easily alleviated by photographing on flat terrain with a distant view to the horizon. (See CD-ROM: Deserts > Sunsets)

SUNRAYS

The saguaro is the perfect subject to create sunrays or a sun-star. You need to position the sun behind it—a blazing sun is quite appropriate. Here again, the saguaro will be somewhat dark and rather colorless because it's backlit, so form is essential. Plan on making lots of exposures while the sun slowly creeps out from behind the saguaro. You never know what you'll get until you see the film or examine your digital files. (See chapter 17, under Photographing Sunrays and Sunbursts and CD-ROM: Sunrays > Sunray1.jpg)

Desert Flowers

Taking pictures of desert flowers has much in common with photographing other flowers. The big difference is your window of opportunity is shorter, often just a week or two in a particular area. They're also dependent on sufficient moisture earlier in the late fall and early winter, so quality can be sporadic. To retain precious water, some blossoms are only open during cool morning hours, shortening your day even more. What it all boils down to is that pre-trip planning is vital, and it's critical to keep in contact with several local sources. (See CD-ROM: Deserts > Flowers > Flowers2.jpg)

Flower season tends to begin in the south at lower elevations and progresses north and to higher elevations. Have a contingency plan. If you find the flowers are past their peak, look northward or to higher elevations. Organ Pipe Cactus National Monument is at the Arizona-Mexico border. Its brochure lists mid-March to mid-April as the peak for annuals and most perennials. Most cactus flowers bloom about a month later. However, their flowers are small and rather insignificant in a grand landscape. It's nice to be in an area with saguaro or Joshua tree cacti; they can be photographed year round.

STOCK VALUE: DESERTS

During my first visit to the desert I came away with one really good photo, a saguaro at sunset. Besides making some money, it taught me a valuable lesson. It was a vertical format and I remember hearing all too often, "Do you have it in a horizontal?" I didn't make that mistake again.

I have had quite a bit of success selling desert imagery. It's a unique and intriguing place that appeals to adventure travelers and retirees alike. A photo showing the stark contrast of delicate flowers in a harsh landscape can convey survival and overcoming adversity. These images also make gorgeous fine-art prints, posters, and are favorites for calendars. A great trip would consist of catching the end of the desert flowers of Arizona, then heading north to the south rim of the Grand Canyon. After a few days, drive east to Monument Valley or to the slots near Page.

PHOTOGRAPHING SAND DUNES

Sand dunes are hidden gems and can be photographed year round, since almost nothing grows on them. I've enjoyed photographing the Colorado's Great Sand Dunes in winter and California's Death Valley's dunes in summer. (See CD-ROM folder: Sand Dunes)

LOCATION SCOUTING: SAND DUNES

Sand dunes are often viewed as the ultimate desert landscape: There's virtually no vegetation and you can just imagine the oppressive heat. This is true for Death Valley's dunes, but in fact most other dunes experience moderate temperatures and rainfall.

Location scouting is critical when shooting sand dunes. I don't know of any area where the good light is so short-lived. Shots of dunes with well-defined ripples accentuated by shadows

are sensitive to quickly changing light. These ripples, or parallel ridges, are just inches high, and the sun needs to be at low angle, raking the light across them from one side. (See CD-ROM folder: Patterns > Rocks > Sand2.jpg)

Footprints can be your biggest obstacle to good imagery and it's often necessary to walk some distance to escape them. Calm conditions immediately following a very windy day are optimal for shooting. Although most sand dunes don't stretch for great distances, it's still easy to get disorientated when you're out in the middle of them. Before wandering off into the dunes, get your bearings by noting key landmarks. For example, if you get disorientated, you'll know that walking toward a distinctive peak will eventually lead to the road.

Lighting and the Sun's Movements

Massive shadows usually subtract from an image, but are needed to accentuate the dunes and give them character. Close-up images showing individual sand ripples are usually shot within hours of sunrise and sunset. It's imperative to know when and where the sun rises and sets, and that, in the northern hemisphere, it arcs southward as it moves across the sky. The upside is that individual sand dunes face many directions, giving you the opportunity to shoot at both ends of the day.

When you stand farther back, you'll also see that the large dunes cast shadows. Here, the timing isn't quite as critical, but you still need the interplay of light and shadow. Without shadows, the dunes are amorphous piles of sand.

Wind

Wind is both friend and foe. Persistent wind formed the sand dunes, but it also means you can expect to shoot in windy conditions, which is very taxing. Sand gets into everything, so try to keep your gear on your body as much as possible. If you do set it down, keep it upwind from you.

Wind is a necessary evil. It scours away accumulated footprints, rejuvenating the dunes. Footprints are a fatal flaw. So be careful when exploring, you don't want to leave a trail where you might later photograph. Often it's best to plan on hiking a bit, to leave most of the crowds behind. Isolated dunes can be found tucked away in many locales, including beaches. Visit areas that restrict off-road vehicles.

SAND DUNE: TWO COMPOSITIONS

You can interpret sand dunes on two basic scales, still-lifes (patterns) and the grand vista. (Compare CD-ROM images: Sand Dunes > White Sands > White1.jpg, and Sand Dunes > Great Sand Dunes > Great6.jpg) Most patterns or still-lifes have ripples of sand radiating out from under the camera or diagonally across the frame. Get close and use a wide-angle lens to make the ripples radiate even more dramatically. The ripples of sand might be your only subject; it's a simple pattern, but a valuable stock image.

This simple pattern can also form the background in a still-life, accented with a singular survivor, a green plant. Animal tracks also make a positive statement; there *is* life out here. Adding a subject to a simple pattern tends to make the image more suitable for calendars and fine art, and less so for commercial stock. The best lighting for these images is a thin veil of clouds. These cut the light in half (one f/stop), making shadows pleasantly soft and revealing every subtle detail. These techniques can be used to photograph the patterned salt flats of Death Valley and Utah's Great Salt Flats.

111

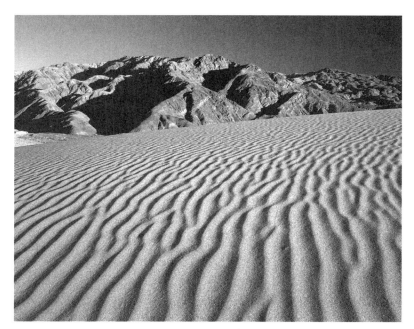

DEATH VALLEY NATIONAL PARK, CA. JULY 29, 8:00 P.M.
Most sand dunes can be photographed year-round, in the morning or afternoon. However, since you want the sun at your side and at a low angle, optimal lighting lasts just a couple of hours.

If your goal is to capture the landscape of the dune you should consider both foreground and background. A powerful background, like the sandstone buttes in Monument Valley, really benefits from an effective foreground. Carefully position the ripples, so they lead to the background. A tripod allows you to critically evaluate the lines and to use at least f/16 for maximum depth of field. Also, choose dunes that slope uphill, expanding the foreground. Try a normal lens (50 mm), so the background remains fairly large and impressive. A wide angle lens increases the drama of the radiating lines, but might make the background small and insignificant.

One of the best ways to photograph dunes is to position the camera along the crest of a dune. Look for an S-shaped ridge leading away from you, like a winding road. It's even better if it leads to an impressive background. (See CD-ROM: Sand Dunes > Misc. > Death_Valley1.jpg)

At the start of the dunes, there are often hardy plants intermingling with the sand. These can add an important splash of color to a graphically powerful, yet often monochromatic, scene. The White Sands of New Mexico have scattered yucca plants. Strategically placed footprints, or better yet a hiker, can also be added to enhance the photo.

STOCK VALUE: SAND DUNES

There is a need for photographs of simple patterns in stock, especially in advertising. Often another photo or text is placed over the pattern photograph. In essence, you the supply a background and the designer supplies the subject. These simpler photos can also be used to make composite images, using Photoshop. You don't want large shadows becoming too dark, or the photo can have a zebra effect.

Background or pattern shots are good for designers, but they don't have enough visual content to stand on their own for fine-art prints, calendars, and tourism publications. Grand landscapes require carefully chosen subjects and strong composition. Most tourism and travel uses aren't looking for art, but instead want clearly recognizable places.

Photographing Mountains

I'm going to take a seasonal approach to mountains. Photographic considerations depending on the season and how changes in elevation come into play. Although the dates won't apply to all mountains, the general progression of the seasons and your concerns are the same.

There is an ecological rule of thumb: every 1,000-foot rise in elevation is equivalent to traveling 300 miles north. This translates to great diversity. For instance, in California's eastern Sierra Nevada Mountains, the terrain rises from below sea level in Death Valley to the summit of Mt. Whitney (14,495 ft.) in a mere fifty miles. That's like traveling from Mexico to the Arctic Circle—you progress from salt flats through sagebrush, up through meadows and forests, ultimately topping out at alpine lakes and the treeless tundra. (See CD-ROM: Mountains)

LOCATION SCOUTING: MOUNTAINS

When I think mountains, I envision the great Western mountains of the United States. The Rockies extend from northern New Mexico, through Colorado and Wyoming, to Montana's Glacier National Park, and then into Canada. West of the Rockies, the interior hosts many smaller mountain ranges that rise above a patchwork quilt of a semi-arid and agricultural landscape. (See CD-ROM: Mountains > Colorado; Montana; Wyoming)

In California, we find the Sierra Nevada Mountains. Described by John Muir as the "Range of Light," they're home to the incomparable Yosemite Valley and the giant Sequoias. In many ways, the Sierras are similar to the Rockies, a long north-

south mountain range, topped with stunning alpine tundra. (See CD-ROM: Mountains > California)

At the north end of the Sierra, the Cascade Mountains begin. Starting with northern California's Mt. Shasta, the mountains change from rugged ranges to isolated, volcanic peaks. Although Oregon's Cascade Mountains are largely tree covered, there are also glaciated mountains, such as Mt. Hood, which rises like a great white pyramid to 11,235 feet. (See CD-ROM: Mountains > Oregon)

The Columbia River Gorge separates Oregon and Washington. From here you can see infamous Mt. St. Helens and the crowning glory of the Cascades, Mt. Rainier. In the North Cascades, near Canada, is home to one of the best places I've never shot—Mt. Shucksan and Picture Lake. (See CD-ROM: Mountains > Washington)

Altitude

Although mountains are widely separated around the world, they have a lot in common. One of the first things that comes to mind is the decrease in oxygen as you increase in elevation. Some signs of oxygen deprivation are shortness of breath, dizziness, and headaches. The situation becomes serious if you become very congested, because your lungs are filling with fluid. This medical emergency is called high-altitude pulmonary edema (HAPE).

Even if you don't suffer headaches or other symptoms, hiking uphill at higher elevations definitely slows you down. To avoid problems, acclimatize by gaining elevation over several days, especially if you're coming from sea level. Remember to "work high and sleep low." You're not immune the effects of altitude just because you're young and fit, and the best treatment is a quick descent.

While photographing on Mt. Rainier, you're often restricted to 5,000 to 6,500 feet above sea level. Permanent glaciers lie just above—always dangerous terrain unless you're skilled with a rope and ice ax. While Colorado has relatively few permanent snowfields, it does have an abundance of high alpine terrain. Treeline is around 11,300 feet, and there are fifty-four "fourteeners"— mountains higher than 14,000 feet.

Mountain Weather

Mountains create their own weather because of the changes in elevation, so you always need to be prepared with some basic

survival gear. As you go higher, the temperature steadily decreases. It's this temperature differential that gets the weather ball rolling by causing wind and the formation of clouds. These weather cycles impact every aspect of your photography.

Thunderstorms are often your greatest concern and can't be taken lightly. The resulting clouds, wind, and rain often put an end to shooting by early afternoon, so you need to get started early. The accompanying lightning and the possibility of hypothermia are the real hazards that drive you back down the trail and into the protection of the forest.

HYPOTHERMIA

Hypothermia is the gradual lowering of your core body temperature, and becoming wet is the fastest way to get there. Besides feeling cold and shivering, your mental and physical capacities diminish. You need to be alert and *prevent* hypothermia, rather than recover from it. This means it's vital to carry the right clothing and survival gear discussed earlier. I started carrying an umbrella several years ago while llama packing and wonder why we don't see high-tech models in outdoor stores.

One spring, our family had the pleasure of spending three nights at Phantom Ranch in the bottom of "The Canyon," as the locals say. It's as fine a trip as I've ever had. We began our return hike up to the south rim at 6:00 A.M., and by 9:00 A.M. had reached Indian Gardens. Then it began to rain, hard. As we ascended the canyon walls, the rain stopped and started, eventually turning to snow. We topped out at 2:00 P.M. in swirling snow, clouds, and wind. It was fantastic. Although we were wearing the best jackets and fabrics, they eventually let the water in. If we hadn't worn garbage bags during the heaviest downpours, it could have been rough.

ALPINE TUNDRA

The distant views and shear exhilaration that come with being in the land above the trees—the alpine tundra—can't be beat. It's best to start before sunrise, particularly if the hike begins in the forest. On the way up, keep an open mind to photographic opportunities for the way down. The forests can be home to beautiful streams, which are best photographed under cloudy skies—conditions found when afternoon showers put the high country out of commission.

The Treeline

One of the best places to spend your time is the area straddling treeline, called the sub-alpine zone. The landscape opens up, and wind-sculpted trees reluctantly give way to the tundra. The snow that falls on the rocky slopes above collects in this more protected area, forming lakes and lush meadows. It's a great place to make a basecamp and then work out compositions of alpine flowers and high lakes surrounded by jagged peaks. If you find a great spot for later, discretely mark it. As always, understand the sun's movements, so you know the best time to return. Generally, mornings are much calmer, weather wise, than afternoons.

Tundra: Land above the Trees

As you climb higher, the terrain loses its park-like qualities, but the open land provides the grandest views. Lakes are shallow tarns, and dwarf alpine flowers dot the rocky slopes. You can often photograph sub-alpine lakes from this higher perspective. In summer, a sky often evolves from cloudless to cloud-covered over the course of a couple of hours. Be sensitive to when the clouds look their aesthetic best, a nice balance of blue sky and clouds. That's when you take care of business. (See CD-ROM: Flowers > Washington > Washington3.jpg)

Being high on a mountain is akin to standing on a canyon's rim. Both situations have the potential for massive shadows. Determine when and where shadows will form, to eliminate a long wait that ultimately ends in disappointment.

PHOTOGRAPHING IN EARLY SUMMER

Let's start with June. It probably took me five years before it sunk in that the arrival of June doesn't mean summer in most mountains, especially in the high country. In June, you find the most dramatic changes as you climb in elevation, from full-fledged summer in the lower valleys to winter at the high passes. Although the weather is a bit unsettled, the mountains often look their best in early summer. The higher peaks still have snow, while the lower slopes carry the vibrant green of newly emerged leaves—a beautiful contrast. (See CD-ROM: Reflections > Colorado > Indian_Peaks1.jpg)

Higher Elevations

Whenever possible, consider beginning and ending your day higher up along the road. It's the same idea as shooting at the canyon's rim

versus from deep within its depths. The higher terrain gets the first and last rays of sun, making for a much longer day than the shadow prone valleys. Understanding the sun's movements to photograph the best light, while minimizing deep shadows, is one of your biggest concerns.

Higher elevations are also great for sunrises and sunsets, because the expansive vistas often let you point the camera in many directions, increasing the odds of capturing a colorful sky. At this time of year you might still be able to take winter-like images. Although the chance of avalanches is diminished, don't be lulled into thinking snowfields are safe. Your big concern is slipping and taking a long slide that ends on hard rock. (See CD-ROM: Moon > Moon1.jpg)

Lower Elevations

At the start of summer, the alpine meadows and lakes are often buried in snow. So, if you'd like a photograph that includes the green meadow *and* the white mountain peak, most of your best shooting is

YELLOWSTONE CANYON FROM ARTIST'S POINT, YELLOWSTONE NATIONAL PARK, WY. SEPTEMBER 24, 1:00 P.M.
Canyons are found everywhere. It's often better to photograph canyons when the sun is relatively high in the sky, so the inner canyon receives light. However, keep the sun to your side and behind your outstretched arms.

likely to be lower down, where it's green. Location scout along roads, lakes, streams, and open meadows—places that provide a good, clear view of the higher peaks. Concentrate your efforts on finding a great foreground. A rushing stream or a lake's reflection makes a far more accomplished picture than a stand-alone mountain. (See CD-ROM: Reflections > Wyoming > Tetons8.jpg)

PHOTOGRAPHING IN MIDDLE SUMMER: THE PEAK SEASON

As June transitions into July, the high slopes grudgingly lose their snow and give way to summer. Now you're given access to the high country via a variety of roads and hiking trails. This is the time to concentrate your efforts in the sub-alpine and alpine zones. Where the vegetation begins to lose its stranglehold on the slopes, the landscape more resembles a park. Patches of wind-sculpted trees mix with alpine meadows, clear streams, and photogenic lakes, all set against the backdrop of mountain peaks.

Flowers are one of the most popular subjects, and if they're on your shot list, it's imperative to monitor conditions and show up when they're at their peak. You'll have a two- to three-week window of opportunity in any one area. Concentrate your efforts on finding a stunning patch of flowers set in front of a beautiful mountain. (For popular locations and dates, see CD-ROM: Flowers)

Plan on an early start—to take advantage of the clear skies and calm air—when venturing above tree line. Plan to accomplish most of your photography before any possible early afternoon thunderstorms roll in. As the lightning chases you down into of the trees, be alert for rainbows. Cloudy afternoons are best spent taking advantage of the lower-contrast light. Ideal subjects include streams, forests, and still-lifes. It's also a good time to location scout for next morning, if the clouds don't clear before sunset.

PHOTOGRAPHING IN LATE SUMMER

Summer is usually winding down by mid-August. The weather is often excellent, but the flowers are nearly gone. Tundra plants are already turning red, signaling the impending fall. I say "usually" because I remember having to leave Mt. Rainier in mid-August, while the alpine flowers still looked great. Quite disappointing. At this time of year, water might be difficult to photograph. Streams are at a trickle and many lakes are low. Conditions stay like this until

mid-September and the arrival of autumn. (See CD-ROM: Mountains > Colorado > Northern Ranges)

This is a wonderful time to roam the high country and concentrate on photographing grand vistas with great skies. However, special care must be taken to make the mountains look their best, since most peaks will have shed their snow. When confronted with hazy skies, keep your eyes open for backlit scenes. Look for vistas that show many overlapping valleys and intersecting ridges. These images are most characteristic of the Smoky Mountains. (See CD-ROM: Sunset > Sunrise > Sunrise4.jpg)

AUTUMN MOUNTAINS

Great autumn color is largely the domain of the deciduous hardwood forests, predominantly found in the eastern third of the United States. In the Western United States, the coloring job falls to the aspen tree, with some contributions from cottonwoods, larches, and scrub oaks. (A series of photo trips to the Maroon Bells, a premier fall location, is documented in the CD-ROM folder Maroon Bells)

119

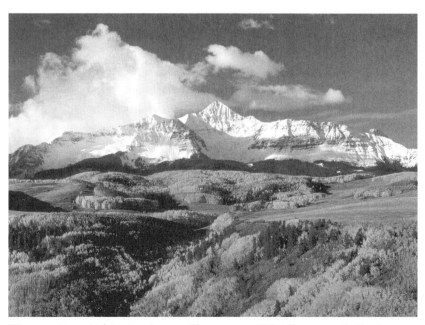

WILSON PEAK (14,017 FT.) NEAR TELLURIDE, CO. OCTOBER 1, 9:00 A.M.
Pointed peaks reign supreme, and a good one should be photographed under a variety of conditions and seasons. Study landscape paintings for a valuable learning experience.

As with alpine flowers, any one area tends to have a two week window of opportunity for fall color, usually sometime from mid-September to mid-October. In prime areas, there are often phone numbers and media coverage regarding the state of the autumn foliage. As expected, timing is everything, but being a little early is better than being late.

It's rare for roads to be closed for the season in autumn, and with the shorter days, don't plan on hibernating at midday. Perhaps no subject is more important to shoot while the shootin's good, because a change in the weather can put a halt to shooting until next fall. When snow's predicted for the high peaks, it's really worth sticking around. Usually the best conditions occur right after the unsettled weather moves out.

By far the most popular autumn images are grand landscapes, with fall color framing a mountain or rugged ridgeline, all under a great sky. Having the mountain tops covered with fresh snow is a real bonus and takes any image to a higher level. When the snowfall descends to lower elevations, you have the potential for truly unique imagery. It's rare to be given the opportunity to photograph unfrozen lakes and streams surrounded by fresh snow. Usually, temperatures quickly recover and the snow is short lived. (See CD-ROM: Autumn; Forests)

WINTER MOUNTAINS

All things considered, it's just plain difficult to photograph the mountains in winter. When you're below the snowline, the land is brown and lifeless. At snowline, you'll usually need skis or snowshoes the moment you step off the plowed highway. Expect all but the larger roads to be closed, especially if you're away from population centers. The most conspicuous part of winter in the mountains is snow, and it's discussed next in chapter 15.

Here's an idea of what to expect and where to concentrate your efforts. Most national parks remain open, and ski resorts provide a unique access via ski lifts. For instance, Aspen Highlands Ski Area gives unsurpassed views of the Maroon Bells. Like cityscapes, a landscape photo of a ski area has value for postcards, calendars, and tourism. Explore roads opposite the ski area for nice vantage points. If you're serious about getting a unique shot, determine if the ski area has a fireworks display scheduled, perhaps around a holiday or winter festival. (See CD-ROM: Man-Made > Misc. >Aspen1.jpg; Vail1.jpg)

A common sentiment voiced by clients is they don't want photo-graphs of winter to look too cold, hence uninviting. One answer is to photograph closer to sunrise and sunset for the warmer light. You might also try a subtle red or magenta filter, not yellow. Another trick is to include sunrays or a sun-star. Add color like blue skies, sunsets, evergreens, or red sandstone cliffs to lessen the cold bite of winter.

Day Length

Winter's daylight is short and the sun is low in the sky. Generally, you're better off photographing winter scenes in the late winter and early spring. The slopes are blanketed with snow, the days are longer, and the sun is much higher in the sky. If you intend to visit a specific area, use a topo to determine which direction the mountains face. The classic view of Wyoming's Grand Tetons face directly east and get fantastic morning light, but by 11:00 A.M. the shooting is over and it's time to go skiing. North-facing mountains might be the most difficult to photograph. They'll get very little sunlight in mid-winter, making for a shadow-laden image.

STOCK VALUE: MOUNTAINS

I estimate that 75 percent of what I sell has a mountain in it some-where. I've learned that the grand vista far outsells everything, and the mountains have some of the grandest. Mountains are icons for everything, from serenity to something to conquer, but more than ever the mountain landscape is a place to live, work, recreate, and drive our SUVs. This appeal correlates to demand for imagery.

Simple images make great stock shots for advertising. A homo-geneous evergreen forest leading to a rugged mountain range, capped-off with a blue sky, has room for the advertiser's message and can often be cropped anywhere. The more complicated shot requires many elements to come together. These have a home in advertising as well as prints, tourism, calendars, and postcards. In either case, fresh snow is a real asset.

Photographing Snow and Cold 15

It takes some skill and preparation to enjoy winter conditions, especially if you plan to venture any distance from the car. You have to be able to protect every part of your body, but your hands are of particular importance. Lint-free gloves are often your best bet for warmth while working. A quality windbreaker affords protection, while deep pockets allow you to quickly stow a lens or film. Chemical heat packs should also be considered.

When planning, envision not being able to set anything down on the snow, unless it's a substantial camera case. Once you drop something in snow, it's often out of commission until you return to basecamp. (That's if you're lucky enough to find it.) Having a whiskbroom, canned air, and absorbent towels back at the car can help eliminate snow that does get on your gear. (See chapter 10, under Tripods and Snow)

CONDENSATION

Moisture or condensation forming on colder surfaces is a problem and is best avoided by keeping gear at a constant temperature. It's also helpful to use lens caps and put the camera in a case when moving from cold to warm. A stuff sack is particularly useful to protect your camera and tripod head while moving about and waiting out the weather. When you get into your warm car, the sack will help reduce condensation.

When you get snow or lint on a lens, don't blow it off. Your warm breath will instantly freeze, making matters worse. Even holding a cold filter in a warm hand will cause condensation, which

freezes. A lint-free cloth and soft brush is vital, because it's best to brush off snow before it melts.

COLD

One immediate concern is running low on battery power in cold weather. This will put most of today's cameras totally out of commission. It's suggested that you keep your camera protected in your jacket to keep batteries warm. However, this isn't very practical. Besides cameras being bulky, you're often working hard when hiking and your body gives off considerable moisture. Another complication is that when changing to a cold lens or filter, condensation forms at the warm/cold interface. The best solution is to keep your gear at a constant temperature while you're using it. Spare batteries are a necessity. Know that almost everything has a greater tendency to break when cold, so it's best to treat things carefully. This is particularly important when rewinding cold, brittle film.

EXPOSURES AND SNOW

Generally a snow scene is twice as bright as the same scene and lighting without snow. This is because of the light reflected from the snow. Even so, there's a tendency to underexpose, making the snow look gray. This is because a light meter doesn't know what it's pointed at. Whether it's a white or a black surface, the light meter gives you a reading that renders the surface neutral gray. Consequently, when pointing the camera at bright snow, the meter gives you a reading rendering the snow neutral gray. To correct, add about one f/stop to your meter reading and bracket. Also, take readings from mid-range subjects such as gray rocks, blue sky, or a road. (See chapter 9, under Sunny-16 Rule)

TIPS FOR BETTER WINTER COMPOSITIONS

Besides the physical challenges of a snowy environment, the surroundings often lack color and there's little detail in the snow. You overcome this by utilizing available color, incorporating strong graphic elements, and optimizing the lighting. (See CD-ROM: Winter)

Foreground

Incorporating foreground provides a vital element to punctuate or frame a snowy composition, which can otherwise look too white and monotonous. Branches, grasses, a sunset, and fences are great ways to

contain a sea of white. Powerful shapes can be a winding stream, fences, wind-sculpted snow, tree trunks, and ridgelines. Like sand dunes, be aware of where you're making tracks or otherwise disrupting the scene so you don't ruin a potential composition.

Evergreen trees are particularly good for snow compositions, especially ones with the classic Christmas-tree shape, like spruce. Have them receive plenty of the sun, otherwise they'll look dark. Low-contrast light from cloudy skies brings out the green color, but be sure to position branches to minimize the drab sky. Deciduous trees look dead and convey the message: "It's going to be a long, cold winter." This is unappealing, so try to find powerful shapes or photograph trees when they're covered with fresh snow, always a great touch. (See CD-ROM: Forests > Misc. > Winter2.jpg)

Adding Texture to Snow

Look for subtle features. These might be undulating hills or shapes carved by wind. As with photographing flowers, foreground subjects don't have to be vast; a square yard does the job. Photograph with the sun off to the side and slightly behind you. As you would with sand dunes, have the sun at a relatively low angle, so it's raking the surface. This accentuates the surface by creating many small shadows. Thin cloud cover that reduces the contrast range and produces soft shadows is also good: You'll see the snow's subtle details in both the highlights and the shadows. (See CD-ROM: Winter > Colorado > Boulder3.jpg)

Blues Skies and Sunsets

A colorful sky is one of the few sources of vibrant colors in winter and often deserves additional space in your composition. A couple of days immediately following a snowstorm are the most rewarding. You have blue skies, calm winds, and a clean mantle of snow. It's often better to shoot winter scenes toward the end of the season. The sun is higher in the sky and the days much longer, so there's more opportunity to shoot. Sunrises and sunsets also hold potential. Besides the warm color, light-colored foregrounds won't go black.

To make sure all your hard work pays off, be alert to fresh snow blowing off trees. Falling snow will look like random white streaks or imperfections against the blue sky. If falling snow can't be avoided or is desired, use a fast shutter speed so it looks like snowflakes. Whenever the snow is flying, it's important to keep checking your

lens to make sure it is free of snow. (See CD-ROM: Winter > Misc. > Snowflakes2.jpg)

Backlit Conditions

Photographing into the sun is difficult, because objects lose color saturation and the sky tends to look hazy. Try to capture the interaction of sunlight and the crystalline snow against a blue sky. Experiment by throwing fresh snow into the air or shaking it off a tree. You can also position the sun behind a tree branch to produce a sun-star. Placing the sun in your image is a great way to add warmth and vitality to a cold winter scene. (See CD-ROM: Sunrays)

STOCK VALUE: SNOW

I have a handful or two of excellent winter images that sell again and again, but from a monetary standpoint, winter is a distant third to summer and autumn. Concentrate on more complex compositions, which are appropriate for calendars and greeting cards, especially for Christmas or "The Holidays," as the weeks between late November and January are becoming known. Try to warm up a cold image by using subtle warming filters or Photoshop. You'd think that calendars would always need a couple of snowy months, but most national calendars prefer to use desert and canyon pictures for the winter months.

Photographing Flowers, Forests, Patterns, and Still-lifes

Running a stock agency, I see my share of unimpressive nature photography. One of the biggest mistakes I see is a fear to get close to the subject, especially the foreground. I'm not talking about close-up photography. I'm visualizing the complete package—what I generally think of as the classic landscape photograph. A carefully selected subject that dominates the foreground and is precisely positioned in front of an equally stunning background. These valuable images can be photographed in many environments, but require considerable care and planning to execute. Many of the techniques used to photograph flowers, forests, and still-lifes are employed in these more complex mages. (See CD-ROM: Patterns)

THREE BASIC FLOWER COMPOSITIONS

Let's assume you've done your homework and you're in the right place at the right time (See chapter 11, Planning a Successful Photo Trip). Realize that not all flowers have the same impact. The bigger the bloom, the easier to photograph. Yellow flowers have the most impact, followed by red, then blue. Also, some areas are known for signature images, such as the columbine of Colorado or the redwood trees of Northern California. (See the Cacti and Flowers section of chapter 13 and the CD-ROM: Flowers)

The Complete Package

A classic composition is a beautiful patch of flowers in front of an equally stunning backdrop, like a mountain, a redwood grove, or a waterfall. Finding an impressive backdrop is usually top priority.

127

Then you start looking for a subject to put in front of it. Ideally, find a slope that leads uphill to your backdrop. This way, it's easier to fill the frame with flowers, and the upward slope will lead the eye to your well-chosen backdrop. Also, review the discussion of depth of field from chapter 6, Lenses and the Creative Process.

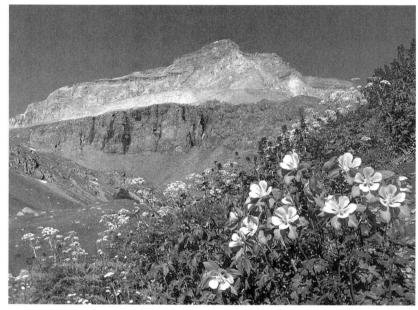

COLUMBINE FLOWERS AND MT. GILPIN (13,694 FT.) IN YANKEE BOY BASIN, CO. JULY 16, 9:00 A.M.
When incorporating any prominent foreground, begin by finding a stunning backdrop. Then search for the perfect subject. It only needs to be a few feet wide.

After finding a patch of flowers, choose the perfect part of it. This is the star of your photo and only needs be a few square feet. Remove twigs or dead flowers, which detract from the pristine feeling. Look for areas in the foreground that might be enhanced by adding a few carefully picked flowers, but make sure they don't wilt or slip out of place. Consider bringing green garden wire or a spray bottle to spray the leaves to add water drops and increase color saturation.

THE SUN AND WIND

When working close to your subject, everything is magnified. Don't let a shadow sneak into an important part of the foreground. This is

where you might place an extra flower or two. Generally, keep the sun somewhere behind your outstretched arms. If you're serious, consider bringing a sheet of white cardboard or a collapsible reflector to use as a fill card. By adding reflected light, a fill card can lighten the shadows and also act as a wind deflector. Bring along some clamps to secure the card to a spare tripod or to nearby vegetation.

Wind is a real frustration. It's usually less windy in the morning, and if you are patient, you'll discover that even windy days have calm moments. A tripod is essential for producing tight compositions, and it lets you stay ready for whenever the wind dies down or the sun reappears from behind a cloud. Keep your eye on the most important flowers; expose when they're most still or have the best light.

Flower Still-Lifes and Patterns

Another favorite composition is a pattern of flowers, especially if there isn't a nice background. The key is filling the frame with a fairly homogeneous field of flowers. Try to eliminate any gaps in the flowers and minimize distracting shadows. The immediate foreground doesn't need to be spectacular. In fact, the key is *not* having an overly prominent subject, especially if you want the image to sell as a backdrop for a graphic designer's layout.

It's best to use a normal or a slightly longer focal length, like 50 to 80mm. The background, if there is one, is often sky. These images can be photographed under morning sunlight and also under cloudy, low-contrast lighting. (See CD-ROM: Patterns > Misc. > Flowers4.jpg)

Flower Close-ups

A third composition is a close-up of just one or two flowers and usually requires a 50mm or 100mm Macro lens. Search for the perfect specimen and remove dead leaves, because every imperfection stands out. When focusing on something close, there's very little depth of field. It's imperative to have the critical parts of the photo in the same plane of focus. For example, if you have two flowers, they need to be side by side and not one behind the other.

You should also analyze the background. It will be out of focus, but you want it to look homogeneous. When most of it consists of different shades of green, a large dark spot is disconcerting. Experiment with f/stop setting from f/11 to f/22, while using the camera's depth of field preview button. You want the flower razor

sharp and a blurred background. The greater the distance from the subject to the background, the easier it is to make the background well out of focus. After photographing, add water drops with a spray bottle or eyedropper, and reshoot. Voilà, two shots in one. A tripod is mandatory for tight compositions and long shutter speeds. These photos are best made under an overcast sky or in a shaded area.

STOCK VALUE: FLOWERS

Images integrating a beautiful display of flowers into a grand vista are in demand in every market, from calendars and fine-art prints to advertising and tourism. However, I've accumulated a disproportionate number of verticals that are seldom in demand. Shoot horizontals when possible.

Pattern or background photos are very useful in advertising. They're used as backdrops for text and other photos. Without a stunning subject or backdrop, they don't have the impact for fine-art prints, and they don't have the geographic identity for local advertising, tourism, and most calendars.

I do relatively little true close-up, or macro, photography of flowers. I use my 55mm macro lens to photograph an area measuring from 4×5 inches up to 10×15 inches. However, I do observe the world of print and I don't see or receive many requests for close-ups.

By far my biggest selling close-up photo is of two columbine flowers, side by side, against an out-of-focus green background. It sells because the columbine is Colorado's state flower. These photos are usually used as accents to other images, meaning they're reproduced fairly small. A cluster of columbine reproduced 2×2 inches isn't readily identified as columbine, whereas a close-up of two flowers is. (See CD-ROM: Flowers > Colorado > Colorado010.jpg)

PHOTOGRAPHING FORESTS

Here I'm addressing intimate forests shots, where the forest is the subject. These are often more like giant still-lifes, rather than grand vistas in which the forest is more an accent to a snow-capped peak. When the skies are overcast, head to the forest to take advantage of the low-contrast light. It might also be helpful to recall the previous discussion on autumn foliage in chapter 14. (See CD-ROM: Forests; Autumn)

Open Areas

When you want to convey being surrounded by the forest, one difficulty is standing far enough from the foreground trees to hold focus: You literally can't photograph the forest for the trees. Get some distance by finding a clearing, perhaps shooting from a quiet road or along the edge of a meadow. The distance lets you use a normal to medium focal length. This keeps the trees from converging or appearing to fall over, especially noticeable when you use a wide-angle lens and tilt the camera up. A more open location also lets the sun in, so the trees and ground cover are far more photogenic.

Framing the Photo

To produce a fine forest still-life, rather than a jumble of sticks and vertical lines, examine all four edges of your composition. Consider positioning healthy trees along the left and right borders to form strong boundaries. Make sure tree trunks appear vertical, particularly the more prominent ones.

Now work on the top and bottom of the image. Avoid photographing just tree trunks. Include some forest floor to visually anchor the tree trunks. This is most successful when there's something interesting, like green ferns. Where a shaded forest floor is relatively lifeless, point the camera upward to give the impression of a towering forest. This might include colorful leaves and blue sky. Before exposing, take one last look using the camera's depth of field preview button, making sure nearby branches will be in focus. (Compare CD-ROM images: Forests > Aspen Trees > Aspen1.jpg and Aspen2.jpg)

131

TWO FOREST COMPOSITIONS: REDWOODS AND ASPEN

I've always enjoyed photos of the massive redwoods accented with blooming rhododendrons, a stunning contrast between massive tree and delicate flower. In many ways, aspen trees are the opposite of the formidable redwoods. Relatively small in stature, their impact is from their sheer numbers, aspen literally carpet mile after mile of mountainside. They're most easily recognized by their whitish bark and brilliant yellow fall foliage.

Photographing Redwoods with Rhododendrons

My first West Coast photo excursion was timed to arrive at California's Del Norte State Park for the peak rhododendron bloom,

in mid-May. Having seen photos, I had preconceived notions as to what to expect and how to photograph them. The flowers should have been at their peak, but very few were blooming, so I ended up shooting the same flowers every possible way. I left disappointed but inspired to return next year and take advantage of what I'd learned. (See CD-ROM: Forests > Redwoods)

My first observation was there aren't many coastal redwoods, just small pockets called groves. Secondly, "rhodos" don't grow everywhere. They prefer sun, so the best are found along the roads and wider trails, and in clear cuts. Plus, the understory is so thick that bushwhacking any distance is impractical. This narrows down the search considerably.

Redwoods are monstrous trees and rhododendrons are proportionately large bushes. To get a nice view of the flowers, you need to be level or above them. Unfortunately, when hiking on most trails, the flowers tower over you, and you often must work perched atop a giant fallen log (or better yet, a ladder).

I concluded that many successful photos are shot from roads, which are elevated and create some of the few swaths of light through the dense forest. Also, I suspect quite a few images have been created (or perhaps manufactured is a better word) by cutting off the flowering branches and positioning them as desired. A classic still-life is a flowering branch positioned in front of a sculpted tree trunk enveloped in fog. (See CD-ROM: Forests > Redwoods > Redwoods13.jpg)

WEATHER PATTERNS

Plan to photograph during the morning's predictable mix of clouds and fog. The massive tree trunks make a powerful statement in a foggy scene, and the red flowers have enough punch to be visible. Anticipate when the fog might lift and take advantage of these ephemeral moments. Try shooting into the sun through the thinning fog, or as it peeks out from behind a tree, to capture dramatic sunrays. (See CD-ROM: Fog; Sunrays)

Photographing Aspen Forests

While I enjoy photographing a tranquil aspen forest on overcast days, it seems more appropriate for their shimmering leaves to stand against a Rocky Mountain blue sky. Try a polarizing filter for more color, but at 50 percent. I made the mistake of overpolarizing the sky

while shooting along Kebler Pass Road, and the sky looked more black than blue. (This is one of the best places for aspen. See CD-ROM: Autumn > Kebler Pass)

Due to the aspens' white bark, the contrast with dark shadows can be quite pronounced on sunny days. Try positioning the sun behind you, so the shadows on the trunks are minimized. Shooting from an open meadow or a roadway is a good solution, and lets the light penetrate the forest.

Photographing backlit aspen trees also can produce fine results. Carefully position the camera so the sun peeks out from behind a tree trunk to create sunrays or a sunburst; the trees' translucent yellow leaves will literally glow. (Sunbursts are one of the best ways to take *any* photo to another level.)

STOCK VALUE: FORESTS

Forests are usually secondary subjects in the stock business, particularly when photographed as a giant still-life. Integrating elements like flowers, a stream, or a hiking trail often increases the photograph's value. Even in Colorado, which is known for its aspen, I sell relatively few aspen forests when they're not associated with a grand vista. Standing alone, they are often used as patterns and backdrops in advertising.

Undoubtedly, the most common forest backdrop I've seen over the years is composed of a wall of vibrant evergreen trees, filling the frame from edge to edge. Simple, but effective. I saw this photo advertised year after year in Direct Stock, and I can attest that these do sell. (See CD-ROM: Patterns > Forests > Forest1.jpg)

PHOTOGRAPHING STILL-LIFES, PATTERNS, AND BACKGROUNDS

I've already touched on some principles while discussing sand dunes, flowers, and forests. This is meant to broaden your horizons. A still-life is an arrangement of objects into a pleasing composition. There are two basic styles, and the one that's most effective largely depends on the marketplace. (See CD-ROM: Patterns)

Simple

One style is to make the pattern fairly homogeneous in color, shape, and contrast. You might rightfully ask, where's the subject? These have their greatest value in advertising and are often referred to as

background images. The image might then be ghosted (lightened and color reduced), so text and inset photos stand out even better. But simple doesn't mean easy. Photo buyers are knowledgeable, so quality matters. Remember that just because an image is used as a background doesn't mean it's not a valuable commercial stock photo.

White Sands National Monument, NM. April 13, 8:00 a.m.
The yucca and small cloud makes this a calendar or greeting card image. Without them, it's a commercial background or a pattern for use in advertising.

Complex

The second style is a more thoughtful arrangement of different elements and colors. It requires greater visual skill, because you're creating art using natural objects. These complex images have the most value as fine-art prints and calendar photos.

Preparation

There are a couple of ways to get started with either design. You might begin by looking for a piece of the landscape that already has a nice arrangement or pattern and spruce it up a bit, or you can start from scratch on an empty canvas. I'll describe the latter approach, since it will also highlight what's needed to enhance a naturally occurring still-life.

YOUR CANVAS

Ideally, choose a flat surface, because there's little depth of field when photographing close to the subject. Maximize depth of field by keeping the film plane parallel to the surface. A level surface keeps objects in place. Remove eyesores. You want it to look natural, only better. A 55mm macro lens is ideal, but not required. Use a tripod and establish the camera's position and the exact boundaries of your canvas. Natural still-lifes take time to design, so find a comfortable working position.

LOW-CONTRAST LIGHT

Low-contrast light on a cloudy day is ideal, but you can also work on a shaded slope. A cardboard fill card or a collapsible reflector can add light to the scene and also protect it from wind. Position the reflector opposite the sun, so it bounces the light back into the scene. A white fill card adds neutral light, whereas a gold reflector adds a warm light.

Autumn Leaves: A Classic Composition

My first still-life had yellow aspen leaves on a moss background. It looked good, but when I used it in a design, it proved troublesome. The green moss was dark, whereas the leaves were very light, creating a mottled look. I spent much effort trying to design around these dark areas. (See CD-ROM: Marketing > Print Media > Print_1.jpg)

My next attempt proved more successful, because I covered the area with carefully selected leaves. To make a leaf pattern like this, you must find healthy leaves that are similar in color. You'll want to intersperse some dried out leaves so it doesn't look too phony, but even these must look nice. Pay particular attention to all four borders. Since these pattern images often serve as a backdrop to photos and text, the edges are often the only part left showing. (See CD-ROM folder: Patterns > Leaves > Leaves2.jpg)

A homogeneous background can be the foundation for a fine-art still-life, created by carefully adding elements such as pinecones, rocks, or wood. Once you've captured the image, spray it with a 50/50 mixture of water and glycerin. If you've noticed frost in the mornings, choose a protected spot and compose a still-life at night, then return at first light. (See CD-ROM: Patterns > Leaves > Leaves3.jpg)

Water might be the single most important landscape subject we have. It's found everywhere in one form or another. As an icon, water represents life, vitality, serenity, change, danger, destruction—literally everything. Consider incorporating water in your imagery wherever you visit.

PHOTOGRAPHING REFLECTIONS, LAKES, AND CALM WATERS

Some of the most pleasing subjects to photograph are bodies of water of all sizes, especially when there's a great reflection. Reflections add color and a subject to what otherwise might be a gray void. Perhaps the most important consideration when location-scouting water is to determine exactly what's being reflected. It could be a mountain, but often it's the sky. If you remain in one place, a reflection doesn't change position through out the day. But if you move around, the reflection's position relative to objects in the water, like a fallen log, changes dramatically as the camera angle changes. (See CD-ROM: Reflections)

Bigger Isn't Better

When planning a trip or location scouting, it's worth finding water because, besides reflections, they often provide open views. However, keep an eye out for ponds and seasonal pools that don't make the map. The biggest misconception is it takes a large surface of water to capture a grand landscape. Not so—small pools will do the job. The key is getting close to the water. Small pools are also usually protected by the wind, and if disturbed, quickly settle. (See CD-ROM: Reflections > Colorado > Elk_Mtns.jpg)

TWO COMPOSITIONS

The biggest and most consistent mistake I see is having an important part of the reflected subject missing, such as having the summit cut-off by a partially submerged rock. Perhaps the photographer sees the reflection when scouting and doesn't appreciate how dramatically it shifts position when the camera is at a slightly different angle.

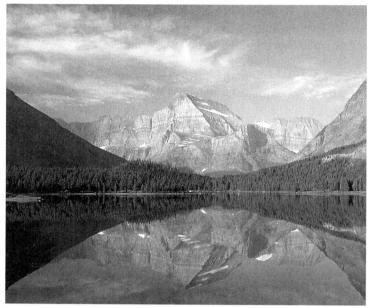

MT. GOULD (9,551 FT.) AND SWEETWATER LAKE IN GLACIER NATIONAL PARK, MT. JULY 26, 7:30 A.M.
Early morning is the best time to capture a reflection, especially on larger lakes. When it is windy, look for a small pool or protected cove.

Foreground

One way to take your reflection photos to a professional level is to incorporate foreground. You can frame a reflection with a protruding log or cattails along the shore. Determine which parts of the reflection must be seen and observe how they interact with foreground objects. Precise camera placement is critical, so use a tripod. Wind is frustrating; with a tripod you're ready to shoot when the reflection looks best. (See CD-ROM image: Reflections > Colorado > Sawatch2.jpg)

The reflective quality of water is especially useful at sunrise and sunset. For the best colors, point the camera toward the setting sun,

with the water in between. Foreground, like trees or seastacks, become dark when backlit, so incorporate recognizable shapes. (See CD-ROM folder: Reflections > Pacific Northwest > Ocean)

No Reflection

Not every body of water has a good reflection, or perhaps it's too windy—but you still have options. Don't photograph right at the shoreline, because a large colorless area will dominate your composition. Reduce the water's prominence. Find logs or rocks in the water that can act as subjects.

Better yet, pull back from the lake and incorporate foreground to act as a frame. A curving shoreline might be used to draw the viewer into the image or to show how the lake is nestled in its environment. You'll still show the lake, but you reduce its size and impact.

You might also position a tree or rock in front of the water. This technique is also used to deal with prominent shadows. The foreground tree hides much of the shadow or lake. Plus, the shadow or lake acts as a homogeneous background to accentuate the subject. (See CD-ROM: Reflections > Colorado > Indian_Peaks2.jpg; Reflections > Montana > Glacier9.jpg)

Coping with Wind

Understand local weather patterns. It's common to start the day with calm air. As things heat up, warm air rises and wind forms. That's why your chances of shooting a reflection at sunrise are better than at sunset. As mentioned, smaller bodies of water are more protected and settle down more quickly. Also, check the wind direction and find small alcoves, which may be sheltered by trees or a hill. Finally, use a tripod and wait for a lull.

Filters and Reflections

Polarizers can be used when photographing a reflection encompassed within a grander landscape, but be careful not to eliminate the reflection. Observe the polarizer's effect on the sky and reflection, while rotating the filter. Find a suitable compromise. Even without an obvious reflection, the water still reflects the sky. A beautiful blue sky yields aesthetically pleasing water. However, when you polarize the water, its surface becomes dark and lifeless. (See chapter 7 under Polarizing Filters)

When photographing reflections at sunrise and sunset, there's often considerable contrast range. For example, sunlit peaks may be very bright, compared to the reflection and its surroundings. Graduated neutral-density filters are used to compress this wide contrast range, but they have limitations. You can also bracket your exposures to make the best exposure for the highlights, and then the shadows. Afterwards, digitally combine the two best exposures into one file. (See chapter 7, under Graduated Filters and Digital Filters)

STOCK VALUE: REFLECTIONS AND WATER

Water in general is of exceptional value, and a reflection seems to add to any image. Those images with some cloudless sky provide a perfect background for designers. A grand landscape incorporating a beautiful reflection is particularly valuable for use in advertising, tourism publications, fine-art prints, and calendars. Reflections photographed as a pattern or still-life are useful for advertising and fine-art prints (For many classic locations, see CD-ROM: Reflections).

PHOTOGRAPHING SEASCAPES AND COASTLINES

Photographing seascapes is truly exhilarating. The crashing surf, coupled with fragrant salt air, makes for a sensory-filled experience. However, this environment needs to be taken seriously, because the potential for danger is the same as exploring rugged mountains or canyons. (See CD-ROM: Seascapes)

LOCATION SCOUTING: COASTLINES

I arrived in the Oregon coastal town of Bandon on a late afternoon in May. I didn't realize it at the time, but it's quite special for both its seascapes and its marine wildlife. Many of the classic photos of seastacks, the towering rock formations just offshore, are taken right from the town's beaches. From a large parking lot, I took a trail down through the cliffs, which served as a natural boundary to the summer cottages. What can I say—it was perfect. Pounding surf and a soft breeze filled with the scent of salt and marine life. There was a thin veil of clouds over the western horizon, so I picked up my pace. I anticipated a colorful sunset serving as a backdrop to the silhouetted seastacks. I learned a couple of lessons that night; fortunately it cost me only some money and a few scratches. (See CD-ROM: Seascapes > Oregon > Bandon1.jpg)

Mistake #1

I set up my view camera on the sandy beach, back a bit from the water's edge, and began working under the dark cloth at a frantic pace. Shooting into the setting sun with water in the foreground can yield a photo filled with outlandish color. I wanted as much foreground in the frame as possible, so I was constantly moving my tripod just ahead of the rising tide. At times like this, I get so focused that I'm not really able to stand back and take it all in. I just want to make sure I get the image and do not make any mistakes.

Before I knew it, the rising tide and a series of surge waves conspired to wash up over my open Lowe camera case. Fortunately, it floated. I've always protected my view camera lenses with color-coded, waterproof stuff sacks, so only one lens got drenched in a slurry of salt water and sand. I felt pretty bummed, but the sky was changing so fast I had time to worry only about the photography.

Mistake #2

At the end of any great shooting experience, exhilaration slowly turns to contentment and satisfaction—I can finally relax. After slowly packing up, I came to the cold realization that my return trip might not be so straightforward. I hoisted my water-laden pack and headed back. It was a short hike and I soon saw that my concern was well founded; my route was under water. At this point, the friendly beach turned to a jumble of rock headwalls, with a few tree trunks thrown in for good measure. Figuring it was just a few feet deep, I strapped my tripod to my pack and headed into the black water.

I've had my problems with water before and have a healthy respect for it, but it was late, dark, and I had only forty feet to go. Working my way through the barnacle-encrusted rocks, my lightweight shoes provided little protection. Just when I took a deep breath and figured I'd make it, an aberrant wave sent my foot off its tenuous perch and there I went, face forward into the water. Having an unwieldy, sixty-pound pack forcing me down and cold waves washing over me didn't help. It might as well have been a pit of squirming snakes, so rather than calmly standing up and cautiously proceeding, I ran hell bent toward the awaiting beach. Because of my rush of adrenaline, I didn't notice the beating I was taking against the gnarly rock. I just wanted to plow through and be done with it.

I'm not a natural in water, but I've survived my share of close calls over thirty years of solo travel in the outdoors. What I learned for the third or forth time is that moving water, while only two feet deep, has more than enough force to knock you over. If you're holding onto camera gear or have a heavy backpack, you're asking for trouble. Also, it's not one major blunder, but a series of mistakes that leads you step by step to most accidents (See chapter 12, Location Scouting Basics).

Tides

When shooting along the coast, the most pervasive phenomena are the tides. You must use local tide charts, because tides have enough variability that you can't predict the conditions with one. There are three generalities worth knowing. First, tides change about four to seven feet in depth from low to high tide; second, there are two low tides and two high tides each day; and third, the first high tide of the day occurs about fifty minutes later than the first high tide of the previous day. Tides are mostly caused by the gravitational pull of the moon, and the moon rises about fifty minutes later each day.

Unfortunately, there's some unpredictability. Strong onshore storm winds produce higher than normal tides by pushing more water onto the land. Local geographic features, such as an inlet, funnel water into a narrow area and will increase tides compared to surrounding beaches.

This means water levels are always changing, and these changes profoundly influence both the aesthetics of the scene and your location scouting. For instance, rocks that create a great composition at mid-tide might be completely submerged at high tide or surrounded by mud flats at low tide. Upon arrival at the coast, pick up a local tide table at a marina or visit a seashore park, which might have a schedule of the tides. (On the Internet try *www.tidesonline.com* or for greater detail *http://co-ops.nos.noaa.gov*)

LEARNING THE COASTLINE

In addition to scouting public parks, check road maps and topos for irregularities along the coastline. Standing at the end of a peninsula is akin to a climbing to a higher vantage point. It puts space between you and your subject, opening up the seascape. Photographing into a c-shaped harbor is also effective. (See CD-ROM: Composition > Frames > Frame7.jpg)

Like canyons, these points often let you photograph in different directions and at different times of day, so you're more productive. Many lighthouses are situated on points for the unobstructed view, like the Point Arena lighthouse on the northern California coast. (See CD-ROM: Seascapes > California > Northern Coast > Pt_Arena1.jpg)

On the coast, it's often very difficult to move between high and low ground. Many roads travel well above the shoreline, so check detailed topos and trail guides to learn where you might gain access to the shoreline. These might be parks, beaches, and established trails. Keep an eye out for crowded roadside pull-offs for trailheads.

When hiking along the shoreline, it's important to know if the tide is coming in or going out, so you can get back safely. Check the hide tide mark by looking for erosion or debris from previous high tides. Make sure you can safely hike above it. High water marks are also essential in determining whether rocks are exposed at higher tides and can be part of your composition.

Headwalls or Headlands

These are steep slopes and rocky outcrops that descend directly into the water, creating a potential hazard for someone trying to walk the shoreline. A headwall is deceptive because you can walk along its base at low tide. However, your route slowly disappears with the rising tide. Be sure to locate the trail around any headwall beforehand, particularly if the tide will be rising when you return. When tempted to wade, remember that the steep terrain creating the headwall often extends into deep water. It's a killer. (See CD-ROM: Seascapes > Washington > Rialto5.jpg)

Surge Waves

Besides dealing with slippery or barnacle-encrusted rocks, always be on the lookout for what are referred to as surge, sneaker, or rogue waves. Whatever you call them, they can spell disaster. These are a series of three to four waves that, for whatever reason, have grown to be larger than all the others and they can really catch you off guard.

Low Tide

Low tide gives you access to previously submerged rock outcrops, and also to tide pools where starfish and anemone seek refuge. As always, you need to be aware of the changing tides and be certain

to note any low spots in the terrain that might prematurely fill with water, leaving you stranded. Working on a rock outcrop just above the crashing surf is exciting, but risky business. Before you set up a tripod, it's prudent to see where the waves break upon the shore, then give yourself a healthy margin of safety from surge waves. (See CD-ROM: Seascapes > Washington > Rialto3.jpg and Rialto4.jpg)

Precipitation

Many coastal areas receive abundant rainfall, resulting in a coastline choked with vegetation. Roadside pull-offs often have a nondescript trail leading to the shore and emerging from a sea of green. If you explore up or down the shoreline, note the trailhead by building a rock cairn. It's also a good to keep track of your hiking time. Nothing's worse than returning from a hike and not knowing when you should be approaching the trailhead or seeing a familiar landmark. Bushwhacking through this vegetation is nearly impossible.

EXPLORING THE COAST'S HIGH GROUND

A higher perspective generally yields a much grander landscape, but scoping out these higher viewpoints needs to be taken seriously, especially when you're off trail. Coastal terrain can range from solid granite cliffs to undercut sandy bluffs. It's often a necessity to go right to the edge to eliminate unwanted foreground. However, hillsides often have a deep layer of spongy soil and knowing where terra firma ends and air begins isn't obvious. More than once my tripod leg has entered seemingly solid earth and exited into open space, so stay back from the edges of cliffs and bluffs.

From a high vantage point, try to find rocks or small islands that punctuate the vast open water, creating crashing surf. When you locate a view with potential, check the time, the sun's position, and a tide table. A shot of a lighthouse resting high and dry above a sea of mud isn't nearly as appealing as one withstanding the crashing waves of high tide. If you're considering returning in several days, keep in mind that identical tides will occur hours later. (See CD-ROM: Seascapes > California > Big Sur > Big-Sur5.jpg)

FOUR OCEAN COMPOSITIONS

Standing at the water's edge, the ocean stretches endlessly in front of you. However, when all you have is a sprawling body of water, you

have a boring photo. There are two hurdles to overcome when producing interesting seascapes. First, you must make its vast surface interesting by punctuating it with powerful waves, strategically positioned rocks, or stunning reflections. Second, you need to gain control over its infinite expanse by framing it with a beautiful sky, curving coastline, lighthouse, or a sculpted tree.

When shooting along the coast, you experience an ever-changing world because of the tides. Generally, you have your most photogenic opportunities at mid to higher tides, especially when the water level is rising. As the tide surges inland, it produces more powerful surf. However, shooting only during these tides is like photographing only during the golden light—severely limiting.

Nothing but Water

Although higher water levels tend to be more beautiful, they may not make the best images; if the surface covers all the rocks, it can look too homogeneous. One of the best ways to break the monotony is with white crashing waves. These stand in sharp contrast to the darker, calmer water. When photographing a grander seascape, waves forming long, white ribbons are the perfect filler. (See CD-ROM: Seascapes > Oregon > Brookings2.jpg)

A telephoto lens lets you isolate more powerful waves from a safe distance. Use a fast shutter speed (1/250 to 1/500 second) to freeze their form, otherwise larger water drops show as white streaks on film. Shoot along the shoreline to position the wave against a nice sky and accentuate its shape. A large aperture (f/5.6) helps isolate the wave by letting the background go soft, or out of focus. Remember, a wave is continually moving and changing shape; expose when the wave looks best and continually recheck focus. A monopod is helpful.

Another way to successfully incorporate a large expanse of water is to take advantage of its highly reflective surface. Calm seas under a rich blue sky reflect the sky's color, and the resulting blue water is far more appealing than gray. As with lakes, try shooting over the water and into the sun, particularly at sunrise or sunset. Its surface will reflect the sun and sky, filling the frame with color. Try to incorporate the sun as it moves out from behind a cloud or seastack to create a sunburst. (See CD-ROM image: Seascapes > Washington > Beach4.jpg)

Adding Subjects to the Water's Surface

Seastacks and rocks of all sizes are the most common subjects, because they're some of the few things that can withstand the incessant surf. Seastacks make great subjects by standing defiantly above the horizon. Plus, they can often be photographed throughout the day. I've found that, along the Pacific, seastacks can be photographed catching the morning sun or shrouded in fog. Later in the day, their towering stature gives you plenty of opportunity to make stunning sunbursts. At sunset, they produce powerful silhouettes.

Most often, we're left working with a humble collection of rocks, rather than the mighty seastack. One of the main objectives of location scouting along the coast is to find interesting features that are visible at higher tides and can punctuate the water's surface. Nothing shows the ocean's power better than when the unstoppable wave

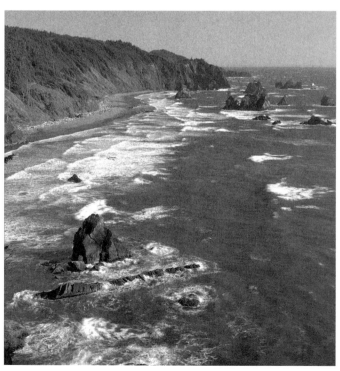

CAPE FUENTES, NEAR BROOKINGS, OR. MAY 27, 6:00 P.M.
A c-shaped coastline or point of land extending into the water help contain or frame the vast ocean. While rocks and waves make its surface more interesting.

meets immovable rock. It's literally a collision in nature. (See CD-ROM image: Seascapes > Oregon > Boardman3.jpg)

When there isn't any exciting surf, don't give up. Find water flowing over a rock and funneling through its cracks as it recedes. Use a slow shutter speed, a half second or longer, to give the water a molten look. Rocks are usually quite dark and the white water is well defined. If you're not getting enough excitement, find a rocky outcrop at the water's edge. Before you get too involved in your work, see how far the waves travel up the rocks and add a healthy margin of safety. (See CD-ROM: Seascapes > California > Northern Coast > Crescent1.jpg)

Framing the Vast Ocean

Many objects and geographic features can be used to help frame or reign in the ocean's endless nature or integrate it into its surroundings. You might use a curving coastline, pier, sea cliffs, shipwreck, or lighthouse. (See CD-ROM: Seascapes > Oregon > Oregon1.jpg)

Most objects are deposited at the splash zone (high-tide mark). Kelp isn't very photogenic, but there can also be massive tree trunks. By carefully choosing your camera angle, a tree trunk can be positioned diagonally to draw the viewer into the image. It can also be used to hide footprints.

On a grander scale, one of the best ways to frame the ocean is with the coastline; often nearby sea cliffs are perfect. Land that curves, such as a crescent-shaped bay, forms a perfect border. Also, positioning yourself at the end of a point or peninsula lets you photograph back toward the land. (See CD-ROM image: Seascapes > Oregon > Brookings1.jpg)

COASTAL SAND DUNES

You'll often find small sand dunes held in place by grass. These can change a forbidding seascape into one that feels tourist friendly. You don't need a large area to do the job; concentrate on finding a small, but powerful, foreground. Include the water, so there's a geographic reference. Use a wide-angle lens and get in close. Take the time to examine the strong lines of the sand ripples. See how they look as they radiate out from under the camera position or run diagonally across the frame. (See chapter 13 under Sand Dunes and CD-ROM: Sand Dunes)

COLOR

Many seascapes can be rather monochromatic and benefit from a splash of color. Grasses, rocky cliffs, flowers, buoys, marinas, and wind-sculpted trees are always a welcome accent or border along the bottom and sides of your image. (See CD-ROM image: Seascapes > California > Big Sur > Big-Sur3.jpg)

When the sky is overcast and you're fighting a preponderance of gray, see if you can find some overhanging evergreen branches to hide the sky, while also framing the water. On the other hand, when the sky comes to life, put it to good use. Whether the sky contains a beautiful sunset, or is a rich blue accented with cumulus clouds, it puts boundaries to the endless ocean and adds color to its surface. Avoid a drab ocean running seamlessly into a hazy sky. (See CD-ROM folder: Seascapes > Washington > Rialto1.jpg)

Tide Pools

Although low tide might be less photogenic, it's one of the most enjoyable times to visit the shoreline. You're given access to the inter-tidal zone, with terrain from sandy beaches and mudflats to rocky, rough slopes. When possible, start exploring when the tide is still going out; it's far more relaxing not to have to worry about a rising tide. When looking for marine life, you need to locate tide pools. These are best found on rocky but flatter terrain, where depressions a couple of feet deep provide refuge.

You'll often see very little at first glance, so give yourself a few minutes. Tide pools often come to life with sea anemone, nudibranchs, and crabs. When composing a seascape, get close using a wide-angle lens. This lets you to focus on the tide pool, while still including the surrounding surf or cliffs. Try to find something colorful, like a starfish. Use a polarizing filter to cut reflections for a clearer view. Keep the sun to your side, behind your outstretched arms.

STOCK VALUE: SEASCAPES AND COASTLINES

Seascapes, like mountains, have great value when you can personally market them to a local audience, and because national photo buyers search out the locals to supply photography.

Seascapes have wide use in every area of stock photography, from advertising to tourism publications to calendars. Upbeat imagery that makes the viewer want to visit is most valuable. The grand seascape will outsell more intimate compositions of tide pools, and a Pacific

seascape at sunset is a classic. To see an example of trends in advertising photography, one need look no further than the close-up image of a curling wave, like the ones the top surfers ride. I don't know of any image that was in such demand during the rise of the Internet. It was used repeatedly to symbolize this new wave of technology.

PHOTOGRAPHING STREAMS

When investigating a new area, such as Yosemite, it's natural to be drawn to its more prominent features, like Merced River. However when it comes to streams, I usually prefer smaller, more intimate settings. Potential streams often appear as nothing more than an anonymous blue squiggle on the topo maps, but they give you the opportunity to get off the beaten path and find something that's rarely photographed. Stream and waterfalls tend to be vertical forms, but make a conscious effort to photograph in the horizontal (landscape) format as well. (See CD-ROM: Streams; Waterfalls)

Principles of Stream Composition

When a stream or river is the main subject, I look for several things. Most of these techniques emphasize streams, but they also provide an approach to incorporating streams in grander vistas, and to waterfalls.

Smaller streams let you get close to and even in the water, while feeling relatively safe. This gives the viewer a sense of being part of the scene, not just observing. Smaller streams also tend to have clearer water. This is very important; it's almost a necessity. Murky water is not appealing, unless is has a reflection. Keep in mind that water is the critical element in these images, and people like to imagine sitting and enjoying the stream. They're not looking for a death-defying torrent.

Face uphill to open up and expand the foreground, particularly when shooting small waterfalls. Although I have nice images shooting directly across a stream, I've had little success photographing facing downstream. (See CD-ROM images: Streams > Streams Only > Stream7.jpg and Stream8.jpg)

Find s-shaped sections of the stream that wind through the scene. This dynamic element carries the viewer through the frame, like a road or a hiking trail. Look for curves and protrusions. These provide excellent vantage points, and give a feeling of being part of the water. (See CD-ROM images: Streams > Streams Only > Stream2.jpg and Stream9.jpg)

ATTRACTIVE SURROUNDINGS

Take a good, hard look at the surroundings, from the waterline to the background. Generally the greener and more lush the better. Try framing both sides of the stream with green vegetation, flowers, or sculpted rock. Avoid eroded hillsides, and when practical, remove dead branches and debris.

Roads and streams often go hand in hand, because they both follow the lay of the land. Roads and eroded slopes can be hidden from view by positioning vegetation or a large boulder in the foreground. Try a lower camera angle, right along the stream. Besides providing access, roads let in more light, which promotes vegetation, which in turn helps to hide the road.

Generally, the faster the water flows, the better it looks. However, what are really important are rocks and logs, which produce ripples and small waterfalls. Their white shapes give excitement and texture to the water. Without them, most water is dark, lifeless, pointless. In smaller streams, you can often add or reposition rocks to make little waterfalls. (See CD-ROM: Streams > Streams Only > Streams1.jpg)

LOW-CONTRAST LIGHTING

When it's overcast, head to the forest, especially a stream in the forest. The low light level lets you use a long shutter speed (1/2 second to 8 seconds), to capture water with a velvety or molten look. White clouds give a white, clean look to the water. To decrease the shutter speed, use a neutral-density or polarizing filter, but do *not* polarize the light, because it will eliminate the reflections in the water.

The Stream in the Grand Landscape

A stream as part of a grander landscape is a favorite photographic subject. Besides the beauty of the stream, the water spawns a diversity of plant life. Whenever I see a great background with a stream in the general vicinity, I start location scouting in earnest. I've walked many a mile searching for that one vantage point where a stream leads through a valley and to the base of a pointed peak. (See CD-ROM: Streams > Mountains; Streams > Canyons)

When the stream is an important element in a grand landscape, most of what works for an intimate stream still-life applies, including getting close to the water. The biggest difference is that it's better to

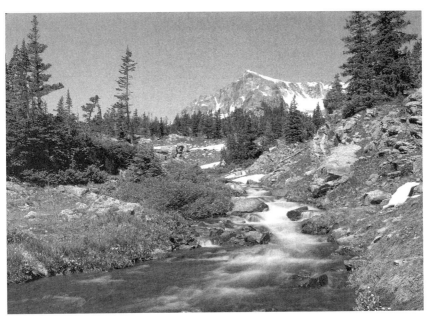

MT. NEVA (12,814 FT.), INDIAN PEAKS WILDERNESS AREA, CO. JULY 4, 9:30 A.M.
Try to position your camera so a winding stream leads to a pointed summit. A slow shutter speed yields a molten look to the water and helps define the stream.

photograph under sunnier skies, because this adds so much to the landscape. Also, experiment with a polarizer to decrease shutter speed.

PHOTOGRAPHING WATERFALLS

Waterfalls are open to many kinds of interpretation. They can be photographed as an intimate still-life and generally follow the same rules as photographing small streams. They can also contribute to a grander landscape. The nearby terrain is often steep and slippery, so you need to be careful. Use a normal to longer focal length lens for safety and to keep your gear dry. Yellowstone and Yosemite Falls are so powerful, you don't even think of getting close. While most waterfalls are much smaller, they still generate enough wind and spray that freezing the movement of nearby vegetation is difficult. (See CD-ROM: Waterfalls)

The Waterfall Still-life

These intimate compositions usually isolate a small portion of the falls and can be photographed wherever you have clear water

cascading over steep rock. Zoom lenses are ideal for perfecting your composition. Most are patterns created by the interaction of water and rocks. Like a stream still-life, these are best photographed under cloudy skies with long exposures. (See CD-ROM: Waterfalls > Oregon > Proxy2.jpg)

When a composition shows a considerable part of the waterfall, so it's not a close-up anymore, consider including the top, or start, of the waterfall, or the bottom where it forms a stream again. This adds a sense of place to the image and anchors it to one edge of the composition. It's analogous to a wall of tree trunks; it helps to have one end anchored in terra firma or coming to a conclusion by reaching the sky. Otherwise there's no start or finish, and the composition doesn't go anywhere; it's static. (See CD-ROM: Waterfalls > Colorado > American1.jpg)

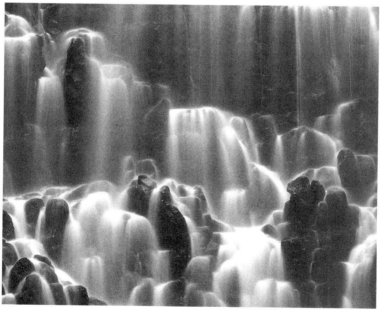

RAMONA FALLS, NEAR MT. HOOD, OR. JUNE 4.
Although best photographed under cloudy skies, waterfall images like this can also be shot early and late in the day, when they're in shade. Use a shutter speed of several seconds.

The Waterfall in the Grand Landscape

Waterfalls are much like a stream in a grand landscape, except they should be prominently displayed because they are so unique. Realize

that small changes in camera position dramatically affect the waterfall's relationship with the background. For instance, it's better to have the falls appear to originate from a pointed peak or jagged ridge than from an uninteresting slope.

As with most landscapes, try to photograph under sunny skies and take advantage of beautiful clouds. Emphasize the waterfall by getting close and using a wide-angle lens. You can fill the foreground with water and produce a dramatic perspective. When you must stand farther back, you'll notice that many waterfalls are rather long and skinny. Try to find a side view or a camera angle that positions the waterfall diagonally through the frame, rather than from top to bottom. (See CD-ROM images: Waterfalls > Colorado > American2.jpg and Longs_Peak1.jpg)

STOCK VALUE: STREAMS AND WATERFALLS

Water has such tremendous stock value, you should consider incorporating it, wherever you visit. A stream, waterfall, or lake strategically positioned in a grand landscape has the broadest appeal and hence the greatest value. Photographs with water are useful to both local and national markets, for advertising, book publishing, and tourism publications.

Generic images of a stream or a waterfall in a simpler setting, like a forest or meadow, have national appeal for advertising (think of ads for bottled water). Colorado buyers want the photo to say "Colorado": That means include mountains in your water images.

Photographing the Sky

The right sky can dramatically improve an image and might even stand alone to make a great picture. This chapter explains how to capture and incorporate the power of atmospheric events in your photo. Review chapter 3 (under Lighting) to understand how the sky affects the quality of light. Also keep in mind the rule of thirds. Usually the sky fills about one third of the composition. The more spectacular the sky, the more space it commands. (See CD-ROM: Skies)

PHOTOGRAPHING CLOUDS AND CLOUDLESS SKIES

Only the most outstanding clouds can stand by themselves to make a great image, but often the right clouds can turn a good picture into an extraordinary one. When you see a beautiful cloudscape, don't be fooled by thinking it will last long. All clouds move and change shape, and there's usually a perfect time to capture them: Good photographers get it right. Be familiar with the advantages and limitations of a polarizing filter (See chapter 7).

Clear, Blue Skies

"Blue skies sell" is the most useful phrase in stock photography. Rich blue skies aren't nearly as common as you'd like, even in the relatively dry West, so never take them for granted. They're beautiful and provide unlimited design possibilities.

Cumulus Clouds

Both mountains and big canyons can form cumulus clouds in the afternoon. These billowing clouds add great drama to a blue sky. They often

begin in clear skies and build to cover the entire sky in just a few hours. Try to expose when you feel the balance between blue sky and clouds is best. Even a little blue sky puts a positive spin to the image. Notice where their large shadows dot the landscape. Decide which parts of the photo are most important and wait until they are free of color-robbing shadows. (See CD-ROM: Canyons > Wyoming > Yellowstone2.jpg; Canyons > Grand Canyon > Toroweap > Toroweap3.jpg)

High Cirrus Clouds

These veil-like clouds can be a photographer's best friend. Cirrus clouds are beautiful and can produce spectacular sunsets. They sweep across vast expanses of sky, often providing a beautiful accent. Also, these translucent, wispy clouds reduce the contrast range just enough to take the sharp edge off shadows. This can be particularly important later in the day, when the inner canyon or a deep mountain valley is getting dark. (See CD-ROM: Skies > Skies and Clouds > Cirrus1.jpg)

Hazy Skies

One of the biggest disappointments is to wake-up to hazy skies caused by dust, forest fires, or distant power plants. Unfortunately, it's nearly impossible to figure out when all the muck will finally clear. Often your best option is to reduce the distance between you and your subject, and limit the amount of sky in the picture. Try a polarizer, or consider Photoshop to enhance or even drop in a new sky.

This is a good time to point the camera toward the sun (back-lighting), especially when it's low in the sky. Begin by looking for layers of interlapping canyon walls, ridges, or valleys. The mono-chromatic color and lack of detail produced by this type of lighting yields a mysterious feel. Use a zoom lens to quickly experiment with different compositions. Try a telephoto lens to compress or fore-shorten the view. (See CD-ROM: Canyons > Grand Canyon > South Rim > South_Rim5.jpg) Sunrays or a sun star can also do wonders for your composition.

Overcast Skies

Overcast skies are probably the least appreciated condition. Clouds scatter the light, eliminating shadows. It gives you the opportunity to photograph all day and in any direction. This alone can be an advan-tage. Although a vast gray sky offers little drama, include enough to

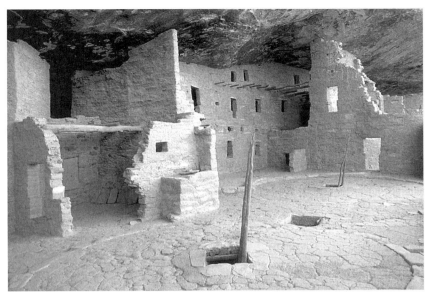

SPRUCE TREE HOUSE IN MESA VERDE NATIONAL PARK, SOUTHWEST CO.
Overcast skies produce low-contrast light and little shadow, perfect conditions to photograph inside an Anasazi dwelling or deep within a forest.

let viewers know they're seeing the whole view. It can always be cropped out later, but it's also useful for text or to inset other photos.

Get more intimate with nature by photographing a forest, a stream, or a still-life. Overcast skies are perfect for photographing every nook and cranny of a narrow canyon, natural patterns, still-lifes, or deep within a forest. Diffuse lighting is excellent for photographing people, because your subjects won't need sunglasses or hats, and wrinkles are less pronounced.

Lenticular Clouds
These long, lens-shaped clouds signal strong winds at high elevations in the near future. You can forget about reflections and your trip to the high country. The good news is the winds they herald can clean up hazy skies.

PHOTOGRAPHING FOG
Fog often adds a sense of mystery, but it's usually quite predictable. Warm air holds more moisture than cool air; as the moisture-laden air cools at night, fog develops. As morning warms up, the fog

dissipates. Anticipating this fleeting moment is the key, because it's often your best opportunity for a dynamic image. When photographing a redwood forest or a rugged coastline, fog imparts a melancholy feeling. Fog also strips the scene of most color, so look for powerful shapes to add impact. Placing a colorful or graphic subject in the foreground can help keep it from getting lost in the fog. (See CD-ROM: Fog)

It's always a treat to photograph a powerful mountain rising above a foggy valley and breaking into glorious sunlight. These short-lived circumstances make for unusual and uplifting images. (See CD-ROM: Fog > Fog9.jpg)

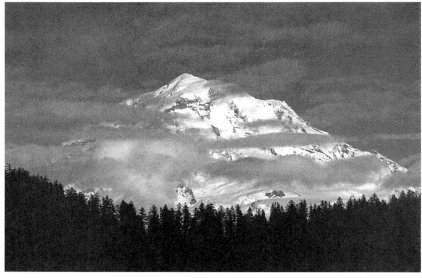

MT. RAINIER (14,410 FT.), WA. JUNE 12, 4:00 P.M.
Try to anticipate when the fog might lift. This fleeting moment will provide your best opportunity. Many mountains are only photogenic from one angle, but not the volcanic summits of the Cascade Mountains.

STOCK VALUE: FOG

Photo buyers prefer images that are colorful, upbeat, or inspirational. Even a fog-laden tourist town sells postcards showing the area bathed in sunlight. Homogeneous fog can cast a static and depressing pall over an image. Try to anticipate the dynamic moments when fog is forming or dissipating. Incorporate uplifting elements like a sunburst, a colorful foreground, or the beam of light from a lighthouse.

PHOTOGRAPHING MOONRISES AND MOONSETS

I never appreciated the complexity of incorporating the moon in an image until I tried to do it. When I was asked for such an image, I didn't have one, so I decided to rectify matters. (See CD-ROM: Moon)

It takes equal parts knowledge and luck to get a good moon image. Besides needing clear skies, the real difficulty comes when you want the moon in a certain part of the sky. The best solution may be to photograph a full moon under a variety of conditions, then add the most appropriate one using Photoshop. This would let you use one lens to photograph the landscape, then add a relatively large moon afterwards. A 300mm lens yields a nice size moon. (See chapter 9, under Suggested Exposures for Unusual Scenes)

Moon Facts

The full moon rises and sets opposite the sun; it sets at sunrise and rises at sunset. The moon also rises approximately fifty minutes later each day. There are only three days in the moon's twenty-eight day cycle when the moon looks full, but the lighting is usually best when it's the "official" full moon. To determine when a full moon will rise and set, check the weather page of the local newspaper. For more detailed moon information visit the U.S. Naval Observatory web site (*http://aa.usno.navy.mil*), then go to "Site Map." If that's too much to remember, use the link at *www.refdesk.com*. Times listed are for a flat horizon; a high foreground delays moonrise and hastens moonset.

A FULL MOON RISING AT SUNSET

The day before the official full moon is good (but not the best) because the landscape is still relatively light as the moon rises. On the day after the "official" full moon, the surroundings are often too dark because the sun set almost an hour earlier. Look for powerful silhouettes.

A FULL MOON SETTING AT SUNRISE

The moon looks full the day before it's officially full, but the surroundings are dark at sunrise, since the sun won't rise for nearly an hour. On the first day past the official full moon, the sky is often a very light blue, because the sun has been up for about an hour. The moon has less impact because there's little contrast between the moon and sky. (See CD-ROM: Moon > Moon3.jpg)

It's easier to photograph a moonset, because there's time to monitor its descent. The moon not only sets fairly quickly, it moves in an arc from the south to north as it sets. This can dramatically effect composition.

THE MOON AND THE FOUR SEASONS

The relationship between the moon and sun is inverse in another important way. When the sun is at it's farthest north in summer, the moon is farthest south. This constant change is dramatic, when trying to position the moon close to a specific landmark, so stay mobile.

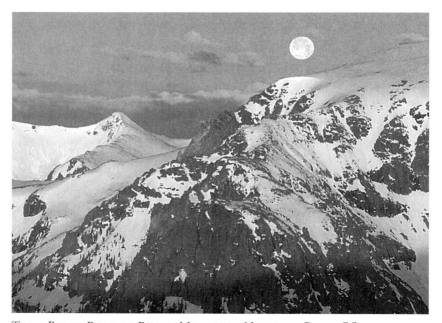

TRAIL RIDGE ROAD IN ROCKY MOUNTAIN NATIONAL PARK, CO.
JUNE 5, 6:20 A.M.
The full moon always sets at sunrise and is best photographed when it's officially full. The next day, the moon will set about fifty minutes later, the golden light will be gone, and the moon will blend into a much brighter sky.

Weather

Clouds are the biggest variable when photographing the moon. At moonset (sunrise), clouds to the west can hide the setting moon, whereas clouds to the east will cast a shadow on the landscape—either one ruins the shot. Ideally, you need clear skies to both the east and the west.

STOCK VALUE: MOONRISES AND MOONSETS

I get few requests for moons, but they're valuable calendar images when part of a strong composition. One asset is the nice lighting at that time of day. Experiment with Photoshop and offer the same great photo with and without a moon.

PHOTOGRAPHING RAINBOWS

Rainbows are magical, because even when conditions seem perfect, there's no guarantee. When one suddenly appears, it often fades as quickly. One of my most intense shooting experiences came while trying to photograph a rainbow. It was a June afternoon in Yosemite National Park. I was setup at Wawona Tunnel, a classic pull-off with a great view of the valley. I wasn't with the hoards at the parking lot—certainly a great vantage point—but a friend had told me about a better spot nearby. I hiked west along the rock slabs, away from the view. After a few hundred yards and one dicey stretch where you definitely don't want to slip, I came to a rocky outcrop with privacy and a perfect view.

I set up the view camera, but when the rain started, I was forced to cover it up and head back to the parking lot. Returning as the skies cleared, a rainbow slowly emerged. I was ecstatic and ready. I quickly exposed a sheet of film and then got under the dark cloth, just to double-check everything. No mistakes allowed.

Stepping away from the tripod, I heard a crash. All I saw was my tripod slowly sliding toward the edge of the cliff, then disappearing. I couldn't believe it. By the time I regained my composure and set up my 35mm gear, the rainbow was largely gone. I shot a few frames to remember the big one that got way. (See CD-ROM: Skies > Rainbows > Rainbow5.jpg)

Understanding Rainbows

The best way to capture rainbows is to know when and where they're likely to occur, then be on alert when conditions are right. Rainbows are the interaction of water drops and light. They form most commonly during scattered showers, when there's rain in one part of the sky and sunshine in another. A rainbow forms opposite the sun (more or less), with the viewer in the middle. The afternoon thundershowers common along Colorado's Front Range spawn many rainbows. The sun is to the west, the rainbow forms over the eastern plains, with the viewer in between.

POLARIZING FILTERS

A polarizing filter improves a rainbow's color and saturation. Look through the lens and rotate the filter, until the rainbows looks best. Warning: Polarizers can also eliminate the rainbow, so double check the polarizer's position after making any camera adjustments. For a proper exposure, just meter the scene as normally done.

Rainbow Compositions

Rainbows are so capricious, finding them is akin to being a tornado chaser. To increase your odds, visit open terrain during thunderstorms (but be careful!), stay mobile, and be ready to shoot.

A rainbow makes a powerful statement, so even simple, generic compositions are effective. Try to include some land to anchor the rainbow or frame the composition. This needn't be more than a rolling field, but avoid clutter like telephone poles. More complex compositions integrate a rainbow into a grand vista, like a mountain range. Both compositions have their value in certain markets.

Waterfalls with Rainbows

Rainbows are also associated with waterfalls that produce considerable spray. Since the water and the sun are predictable, so is the rainbow. For instance, a rainbow forms regularly at Yosemite's Bridalveil Fall. If you hope to get close, plan on protecting your gear from water. Otherwise consider using a long lens. (See CD-ROM: Rainbows > Rainbows3.jpg)

STOCK VALUE: RAINBOWS

The relative difficulty in capturing great rainbows makes them unique and very marketable. As an icon, a rainbow conveys good fortune, the storm is over, optimism, rejuvenation. As such, rainbows have broad advertising appeal, especially in clean, generic compositions that provide space for copy and inset photos. When a rainbow accentuates an already spectacular landscape, it's especially valuable for calendars, prints, and tourism publications.

PHOTOGRAPHING SUNRAYS AND SUNBURSTS

Sunrays, sunbursts, sun stars, whatever you call them, add a great accent. Seemingly you just point the camera into the sun, but several variables exist, so it takes some skill to get consistently pleasing results. (See CD-ROM: Sunrays)

Powerful Shapes

When pointing the camera into the sun, the scene becomes backlit and most objects become silhouetted. You can position the sun in the open sky, but this often produces uninspiring imagery, unless your subjects have powerful shapes—a solo hiker, a lighthouse, or a saguaro work fine. However, it's even more dramatic to have the sun peek out from behind something. Thinner objects produce considerable variety from one exposure to the next as the sun passes.

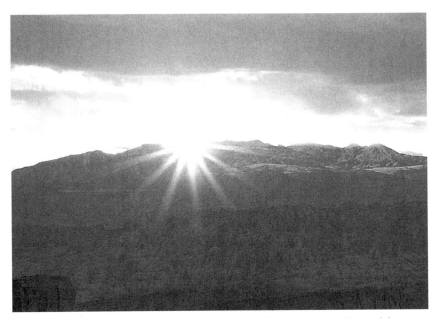

THE LA SAL MOUNTAINS VIEWED FROM DEAD HORSE STATE PARK, MOAB, UT. MARCH 15, 7:00 A.M.
Sunrays can turn an ordinary photo into an extraordinary one. Catch them as the sun moves from behind a cloud, ridge, tree, or hiker.

Translucent Subjects

In addition to graphic subjects, incorporate translucent subjects, which let some light through. Autumn leaves are excellent; they literally glow as the light beams through. The edge of a cloud often scatters the sun's rays dramatically.

Reflective Subjects and Foreground

A reflective or light-colored foreground is helpful, because it will still hold detail when backlit. Snow scenes feel warmer and friendlier

with a sunburst, while the snow's crystalline nature adds a sparkling touch. Try shaking fresh snow off a branch or experiment with icicles. Sunrays beaming across a lake add both color and a powerful shape. (See CD-ROM: Sunrays > Sunray9.jpg)

Lens Flair and Ghosting

Obtaining consistent sunbursts is somewhat unpredictable, because small changes in the sun's position and f/stop can be dramatic. Always use the camera's depth of field preview button. This stops down the lens, so you can preview the effect. Try different f/stops, such as from f/11 to f/22, because sunrays vary from one f/stop to another. Smaller apertures produce more concentrated sunrays.

Use a tripod and pivot the camera. Observe how the sunrays and internal reflections continually change. You'll also realize the sun moves quite quickly. Find a position that yields powerful sunrays and minimizes internal reflections, which are caused by light bouncing back and forth within the lens. (See CD-ROM: Sunrays > Sunray8.jpg)

Making Exposures

Point a reflective meter or in-camera meter to the side, not into, the sun. Meter neutral or mid-range objects, such as blue sky or gray rocks. Bracket your exposures, using apertures from f/11 to f/22. Quickly make a series of exposures, to minimize the effect of the sun's movement. An incident light meter, found on most handheld meters, is excellent for these conditions. (See chapter 9, under Successful Metering and Exposures)

STOCK VALUE: SUNRAYS

Sunrays are one of the best ways to add interest and value to an image, regardless of subject. They're valuable because they still aren't too common, and they can convey many ideas, including rebirth, energy, state of the art, excitement, revolutionary, warmth.

PHOTOGRAPHING SUNRISE AND SUNSET

There was a time when I thought sunrises and sunsets were the ultimate in landscape photography. Looking back, I've missed some great photos by putting too much emphasis on these. Don't get me wrong, I still anticipate what might materialize, but I think they're overrated, from a sales standpoint anyway. (See CD-ROM: Sunsets)

Understanding the Sun

Know where the sun rises and sets. Usually the best color is toward the sun, but it also depends on where the clouds are. As importantly, know when the sun sets. I remember photographing in Bryce Canyon in January, Utah's highest national park. I was nearing the end of a weeklong trip and hoped to catch a good sunset, but it was overcast, so I packed up my view camera and lumbered to the car.

As (bad) luck would have it, parts of sky finally began to turn red and orange. I hustled back to Yovimpa Point and tried to set up, but my tripod legs were completely immobile. During the tripod's stay in the car, snow had melted and seeped into its nooks and crannies. With the frigid temperatures, the legs quickly froze shut during the hike back. All I could do was watch—and no, I didn't enjoy it one bit.

I learned I had to know when the sun went down, then wait a half hour more. This leads to a lot of dark and lonely hikes, but it's the only way to feel confident that the sunset is over. For times, check a local newspaper or park guide. For detailed information, don't forget the Astronomical Applications Department at the U.S. Naval Observatory Web site (*http://aa.usno.navy.mil*). You can also use the link at *www.refdesk.com*.

This paid off during a trip to White Sands, New Mexico. I was far out in the dunes and I was anxious to head back to the road, but my watch told me to hang on. Soon, I was rewarded with an intense sunset and the rest is history. I learned something that night, too. There was a mere sliver of open sky separating the distant mountains and the overcast sky. This gave me my color and my moment of opportunity. (See CD-ROM: Sunsets > Sunset > Sunset4.jpg)

Compositions

A colorful sky by itself falls short of making a good photo. To really make a sunset complete, you need something else. This often becomes dark, so it should have some recognizable silhouette, like a rugged mountaion. In the desert, it could be a saguaro cactus. (See chapter 13, under Desert Sunsets, and CD-ROM: Deserts > Sunsets) To fill the frame with color, include some water in the foreground like a lake, stream, ocean, and even ice. Water is very reflective and becomes as colorful as the sky. Since colorful skies are so unpredictable, find locations that offer views in many directions, like mountain tops or ridges extending into canyons (points).

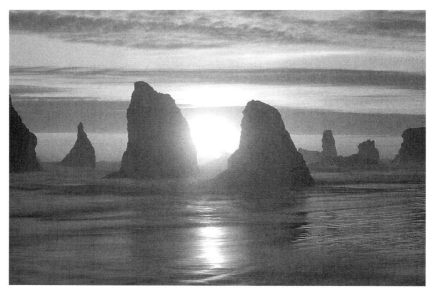

FACE ROCK OVERLOOK IN BANDON, OR. MAY 31, 9:30 P.M.
Photographing over water and into the setting sun is a sure way to increase color. Seastacks make good subjects because of their powerful silhouettes.

Colored Filters

I don't embellish most sunsets with colored filters. Partly, it's a matter of taste. I hate looking at phony, monochromatic images, whether they're sunsets or not. You can tell a real sunset, because it has a range of colors, starting with yellow nearest the sun and blending to reds, then purples. With technology today (Photoshop), there are better ways of doing things (See chapter 7, Filters).

Exposing for Sunsets

I make more exposures during sunsets than in most other situations. For starters, they're so unpredictable. The skies begin their colorful journey, so I click away. A little later, I think things look better, so I make more exposures, on and on. I've also learned there's not one perfect exposure. You can bracket by a half stop to a full stop around your correct exposure and still get different, but perfectly suitable, images.

To meter the light, point the camera's meter to a part of the sky with medium brightness. If pointed directly toward the sun, the meter "thinks" the entire scene brighter than it really is, and you'll

underexpose. When you meter the dark foreground, the meter gives a reading that turns the foreground into the equivalent of middle gray, and you'll overexpose the sky. (See chapter 9, under Successful Metering and Exposures)

STOCK VALUE: SUNRISES AND SUNSETS

As mentioned, vivid sunsets can be overrated, but they still sell, especially if the image has a sense of place or geographic identity. I've had my most success with the saguaro cactus, rugged mountains, and seastacks silhouetted against a colorful sky.

Photographing Agriculture

Heading from one great natural wonder to another, you often pass through agricultural land. Stopping can be a pleasant diversion, because you're usually the only photographer around and the locals are friendly. However, your chance of catching agricultural sights at their prime is unlikely, if your priorities are elsewhere. Since fields, orchards, etc., will certainly be at their best at specific times of year, it's best to concentrate your efforts in your own backyard, where you can easily keep your eye on the seasonal cycle. Agricultural photography offers diverse shooting and contains many of the subjects discussed elsewhere such as flowers, man-made structures, people, and skies. (See CD-ROM: Agriculture)

AGRICULTURAL COMPOSITIONS

Many agricultural subjects have powerful graphic elements, because crops are mechanically planted. The resulting rows and patterns can be positioned to draw the viewer into the picture. The crops are often beautiful; for instance, the rows of tulips found in the Pacific Northwest produce a tapestry of colors. Many farm structures are icons that are easily incorporated to convey a message or feeling.

A common characteristic is that crops are usually very homogeneous in height. Look for fields that slope uphill, this helps fill the frame with your subject. Then it's critical to find a perfect grouping of plants to place in the immediate foreground. Get in close with a wide angle lens.

Rows of plants often become a very important element. Straddle them, so they fan out in front of you toward the horizon. Shooting

169

at a right angle to the rows is less dramatic and produces a homo
geneous foreground, often desirable in commercial stock images.
Evaluate the background: A distant barn and silo are attractive,
whereas electrical lines are a distraction.

Don't ignore the sun's movements. When it's at a right angle to
the rows, you'll have pronounced shadows. Shadows can be a nice
graphic element, but don't let them be too dominant. When planning
an early morning shoot, make certain the sun isn't rising right behind
you, or you'll be working to avoid your own shadow during the best
light. (See CD-ROM: Agriculture > Wheat)

USING AGRICULTURAL ICONS

Once, I came across a classic agricultural landscape. It had the red
barn and a silo, all framed by a white fence. Undulating cornfields
enveloped it, while a blue sky topped it off. Unfortunately, it was
plastered to a wall in a Super Target. All the icons came together so
well; it was so idyllic that it must have been a designer's dream
farmscape coming to fruition through the masterful use of Photoshop.

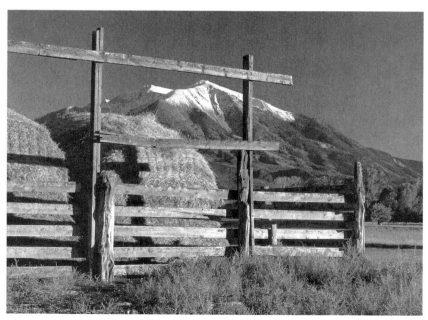

MT. SOPRIS (12,823 FT), CO. SEPTEMBER 15, 4:00 P.M.
*Farmscapes have powerful shapes and strong lines because of their structures and mechan-
ically planted crops. As with any landscape, location scout and return at the best time.*

In many ways, nature photographers are looking for an idealized state. Your imagery should transcend the obvious—"This is a field of corn"—and strive for greater universal appeal.

Key elements like barns, fences, and crops should generally be carefully evaluated. Over the years I've learned that rustic, old barns are good for calendars and postcards, but most advertising agencies want something more upbeat and positive. Ask yourself, "What message do some of the key elements send?"

Every element below can be used to present a positive or negative image. Incorporating an old weathered barn instead of one freshly painted conveys failure instead of prosperity. A great sky is uplifting, washed-out gray is a downer. What do you think the average photo buyer wants? Familiar icons are silos, farmhouses, hay bales, fences, windmills, barns, crops, livestock, and tractors. (See CD-ROM: Agriculture > Harvest)

Flowers

Flowers are colorful and commanding subjects in many agricultural photos. Yellow is probably the best color; it really pops on film. A field of sunflowers can't be more vivid, and the large blossoms make easy photography. Position one flower above the rest, to symbolize rising above the crowd. These are heavy flowers so bring wire, sticks, and garden shears. Canola also has vibrant yellow flowers, often spreading across hundreds of acres. (See CD-ROM folder: Agriculture > Misc.)

The Pacific Northwest, especially Oregon's Willamette and Washington's Skagit valleys are known for their multicolored tulip fields. Even common plants like goldenrods and dandelions can produce an enchanting scene. I've seen fields of weeds in calendars and in ads for allergy medications. (See chapter 16, under Three Basic Flower Compositions and CD-ROM: Flowers)

Pastoral Scenes

Successful farmscapes usually convey a sense of serenity, nostalgia. They often incorporate a dark blue sky with cumulus or high cirrus clouds. Icons tend to punctuate the scene, not dominate it. Golden light adds to the feel, but a beautiful sky can make shooting at midday very rewarding. Livestock is popular, such as horses and, to a lesser extent, cattle. Unlike wildlife, you don't want a cow filling the frame. They're often accents, not the subject. Still, make sure these animals are recognizable and avoid too many rear ends pointing at you.

Fences add a powerful element, and you often have considerable flexibility in positioning them in the composition. Diagonal lines are exciting and lead the viewer through the frame. Placing the fence straight across the bottom or side creates a nice frame or border, but it's usually better to angle it, so it doesn't feel static. Split-rail and white fences are classic styles, and are aesthetically better than barbed wire. (See CD-ROM: Agriculture > Misc. > Farm1.jpg)

Vineyards are now found in many states. The best known and perhaps most beautiful are in Napa and Sonoma counties, north of San Francisco. You can photograph rows of grapes radiating out from the foreground or undulating diagonally across the scene. Grapes are tall, so find a high vantage point and shoot down. Watch out for the wide furrows between the grapes: When in the immediate foreground, they can be prominent; don't have them filled with shadow.

WHEAT: A CASE STUDY

I'm fortunate to have photogenic fields of wheat nearby and I photograph them when conditions are just right. Wheat is also an important food and part of the American psyche, with familiar phrases like, "our nation's breadbasket" and "amber waves of grain." The example of wheat applies to many subjects, by demonstrating how to photograph a subject several ways, and how different images appeal to different markets.

Wheat: Two Compositions

I tend to shoot wheat two basic ways. One is generic, yet very graphic. I get real close to show the details of the wheat; a background overlapping fields blending to sky. Once I find the background, I search for the perfect foreground. I've been equally successful whether the wheat is vibrant green or harvest gold. (See CD-ROM: Agriculture > Wheat > Wheat3.jpg)

The second way is to give the photo a sense of place by including mountains. Again, I first look for a clean background with no housing developments, then I search for the perfect foreground. Location scouting beforehand is critical, so I can return and take advantage of the best conditions. When the distant mountains have snow, it's ideal. (See CD-ROM: Agriculture > Wheat > Wheat1.jpg)

I sell both compositions. The generic images are best for the national advertising market. When I add mountains, they're more

appropriate for tourism publications, calendars, and local companies conveying a Colorado identity. (Tip: If you want great wheat, check out the Palouse region in southeast Washington.)

A word of caution: The closest I've come to *almost* losing my gear was photographing wheat. I'd set down my gear and headed back for something. When I turned around, my pack and tripod were lost in a sea of green. The thought of riding shotgun on a combine during next month's harvest kept me looking for an hour.

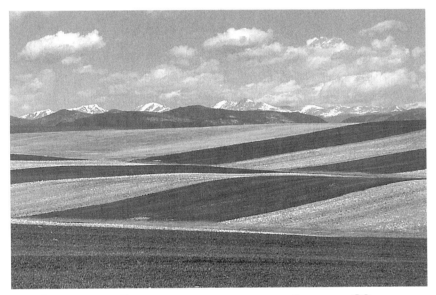

173

THE CONTINENTAL DIVIDE FORMS A BACKDROP TO BOULDER, CO. MAY 15, 9:00 A.M.
Many crops are rotated from year to year, so even local areas provide variety. Winter wheat is planted in alternating rows, every other year, creating unique patterns.

STOCK VALUE: AGRICULTURE

Photos that transcend the descriptive and attain universal appeal have far greater potential than those that don't. Don't try to document every crop in your area, but rather choose icons that define the area and have broader appeal. Today, organic foods are popular, but most are advertised by showing active, attractive people—icons of good health. Can you convey the same feeling with your imagery?

Agriculture will never be the darling of the photo world, but there are many large companies that use agricultural photographers

and photography. So you may be able to combine assignments and stock. There are stock agencies specializing in agriculture, and it also has a place in most general agencies.

The wine industry illustrates how photographers can exploit unique subjects, especially those close to home. I know a photographer making most of his income shooting wine-related imagery (wine and vine). Wine is a lifestyle for some people, and wine-related products include fine-art prints, books, magazines, calendars, postcards, and posters. For advertisers, wine is an icon conveying success and quality: If you enjoy a fine wine, you'll enjoy a European luxury sedan.

Photographing City Skylines and Roads 20

Ever since I began selling photography, I've had requests for landscape-related images. This gets into the realm of travel photography, so I'll discuss what's in greatest demand by photo buyers. The undisputed winner is the classic city skyline—a wall of high-rise buildings—that does not emphasize any specific building or dominant foreground. Other notable landmarks might be: the Capitol Building (or Washington, DC, in general), airports, famous bridges, the Statue of Liberty, sporting arenas, old New England churches, golf courses, lighthouses, or upscale tourist towns. (See CD-ROM: Man-Made)

SKYLINE LOCATION SCOUTING

Keep your eyes open for published skyline photos. These often form the backdrop to local TV newscasts, newspaper ads, and tourism brochures. Look for vantage points that provide an unobstructed view and public access—a big advantage. Usually you want a clean foreground or a higher perspective. Check out views from golf courses, parks, expanses of water, parking garages, building tops, hillsides, road overpasses, and sporting arenas.

Good vantage points often provide several compositions, so explore. The idea is to have everything figured out, then return under a variety of conditions and seasons. Keep your gear to a minimum and stay mobile. The fringe of downtown is often a less-than-safe neighborhood.

Landmarks

When a city is known for a specific landmark, incorporate it in the photo. This might be the Space Needle or Mt. Rainier in Seattle, or

175

San Francisco's Golden Gate Bridge. In Denver, it's a shot of downtown with the snow-covered Rocky Mountains as a backdrop. A fatal flaw is a towering construction crane, which can put a halt to shooting for months unless it can be removed in Photoshop.

FILTERS AND LIGHTING

Cities have been described as being canyon-like, and they are. One tall building in the wrong place can cast a shadow over much of downtown. Often it's best to have the sun rise or set behind you, more or less. Coupled with an open foreground, the wall of buildings will catch the nice morning or afternoon light.

Experiment with a polarizing filter and note its effect on buildings with a lot of glass. By cutting reflections, a building's glass surfaces often become ominously dark, instead of reflecting the sky. On the other hand, this darkening might help differentiate the building from a hazy sky.

Many beautiful images are taken at dawn and dusk. There's still color in the sky and the buildings' lights are on. Don't have it too

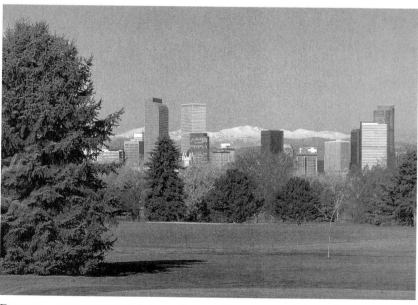

DENVER AND THE SNOW-CAPPED ROCKY MOUNTAINS. MAY 24, 8:00 A.M.
This is a classic city skyline. It's a valuable stock photograph because it has even lighting, a homogeneous green foreground, and blue sky. It can be cropped as a panorama or a skinny vertical.

dark—you want to see some detail in the buildings. Consider shooting these images in winter: By the time the sun finally sets in summer, most office lights are turned off. Here are two suggested exposures for city skylines: city skyline just after sunset, ISO 400 film, f/8 at 1/30 second; city skyline at night, ISO 400 film, f/8 for 3 seconds.

STOCK VALUE: CITY SKYLINES

Larger cities with vibrant downtown areas offer the most photographic and sales opportunity. I've sold many Denver skylines, but have had few requests for Denver's major sporting arenas or its international airport. This is partly because these photos can often be obtained for free from the building's owners or the chamber of commerce. I've also had little success with artsy photos, where the camera is pointed upward, emphasizing dramatic shapes, lines, and textures.

Most tourist towns obtain photos locally, for little or no money. Therefore, take photos with more universal appeal. I have a winter shot of the Clock Tower at the Vail Ski Area. Its holiday look is generic enough that it has sold for prints, greeting cards, calendars, and advertising. As I expected, though, it's never been sold to the Vail ski area. (See CD-ROM image: Man-Made > Misc. > Vail3.jpg)

PHOTOGRAPHING ROADS

I photograph roads the same way I do streams, hiking trails, or railroad tracks. I like to find interesting curves to carry you through the landscape, and long straight sections that lead off to infinity or to a prominent background. (See CD-ROM: Roads)

SAFETY

When you've been driving sixty mph, it takes time to slow down, even after your car stops. Take a few deep breaths and think safety. Be alert and consider wearing highly visible clothing. Most drivers don't expect to find someone out in the middle of the road. I've worked along deserted highways with clear views for miles, and it's rare when someone changes lanes to give you space. (Bicycle riders think this type of driving behavior is directed at them; it's directed at everyone.) While shooting along roads in national parks, it pays to be discreet. The very fact you have a camera prompts people to stop and get in your composition. When you want privacy, park away from where you'll be working.

THREE ROAD COMPOSITIONS

I break down road shots into three basic categories. You're either in the road, along its edge, or at a higher vantage point, with the road secondary to the landscape.

In the Road

When positioned in the middle of the road, try a wide-angle lens (24mm to 35mm); the painted lines will produce a dramatic perspective. Wide-angle lenses provide plenty of depth of field, so you can include the road's surface, background, and sky. They're also easy to handhold and get a sharp image. A zoom lens and motor drive are a big help to working fast. (See CD-ROM: Roads > Mountains > Aspen7.jpg)

As you get closer to the road, the foreground becomes more critical. Minimize cracks, oil stains, and remove litter. Yellow center-lines can become a major part of the photo, so carefully consider their placement in your composition. Over the years, I've come to believe that paved roads are more valuable as stock images than dirt roads, but it may be that they register much better in a photo, whereas dirt roads tend to blend into the surroundings. Emphasize a horizontal format. (See CD-ROM images: Roads > Deserts > Mounument010.jpg and Monument011.jpg)

Side of the Road

Shooting along the roadside can be a productive vantage point, but the edge needs something more photogenic than gravel and weeds. Use a normal lens (50mm) in order to put some distance between you and the immediate foreground. Positioning the camera along a sweeping curve can yield an especially dynamic composition. When photographing a tree-lined road, you must consider the trees' shadows. On bright sunny days, shadows often translate to distracting, black slashes. (See CD-ROM image: Roads > Mountains > Aspen6.jpg)

The High Perspective

Photos showing a road snaking through the landscape, as seen from a distant perch, are the most difficult to pull off, mostly because they usually take a lot of location scouting. Be careful not to let the road become too small or insignificant; it's supposed to be a "road" shot. You'll find such roads while driving up and down switchbacks, and at passes. (See CD-ROM: Roads > Deserts > Colorado5.jpg)

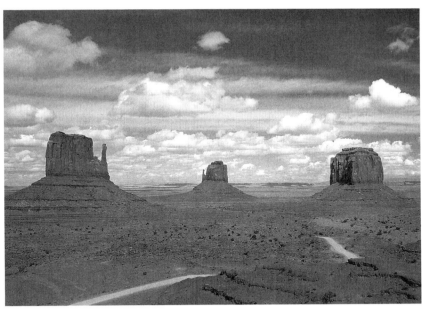

THE MITTENS AT THE ENTRANCE TO MONUMENT VALLEY NAVAJO TRIBAL
PARK, ARIZONA-UTAH. APRIL 17, 4:00 P.M.
Monument Valley is one of the best icons of the American West and one of the most
enjoyable to photograph. This winding road invites you into the image.

STOCK VALUE: ROADS

I began shooting roads for the same reason I photograph cityscapes—I was getting requests and I got tired of saying that I didn't have the shot. The stock value is fairly good for all three categories mentioned, but the road needs to be paired with a nice environment. Images should elicit a desire to hit the road and enjoy life. Look at a variety of road maps, atlases, travel guides, and automobile and gasoline advertisements. What you see is what sells.

Photographing Wildlife 21

When I began as a nature photographer I tried to do it all, but I gradually learned it took considerable commitment to produce quality wildlife photography. I still take advantage of opportunities when they present themselves, but I'm a capable, rather than a great, wildlife photographer. However, I do represent wildlife photographers and see plenty of work by aspiring wildlife photographers. Most of the latter is lacking, either on a photographic or a marketing level. Here are some pointers that will improve your chances to shoot better imagery and to sell what you shoot. (See CD-ROM: Wildlife)

GAIN YOUR SKILLS LOCALLY

Try to acquire your skills nearby. Birds are a favorite because they're colorful, display interesting behaviors, and are often easy to attract. Gardens can be planted to attract birds and other wildlife. Bird feeders can be positioned to utilize the best background and lighting. A bird feeder set in front of an evergreen has a colorful and homogeneous backdrop year round. Besides local parks, investigate botanical gardens and arboretums. Locally, we have the Butterfly Pavilion. (See CD-ROM images: Wildlife > Misc. > Spider1.jpg and Bird.jpg)

ANIMAL PORTRAITURE

As with people photography, facial expression and head position get top priority. When using telephoto lenses, depth of field is limited, so focus on the eyes. Use the camera's depth of field preview button. Carefully analyze the background, so branches and other animals don't conflict with your main subject. Forget the rear-end shots.

Anthropomorphize your animal subjects. Try depicting wildlife in a context that people can relate to. This might be a bird feeding her offspring or leading them to safety. These types of images say "family," no matter what the animal. An animal's facial expression can convey a human emotion. Who knows if dogs smile, but if you've got a photo of a dog that looks like it's smiling, you've got something.

Fill the Frame

Most wildlife photos fail because the animal is too far away. Unfortunately, getting close is easier said than done. It takes patience, perseverance, game parks, and an expensive telephoto and the skill to use it. When you can't fill the frame with your subject, fill it with something nice to look at. Try vegetation, spectacular scenery, nice lighting, or blue skies. Many of the wildlife photos I see are colorless. Let's face it, a mule deer foraging in a field of autumn grass *is* colorless, that's why it's so difficult. (See CD-ROM: Wildlife > Mule Deer > Deer3.jpg)

SHOOT THE STARS

Like images of famous places, the stars of the wildlife kingdom sell again and again. For North American wildlife, this means bull elk, deer, bears, wolves, mountain goats, and bald eagles; these always sell better than squirrels and robins. Not only are they physically more impressive, they're *icons* that convey power, competitiveness, wildness, independence, and survival. They're also large, so it's easier to fill the frame. This doesn't mean other animals won't sell, but you need to have much better-than-average photos to compete.

VISIT NATIONAL PARKS AND REFUGES

Many national parks are known for their wildlife, but you must visit when the animals are most photogenic and accessible. It's relatively easy to find wildlife in the parks; just look for the crowds along the road. Plus, these animals often allow photographers to approach relatively close. One frustration is that when you've been patient and the animals have become accustomed to you, it's not uncommon for fellow visitors to literally run past you to get a snapshot.

Today, wildlife photographers have to do more than find the animals. You have to find animals without various tags and markers.

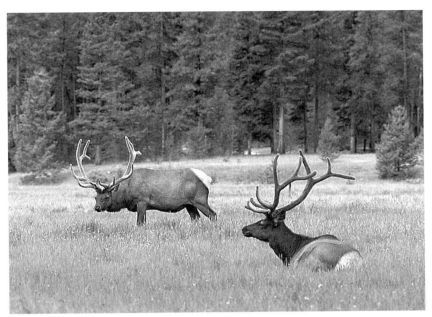

ROCKY MOUNTAIN NATIONAL PARK, CO. JULY 28.
Timing is everything, when it comes to capturing good nature photography. In mid-summer, elk (wapiti) look their best and so do the surroundings.

The mule deer in the foothills near my home often carry impressive racks accented with bright yellow ear tags. I had the good fortune to photograph the condors while hiking in the Grand Canyon; they also sport large tags. How wild is that?

A lot of wildlife photography is done in zoos and game parks, and some photo buyers expressly state not to send any of these photos. Still, these venues are worth considering—at the very least it's a good way to build your skills. Even a state with good wildlife is relatively limited in the diversity of species.

Network

Become involved with nonprofit organizations that may utilize your work, provide access to valuable areas, and give you the opportunity to meet fellow photographers. When in the field, talk to park rangers and other photographers, but, as always, have common sense and common courtesy. Park rangers are on the job and are probably stopped by hundreds of people a day; sometimes they can't spend several hours helping you find a deer.

Be Careful, Be Respectful

Wildlife can be dangerous, especially bears with their young or elk during the rut. When photographing during hunting season, consider wearing an orange hunter's vest (you may be forced to anyway) and use an orange stuff sack for your gear. Survival is difficult for all wildlife, so don't spook animals or disrupt feeding.

STOCK VALUE: WILDLIFE

Making a living as a nature photographer is tough, but wildlife photography is tougher. Besides the greater photographic challenges, there are fewer markets. For instance, there's always some demand for landscape photography from a variety of local companies. This is business I can go after—not so for wildlife. Even a wildlife-rich area like Yellowstone has only a few varieties of big-name animals. Ultimately, you'll have to photograph and market yourself on a national and even international level.

Could it be some budding photographers are given a false impression by what they see on television? Most photo-orientated nature shows concentrate on wildlife. With its interesting behaviors and exotic locales—it's perfect. By comparison, landscape photography is boring. However, if you're interested in making some money, your job is to constantly observe the printed media and note what you see being used. Then draw your own conclusions. If wildlife is your passion, you might consider film and video versus still photography.

Photographing People 22

I'm approaching photographing people from two angles. First, I'll give you tips on how to improve your outdoor photos of family and friends. Then I'll discuss what to consider, if you'd like to take people photography to a professional level.

PICTURES FOR FAMILY AND FRIENDS

Nothing brings back memories of a great trip better than a picture of you and your fellow travelers. It's even better when everyone looks good and you show some scenery. Most people don't really like having their picture taken. They put up with it because they're polite or they like the results. When you finally hand out the prints, everyone wants to see how they look. If *they* look good, it's a great photo. Generally, the more people in the photo, the more skill it takes.

Preparation

Nobody likes to be told to go stand somewhere and then be made to wait, while you figure out the composition or fiddle with the tripod. Few good photos are spontaneous, even those that look it. Give everyone some notice that you'd like to take a photo a little later. It's like alerting your kids that homework starts in ten minutes. Plus, it gives people a chance to look their best.

Determine beforehand where you'd like your subjects to be. Estimate their height and make sure important parts of the background are visible or hidden. Set up the tripod beforehand or note exactly where you'll stand. Then focus the camera and adjust the exposure. When you want someone in front of a certain view, they're

often restricted to a specific spot. This limits your options, especially regarding lighting, so I'm going to keep it simple.

Film

Landscape photographers use color-saturated and fine-grained film. These are overpowering when photographing people, especially regarding flesh tones. Use films neutral in color, rated ISO 100 or faster. These are better for flesh tones, and let you to handhold the camera and freeze motion. The graininess, if any, helps soften wrinkles. Color transparency (slide) film is standard for professional use, but not necessarily better for protraits.

BASIC COMPOSITIONS

After you're prepared, you can bring your subject(s) over. Begin by politely directing them where to go. Now, concentrate on making everyone looking good. If you're in the picture, make sure there's a spot for you.

The face is everything. Take off the sunglasses most of the time. This can be a problem with bright light, so allow some time for the eyes to adjust or take glasses off just before exposing. It's a toss up. Consider removing hats with visors; they're notorious for producing deep shadows right over the eyes. Remember, people want to see the face.

Women are especially concerned about their looks and weight, so give them top priority. Without going overboard, see that hair and clothing are arranged properly and that nothing looks peculiar. No antler-like branches growing from their head and no hip belts expanding the waistline. The more someone fills the frame, the more critical you need to be.

When everything is in place, give notice that your ready to expose and go for it. Always make several exposures; the larger the group, the more exposures. That way everyone can have a print in which *they* look good. After all, that's all that matters.

Several years ago, my family took a weeklong llama trip into a Colorado wilderness area. The one thing you don't do is let go of the llama's lead or rope: Lose the llama, lose your gear. As a safety precaution, we carried dried corn to entice the animal back, just in case. Well, when I saw the family photos, our hips resembled a chipmunk's stuffed cheeks, because our pockets were filled with corn.

Environmental Portraits

These images consist of two basic parts, the person and the surroundings. These images are more involved and can be viewed as a landscape, with someone as the all-important foreground subject. Your objective is to pose someone in an environment to convey something about the person. Instead of just saying, "I was here," the image conveys, "This is me." These are wonderful images on a personal level. However, when done a little differently, they have great commercial value. When the viewer wants to jump into the photo and be there, you've done your job.

Position subjects clustered around a rock, standing on a stairway, or sitting on a hillside. Although this requires some direction on your part, most people find this more comfortable and you won't end up with a police lineup.

Familiar objects, or props, are important. They not only tell part of the story, but also make people more relaxed. There's something to hide behind or someplace to put your hands. Props might be a backpack, a bicycle, or a railing. Generally use a normal to short telephoto lens (50 to 85mm). Use f/11, to keep everything in focus; use f/4 to make the background soft. Wide angle lenses are less flattering, especially when used close to your subject.

187

Lighting

Sunny days are great for landscapes, but the bright light is usually unflattering for people. Generally, stand further back to emphasize the landscape, not the faces. When a portrait is your goal, move into a shaded area for a tighter composition. Cloud cover is often the best compromise. Diffuse, low-contrast light is great for people, and the background remains clearly visible.

IMAGES FOR THE PROFESSIONAL PHOTO BUYER

Many of us want to make a living in the great outdoors, and photographing people is the most lucrative way to do it. High-quality images of people in nature are in great demand by magazines and advertising, and they command the most money. It's that simple. Categories include: lifestyles, recreation, leisure, travel, and adventure sports. This covers everything from a couple strolling in a park to climbing in the Himalayas.

I'll use my experience as a commercial photographer and stock-agency owner to provide insight into what it takes to shoot people

photography for the professional buyer. Photographers doing this kind of work usually get their start by photographing what they love. As they honed their skills, they diversified. They live in the mountains, so they start shooting mountain biking and hiking in the summer, then skiing and snowboarding in the winter. It's fun for awhile, but after a few years they figure out that magazines only pay so much and there are only a few to which they can send their photos.

Next, they begin shooting jobs for local businesses, while lining up stock agencies to represent their work. They eventually get more sophisticated and start designing photo shoots, using their best-looking friends and an occasional professional model. The scenes and concepts become more universal in appeal and involve artificial lighting, so they have greater demand in the advertising world. Their photography evolves to meet the ever-changing marketplace and trends. Below is some advice, if you decide to take the plunge into professional people photography.

Follow the Trends

Just as the national news has become info-tainment, the line between commercial (advertising) and editorial (magazine) photography has blended. Whatever the market, the photographer must constantly look at the style of photography being published, along with the fashions and props being used. I began subscribing to one of the major outdoor magazines about thirty years ago, and as the outdoors and adventure travel became mainstream, boy, have things changed. Today, the competition dictates that all photographs for publication have to be of the highest professional quality. There's no room for grab shots and photos showing "This is how I spent my summer vacation."

Realize that almost every cover photo is planned and virtually all people are models (or could be). Often, photos are so staged as to be ridiculous. I can't count how many times I've seen a tent right at the edge of a lake (often illegal) or a rocky cliff (dangerous), but it does make a cool shot. And of course, there are the beautiful people. Every major publication is owned and run by a corporation that does everything to follow what's trendy at the moment. If this news doesn't go down well, you may not have what it takes.

KEYWORDS

These are some words to keep in the back of your mind as you photo-graph people: active, dynamic, healthy, participating, accomplishment,

adventure, attainable, upbeat, upscale, affluent, success, enjoyment, solitude, dreams, fantasy, good looking, minorities, diversity, women, children, seniors.

Photographic Style

Just like fashion, photographic styles change. For a number of years, the demand has been to get close, be part of the action, the dynamic look. The photographer uses a wide-angle lens to dramatize the perspective and give the image an edge. Many "X-Game" sports have gone to an extreme and often very dangerous level. The photographers have pulled back a little; they have to. I mean, how close can you get when someone is trying a double back flip on a bike?

The photography found in ski magazines is far more traditional than what is seen in snowboarding magazines. The demographics dictate this. Currently, ski mags are for the stodgy parents, and the boarding magazines are for the radical kids, 70 percent of whom are young males. But even now, the original snowboarders are becoming parents, so maybe the more things change, the more they stay the same. Successful shooters will sense this change and be ahead of the curve.

WHAT DOESN'T SELL

Pictures of a photographer crouched behind the tripod. Lone tents in front of a great scene, unless they're illuminated at night. Your significant other (unless you're very lucky). People far off in the distance, usually referred to as "little people, big landscape." Don't be afraid to get in close.

MODELS

Not everyone has what it takes to be in pictures. As a rule, models (the talent) have to be photogenic and healthy. Be honest now, if you're considering your kids, friends, or significant other. I've stressed the importance of visiting a beautiful landscape when it's at its best, because producing good photography is so much easier. It's the same with people; good-looking people are much easier to photograph.

I don't know if we'll ever get tired of looking at blue-eyed blonds, but the astute stock photographer always has one eye on the shifting demographics. The current trend is to fill the growing need for minorities, especially Hispanics, and if you're designing a photo shoot, the more diversity the better.

WARDROBE AND PROPS

Everyone must be appropriately dressed and look the part. Carefully evaluate the wardrobe and related gear (props). Your photography must stand up to the scrutiny of an educated viewer. Have outfits and colors that can be readily mixed and matched, with and without jackets. The photo shoot will yield far more variety.

Success requires insight, so you must devour the media. Remember, it might take a year to get new photos into the pipeline, and you're fronting the money. Examples: Sunglasses do little to enhance a nice face and make it difficult to connect with people. Advertisers want to connect. Take helmets. Today it's irresponsible, even old-fashioned, to show snow-riders, bikers, and climbers without helmets. The same is true for trekking poles. Once unheard of, now common. Do you care enough about getting the details right to produce marketable imagery?

Two Basic Markets

Things get a bit sticky when it comes to manufactures' names and logos. Most magazines want very current photography and their readers expect to see a certain number of labels. Not only are labels difficult to avoid, but today, they're often integral to being accepted into a particular lifestyle.

Advertising is a different matter. Do your best to use quality, but timeless, fashions without designer labels and obvious brands. This is getting tougher all the time, but a company understandably won't use a picture of people wearing another company's logo.

MODEL RELEASES

Every recognizable person in the photo must sign a model release. This is a written statement that gives the photographer the right to license particular images of the person signing the release. This is why most photos you see are staged. I realize that model releases are not needed for most editorial uses, but some magazines still want them. Let's face it, not everyone wants to be photographed without permission, just so you can try to make some money. Plus, there are only so many editorial markets, and if you don't wise up to this sooner than later, you'll fail. Remember, you need to carefully build your stock files for a broad range of commercial uses. (See CD-ROM: Marketing > Forms > Model Release.jpg and Property Release.jpg)

PHOTO EQUIPMENT

I'm not attempting to do much more than open your eyes to what it takes. Don't come from the point of view that you're outdoors and you'll just throw someone into the photo. Think of doing a portrait or fashion shoot, but you just happen to be outside.

Plan to invest in basic lighting equipment, such as an electronic flash unit. This provides some control over the fickle ambient light, very important when models are involved. High-quality artificial lighting will definitely extend and enhance your abilities. A professional on-camera electronic flash unit is essential. You might also consider the more powerful, but less portable, flash systems incorporating battery-operated power packs and flash heads. You'll need to become familiar with light modifiers such as fill cards, reflectors, diffusion material, colored gels, umbrellas, and soft boxes. If you really want to learn your craft and move to another level, study the art of people photography and consider a stint as a photographer's assistant.

STOCK VALUE: PEOPLE

High-quality people photography has the highest initial stock value, but most eventually becomes dated and therefore worthless. Photos incorporating trendy clothes, current hairstyles, or state-of-the-art equipment are at the greatest risk. Look at how cell phones have morphed. The same marketing concepts addressed in nature photography apply here. To succeed, you need to shoot in your own backyard, go generic, think icons, be universal, be timeless.

Example: A healthy couple strolling through a nearby, natural setting will be more successful, both in editorial and advertising, than a couple hiking an exotic mountain trail. First of all, shooting close to home should produce better images, because you're more likely to be able to photograph when conditions are best, and also use a variety of props.

Far more people can relate to a pleasant walk than to hiking in what might be perceived as distant or dangerous mountains. You want to elicit "That's me," and not, "I could never do that." Universal appeal is particularly valuable; an image can be marketed to national and international photo buyers via a good stock agency.

Granted, when a hiking photo includes a specific geographic landmark, it has a clear sense of place and can often best satisfy the

local audience. But ask yourself, what are the odds of a national magazine contacting you for a specific location that you just happen to have? It takes awhile to build such complete files. Remember, stock photography is a game of probability, so shoot the odds and look for generic, universal subjects and locations.

The Business of Selling Your Photography

Photography Business Basics 23

Photographers want to publish their work for different reasons. Some look forward to the sense of accomplishment or validation that comes with seeing their images being used. Others dream of making it a full-time career or hope the extra income helps out at retirement. Throughout the book I've suggested not only how to take better photographs, but what to consider if you plan on selling them. A beautiful image isn't necessarily a valuable stock photo, and not all good stock photos are suited to all markets. There used to be a well-respected stock agency filled with artsy and cutting-edge imagery. It eventually became known for having the best photos that never sold. Shoot what the buyers want.

Most photographers would love to be able to photograph full time, send their images to a stock photo agency, and wait for the checks to roll in. There are a few old-timers in this enviable position, but most successful nature photographers are true entrepreneurs with many irons in the fire. Over the years they've cultivated several avenues for marketing their work, while always keeping an eye out for new opportunities. One of the best ways to learn what photos sell, and to find new outlets, is to become acutely aware of how photography is used. When the new calendars come out in fall, note which companies might need your photography. When there's a newspaper story about who was awarded the state's tourism account, get the name of the ad agency.

BE YOUR OWN STOCK PHOTO AGENCY

Do you ever get a piece of junk mail or a brochure and wonder, "How do I sell my photos to these companies?" These images are

most commonly licensed through a stock photo agency. No matter what your goal, it's time to understand some of the basics about stock photography and running a stock photo business. Most nature photographers will benefit tremendously by viewing themselves as a stock photo agency, right from the beginning.

Most stock agencies go after the vast advertising and commercial market, because it's more lucrative, but they're structured in a way to sell to virtually every market. Envision your stock photo agency as an umbrella, under which you have the various markets and clients you pursue, such as ad agencies, art galleries, magazines, and calendar companies. Your stock photo agency is really a way of organizing your photo business, so you can effectively sell your images to many markets.

ORGANIZING YOUR PHOTOGRAPHY AND YOUR STOCK BUSINESS

Your photography is your business; without it you have nothing. One of your first steps is to organize your imagery, but now it's serious. You're not only organizing, you're taking inventory and looking for your best images—treasure these. At the beginning, you'll use them time and again for your Web site, a portfolio to send an art gallery, or a promotional piece like a postcard. Later, they may sell over and over. (For this discussion, I am using the word "image" to mean both film and digital files)

Before computers and image-management software, the most common way for nature photographers to organize their slides was to arrange them alphabetically, using a combination of geography and subjects. For instance, you begin by state, then go to specific locations, specific features, and specific seasons, thus: Colorado > Rocky Mountain National Park > Longs Peak > Winter. Photos that are best described by subject are under headings like "Wildlife > Elk" or "Flowers > Alpine." It takes some familiarity with the files to use this system.

Image-Management Software

The intuitive method just described still works quite well up to a point, so don't abandon it on a lark. It's risky investing in image-management software, at least until you get a better feel as to where your business is going. For instance, if you're a fine-art or large-format landscape photographer (4×5 inch view camera), you won't

produce nearly the volume of imagery as a travel photographer. Besides the expense, it takes considerable time to learn the software and enter the data. If the software calls for a thumbnail, or small reference image, every image must be scanned. If your business changes or you find a better program, it may be difficult to seamlessly transfer your data or reconfigure the software.

With that said, if you keep on shooting, eventually you won't be able to keep track of your imagery, and it will be completely impossible for anyone to help you. I know, I've been there. Unfortunately this subject is a tough one, because ideally you want to accomplish two different things at once. Job one—you want to be able to locate every appropriate image, send it out, and then refile it. Job two— you'd like to take some of this data and capability and put it on your Web site for photo buyers to use.

Begin by investigating Photoshop and its companion, ImageReady. These two programs, while not image-management software per se, provide considerable power to do a broad range of tasks. You can design pages for many multimedia applications, which can then be optimized for the Web. ImageReady's Web Photo Command can automatically generate a photo gallery from a collection of images, which can then be placed on your Web site or a CD-ROM. (This is how this book's companion CD-ROM was designed.)

Dedicated image-management software programs include Extensis Portfolio (*www.extensis.com*) and S4 Media (*www.fotoshowpro.com*), and HindSight's StockView software (*www.HSLtd.us*). HindSight has a long history, by hi-tech standards anyway, of producing quality software specifically for photographers and creatives. Visit the Web site, *www.GraphicsSoft.about.com*. It's a Web network, or portal, that has numerous links to software products for slide shows and photo viewers.

Keywords

Keywords form the foundation of most image-management software. Here, every image is given a unique ID number, and then is filed by this number, not necessarily grouped with similar photos. After you assign an ID number, you attach or link descriptive keywords to locate it. For example, image ID # CO-3434 might have these keywords linked to it: Colorado, mountain, lake, Dream Lake, snow, flowers, evergreen trees. You find photos by searching for keywords associated with that photo.

Once you've found the appropriate images, a delivery memo is printed with photo ID numbers and captions. When the film is returned, scanning the bar code updates the delivery memo and your database. This is a great way to track film, especially large submissions to calendar companies or stock agencies. When a thumbnail is linked to each ID number, a selection can be sent to a client via e-mail for review. This is often referred to as a lightbox. You might also search your database for the client. Then tag appropriate images with a special keyword. The client then uses this keyword to view a customized selection.

LIMITATIONS AND PITFALLS OF KEYWORDING

Keywording isn't perfect, but it gets the job done. Most limitations become apparent when your files are placed online or made available for use by the photo buyer. Many photographers stretch the truth when it comes to keywording by using too many keywords, in an attempt to increase the chance that someone will find the photo.

You may be tempted to use this strategy when your work is on a group Web site, where you compete against other photographers' images. If someone is searching for a "mountain," they're likely to pull up "mountain bikes," a close-up of "mountain flowers," and a "mountain of money." You must standardize on exact keywords because the buyer may not find all your "National Park" photos if the keyword is actually "National Parks" or it's misspelled. This is often circumvented by providing a list of keywords to select.

Many photographers show prospective photo buyers too much photography by placing their entire library on their Web site. You may want to catalog every image and its variations for your master files, but this is too much unedited imagery for any photo buyer to wade through. Are you really that good? Your Web site should show your better and best photography. Remember, established stock agencies (your competition) are very discriminating when selecting new images from their photographers, and even more editing might be done before an image makes it online.

Subject Lists and E-mail

When you don't show all your imagery, consider using a subject list or index to describe images not shown. For instance, photos from a state park may not be worthy of a place on your Web site, but they could be valuable to a magazine needing a specific location. Invite

interested photo buyers to phone or e-mail you if they aren't finding what they want. Mention that you're likely to have similar images and new imagery that may be appropriate. Making contact with potential photo buyers is valuable. At the very least, collect worthwhile e-mail addresses into a folder for future use.

Databases

Next to your photography, your clients and contacts are what make your business go. Even if you don't invest in image-management software, you must keep track of prospective clients from the beginning, and work hard at expanding and updating this list. I call it my "mailing list." I've been tending to it for fifteen years, and there's not another one like it anywhere. Now, I also collect e-mail addresses, another valuable bit of information that helps me stay in business.

General programs are Macintosh AppleWorks and Microsoft Excel. Your computer database is used to generate invoices, delivery memos, professional correspondence, but most importantly, it helps with direct mail and e-mail ad campaigns. You'll be able to select certain kinds of information or fields. This lets you send out specialized mailings. For example, you may send out one yearly mailing to calendar companies to request their submission guidelines, and another mailing to ad agencies. Be sure to update your database when any promotional pieces are returned. See HindSight's InView (*www.HSLtd.us*). It also has appropriate invoices and delivery memos.

Captioning Software

This is designed to print your name, caption, and copyright information on labels, particularly those sized for 35 mm slides. Even if your images don't have unique photo ID numbers, most people want to see your name and a meaningful caption. It's an inexpensive, yet invaluable, program that also makes it easy to plaster your name on every piece of gear you own. Try HindSight's Caption Writer.

Pricing Aids

Prices and usage fees are so varied, yet so important, that I've included my ideas about them throughout the rest of this book. I present traditional pricing structures and industry standards when I discuss the different markets such as adverting, calendars, and magazines.

There are software programs and books designed to help photographers determine the usage fees for their photography. By selecting various categories and answering a few questions, the software or book recommends a usage fee, usually given as a range from low to high. These can be very helpful, especially for the less experienced. However, I'm not sure if they ask the most important question, "Who's on the other end of the phone?" I mean, if I get two different calls for the same photo and similar usage, I'm likely to quote two different usage fees.

Let's say it's a landscape of the Colorado mountains with fall aspen trees. I assume a graphic designer in Denver thinks he can get this photo anywhere and it's nothing special. Translation: lower price. Whereas I believe a New York City ad agency perceives this image as unique and expects to pay more, so I ask for more. Don't forget to ask your fellow photographers. Take a look at HindSight's Photo Price Guide (*www.HSLtd.us*) and Cradoc's FotoQuote (*www. fotoquote.com*). (Also see Networking and Partnerships toward the end of this chapter.)

200

Image-Manipulation Software

Adobe Photoshop is the undisputed champ; there's really no professional alternative. The good news is that it's a great product and everyone in the business has standardized to it. I deliver the vast majority of our agency's scans in a relatively unaltered state. This mean you don't have to be a Photoshop expert. Leave that to the designers. However you still need to know the basics, so you can remove dust, sharpen, resize, and adjust color balance and brightness.

Photoshop now includes ImageReady, a powerful tool to optimize your photo files for the Web. It also creates photo galleries for the Web. Viable alternatives that will do most of what you'll ever need are Corel's PhotoPaint (*www.corel.com*) and Ulead's Photo Impact 7, which also helps create Web sites (*www.ulead.com*).

Computer Hardware

The basics consist of a computer, printer, film scanner, and CD burner. When you shoot with a digital camera, you'll probably want a laptop. There are two basic operating systems, or platforms: Mac (Apple) and PC (Windows). At one time, the choice was obvious; if you were in the advertising or graphic arts professions, you went with a Mac. That's not so true anymore. I'm comfortable with both

systems, and believe you'll experience less headaches and hassles working on a Mac. However, I'm not convinced Macs are worth the extra money, or worth the hassle of putting up with limited software options.

Most importantly, make sure your computer has enough speed (MHz) and memory (hard drive and RAM) to handle relatively large photo files; 20 to 30 MB (Megabytes) *per photo* are common, and 70 Mb files are by no means rare. A film scanner is one of your best investments. Fortunately, 35mm slide scanners with 4,000 dpi resolution are moderately priced and meet virtually all of your imaging needs.

IMAGE FULFILLMENT: FILM AND DIGITAL

Sending photography nearly always meant sending color transparency film, and this remains true for calendars and some other publishers. However, digital fulfillment has arrived in most other markets, unless an extremely large file size is needed, or the user wants to ensure the highest quality. In the sections on specific markets, such as stock photo agencies, ad agencies, and magazines, I discuss the details of sending imagery.

Sending Film

Imagine receiving hundreds of pieces of film and having to keep it organized and safe, all under the threat of having to pay for lost or damaged film. (This is one reason why the photo-buying world has embraced digital.) Each piece of film must have a label with a unique photo ID number and caption. A second label has your copyright notice (Copyright © John Kieffer 2004), plus return address, and phone number. It's a good idea to place each 35mm slide in an individual slide sleeve, put on another label, and tape it shut. This protects your film and might limit unauthorized use. If someone takes off the tape to get the film, they'll ruin the label.

The best way you can help everyone is by sending organized submissions, with a complete delivery memo. Be sure to reference anyone you've contacted, and why you're sending the images, for example "Requested by Jane Smith for the 2006 calendars." Provide a total count for each format of film and a grand total count. This is where image-management software really pays its way.

For shipment, most commercial users will provide their Federal Express number to ensure prompt and safe shipping. Calendar

companies, on the other hand, usually insist you pay the freight, possibly both ways. Having a Fed Ex account number is critical, and the "Express Saver" rate (three days) is quite affordable if you're picking up the tab. You can also use the postal service, but registered mail and packages weighing over one pound mean you need to go to the post office—a big hassle.

Digital Fulfillment

Generally, there are two reasons to send digital images or files. A potential buyer may have called or e-mailed a list of photo needs. You can e-mail a submission to the client. These should be low-resolution JPEG images. The small file size makes them easy to send and relatively worthless to steal (you hope). As mentioned, some image-management software can make digital submissions an easy process. (See CD-ROM: Marketing > Local > G_of _Gods3.jpg)

The second reason is when someone has purchased the rights to an image and she needs to receive (download) a high-resolution file. When files exceed about 1 MB, upload the file to your Web site using File Transfer Protocol (FTP) instead of e-mail. Afterwards, send an e-mail to the client stating the file is ready, plus an invoice. It might be more practical to burn larger files to a CD-ROM and ship that to the client.

BOOKKEEPING

Keeping accurate records is an integral part of any business, and with a little preparation, it's a fairly simple task. Most of your bookkeeping chores are related to spending money (expenses) and making money (income). When income exceeds expenses, you've made a profit. One of the best ways to make a profit is to take advantage of all valid expenses. There are many business expenses for a professional photographer and those working hard to be, but if you plan on taking them as tax deductions, it's time to get a professional tax adviser. With that said, here's my two-cents worth.

To show the IRS that you are indeed trying to be a professional, you should act like one. This means making a concerted effort to sell your photography, keeping accurate records, and generally functioning in a business-like manner. Begin by establishing a business checking account, business credit card, and keeping all receipts.

Expenses

Long before you make your first sale, you'll be spending money. You already have travel expenses, computer equipment, camera gear, film, and processing. Hold onto every receipt related to the business. Most expenses can only be claimed for the current calendar year. For instance, film purchases and travel expenses in 2004 can be claimed only on your 2004 tax return. However, expensive capital-equipment purchases like cameras may be depreciated (deducted) over several years—talk to your tax adviser. Keep receipts organized by categories and label the envelopes: advertising, automobile (gas/mileage), capital equipment (camera/scanner), film/processing, insurance, office supplies, professional dues, shipping/postage, telephone/ internet, travel (food/lodging).

When using your vehicle for business errands and photo trips, use a mileage log to record the miles and where you went. Before an overnight trip, label and date an envelope to collect travel receipts. It's much easier in the long run. When you claim an in-home office on your tax return, the office should be used exclusively for the business. The value of the deduction is determined by what percent of your house is dedicated to the business. The more you stay organized and provide your tax adviser with total expenses for these categories, the better off you'll be (and the lower your tax preparation fee).

Income

Getting a photo credit is nice, but when you start making some money you're really becoming a pro—now that's an accomplishment. Once you agree on a usage fee, there are two basic ways to get paid. You either invoice (bill) the client and wait for a check, or get a credit card number and send a receipt. Invoicing the client is still the standard in the photo industry, especially with ad agencies, publishers, magazines, and calendar companies. Selling retail prints and royalty-free photography are the notable exceptions.

GETTING PAID: INVOICES AND CREDIT CARDS

I may not always get the price I want, but it's rare that I don't get paid. Here are some things to keep in mind to ensure similar results. I began my career as a photographer's assistant, and one of the first things I learned was to work with professionals, such as ad agencies, graphic designers, publishers, and established companies. Besides having bigger budgets, they generally respect copyright ownership.

An art director doesn't want to risk losing an account or reputation by basing an ad campaign on stolen imagery, nor does a book or calendar publisher. Generally, the photography is a relatively small expenditure, when calculating the entire cost of most projects, and thus it's not worth stiffing the photographer.

Depending on the client, you might sign a calendar company's "Photographer's Agreement," receive a purchase order from an ad agency, or simply get a verbal OK over the phone. Whatever it is, send an invoice. This is more than a simple bill; it's a legal contract that spells out *exactly* how an image can be used. Include the following:

- Image ID number and caption.
- Name of the end user or client actually licensing the image.
- Exact usage: media (like Web site or brochure), duration of usage, size of reproduction, print run.
- Sign and return any purchase order. Reference the purchase order (PO) number on your invoice.
- State that any film must be returned via registered courier, when appropriate.
- Amount due. Also state: "No usage rights are granted until paid in full."
- Include shipping fees, when not billed to the client's account.

Credit Cards

Clients are using credit cards more all the time, and I like it. The Internet has opened up the world, and consequently I get calls and sales from all kinds of photo users. When my intuition tells me to worry—perhaps this is a new company—I insist on a credit card. The money is credited to my bank account immediately after the transaction, before I send any imagery. Contact your bank to get set up. Generally you pay a monthly fee (about $25) or a percent of each sale (about 3 percent), whichever is greater. As before, send a receipt stating the exact usage. The Internet has brought me many sales from Europe, without my ever picking up the phone. Clients make contact via e-mail, we upload an image to our Web site, and the client deposits money in my bank account via a wire transfer.

KNOW THE END USER

Perhaps the most important information is the name of the client who's using the image. This applies mostly to advertising, and it has really saved my hide several times. Stock agencies usually invoice the ad agency. When they're slow to pay, beyond the normal two to three months, you may have to threaten to contact the agency's client directly. This would be a real embarrassment for the agency and this tactic will often quickly work.

Knowing the end user is also critical if the ad agency or multi-media developer is going out of business. I've had apologetic calls from business owners who can't pay up. This isn't easy for anyone, but I want my money. Again, contact the end user. Explain to whoever answers the phone that you own a stock photo agency and you're investigating an unauthorized photo usage. You'll be connected to someone fairly high up; just stay calm and professional.

THEFT OR COPYRIGHT INFRINGEMENT

I can't tell you how much of my imagery is used or reused without my knowledge. I know it happens, because I've seen it and I've gone after the thieves. I regularly look through the local newspapers and direct-mail coupons. Here's a typical example: I licensed an image to an ad agency for use in grocery stores as a 3 × 4 foot display to sell yogurt, often called a point-of-purchase display, or POP. A year later, the same company used my photo for a coupon. The ad agency was gone, so I called the yogurt company and explained myself to the receptionist. The president of the company contacted me within fifteen minutes. She explained that they had hired a new ad agency and the agency had acquired the image on a CD-ROM. They didn't really know where it came from, but they had used it. I settled for an immediate payment of $1,800.

Copyright

This is a legal subject, so it can get complicated. Here are some basics: When a photographer takes a picture, he or she is the creator and the copyright owner. There's a saying, "When it's created, it's copyrighted." Yes, the photographer may own the copyright, but this doesn't ensure maximum protection under the law. To receive all the legal benefits, the photo must be registered with the U.S. Copyright Office, Library of Congress in Washington, DC. To do so, you'll need: Application Form TX (formerly VA), copies of the image(s), and a filing fee. You can now register more than one image at a time,

but there are some requirements that imagery be registered before it is published or used, so register new imagery immediately. Go to *www.copyright.gov*, or call the forms and publications hotline at (202) 707-9100. You can also receive general assistance on copyrights by calling a copyright information specialist at (202) 707-3000.

A copyright notice label should be attached to the protective sleeve covering color transparency film. Some form of identification and copyright notice should also accompany digital files. Options are discussed in chapter 24, under Protecting your Photography. A copyright notice consists of three elements: the word "copyright" or the symbol ©; your name; and the year of first publication. (Under copyright law, "publication" means distributed to the public and available for licensing, not necessarily reproduced in print.) The words "All Rights Reserved" are sometimes added, but are not legally necessary. My copyright notice looks like this: "Copyright © John Kieffer 2004. All Rights Reserved." To make the © symbol, hold down the keystrokes "Option G" on Macs. When using a PC (Windows), hold down the "shift" key and type: (C). Your word-processing program should automatically convert this to the correct symbol. Please note that the letter *c* in parentheses is *not* a valid legal equivalent! For more information about protecting and profiting from copyrights, consult *The Copyright Guide*, by intellectual-property lawyer Lee Wilson (Allworth Press).

Hiring a lawyer to pursue a copyright infringement is very expensive and mentally draining, so I first try to settle disputes with a calm, business-like phone call.

Small Claims Court

I attended an American Society of Media Photographers (ASMP) meeting on copyright law, and the speaker stated that small claims court wasn't an option regarding copyright infringement because it's a state court and copyright is federal law. However, you can use small claims court to pursue your case on *other* grounds, such as breach of contract. My first experience was successful, because once I filed the claim—and the summons was served by a police officer—the client (defendant) quickly paid up. The second time I showed up in court, but the client didn't and I won. A week later I received a letter notifying me that the company was filing for bankruptcy, so I received nothing for my efforts. If I had only known that the company was on the verge of collapse, I would not have sent them my image!

Going to small claims court is not common activity for most people, so I'll be brief. The following is the process in Colorado, and may vary from state to state: the process begins at your county courthouse, when you pickup a form called "Notice, Claim and Summons to Appear for Trial," and a booklet explaining the ins and outs of the process. Most importantly, the trial is held in the county where the defendant resides, so if they're out of state or some distance from you, it's impractical. There is a filing fee and a fee to have someone serve the summons, so you have an investment of about $50. It's much like the TV show, *The People's Court*, so prepare what you'll say and bring any evidence like the film, invoices, or a sample of the unauthorized use, such as a the publication.

RIGHTS MANAGED AND ROYALTY-FREE PHOTOGRAPHY

The terms *photo buyer* and *selling photography* are common, but what's normally happening is the photographer grants permission, or licenses, an image to be used. The photographer retains copyright or ownership of the image. Even a photographic print is "sold" with the understanding that it's to be used as a print. No rights are given that let the client—owner of the *print*, not the image—make copies or use the print in any other way. For instance, that client can't scan the print and resell it for a brochure. With this said, however, the times are a-changin'. Selling photography is now divided into two categories: *rights managed* and *royalty-free*.

Rights Managed

When an advertising agency or a calendar company uses one of your images, the invoice (bill) you send should state exactly how the image is being used, for how long, and how much it costs. This is the way it's always been, so it's often referred to as *traditionally licensed* or *rights managed* because you define the exact usage rights. As the usage increases, the usage fee increases. Photographers and stock agencies save their best imagery for this licensing strategy, and it commands the highest fees. It also allows the stock agency to track how a photo has been used, especially if the agency has *exclusivity* for the image, meaning it is the only entity that can license it.

Royalty-Free Photography

In the mid-nineties, royalty-free became the fly in the ointment. It quickly grew and changed the face of stock photography forever.

Royalty-free means the photo buyer pays a one-time fee and can then use the image for almost anything. This is similar to the "clip art" you often get when you buy a computer. When someone buys a single royalty-free photo or a collection on CD-ROM, they're given very broad usage rights. Basically the purchaser can do almost whatever they want, and since most files are fairly large (20 to 40 MB), they can be used for anything up to double-page spreads. However, the photographer or the stock agency retains the copyright, and the purchaser can't resell the images or download them to a communal library for others to use. This it little consolation when you consider its effect on lowering prices. Like it or not, royalty-free is firmly entrenched.

PROFESSIONAL ORGANIZATIONS AND PARTNERSHIPS

From capturing the images to selling them, photography is a solitary profession, and that can make it pretty tough. That's one reason why it's important to work with galleries, stock agencies, and especially with other photographers. The best professional organization I know is the American Society of Media Photographers (ASMP). It's also the only one that's likely to have a local chapter, so you can actually meet people. Don't let the name scare you off—this it's where it's at for pros and those aspiring to be. I admit it's not filled with nature photographers, but its members are familiar with magazines, advertising, pricing, copyright, and a host of other issues.

Visit ASMP's national Web site (*www.asmp.org*) to get more information and to find a local chapter—for instance, *www. asmpcolorado.org*. Also visit the North American Nature Photography Association Web site (NANPA) at *www.NANPA.org*. This organization is also a good way to learn and network. As a member, you have the opportunity to contact fellow members for all kinds of advice, from pricing to when it's best to visit a new location.

Partnerships

You might consider forming a partnership. Sometimes building a Web site and filling it with great photography is a full-time job. When you add marketing, purchasing new equipment, answering e-mail, and so on, it can be overwhelming. For instance, if you have a nice Web site, it's reasonable to add other photographers' work to it. Search the Internet for appropriate photographers. Don't worry about getting duplicate film made. All you need is a high-resolution

file (about 30 MB) and you're in business. This will help you get to a certain critical mass, where there's enough income to make it all worthwhile.

What if you and another photographer want to go into the fine-art print business? It might make sense to split some major expenses. One might buy a scanner and the other the printer, or maybe go in together to rent a booth at an art festival. Keep the relationship simple, so if you part ways it doesn't turn into an ugly divorce. Before you jump in, take a sober look at your potential partner. For more information on partnerships and other legal entities through which photographers can conduct business, consult *Legal Guide for the Visual Artist* by Tad Crawford (Allworth Press).

BE A PHOTOGRAPHER'S ASSISTANT

If you're rich, you don't need to read this. If making some money while you learn your craft and build your stock files sounds appealing, this may be the best advice in the entire book. To those of you working to be real pros, your success will depend on several factors—but a big factor is understanding the business environment you'll be working in. You may not realize it, but one of the biggest parts of the photo industry is commercial and assignment photography. These photographers produce an endless array of imagery, and professional photographic assistants are an integral part of the creative process. The best resource to investigate and perhaps take advantage of this great opportunity is the book *The Photographer's Assistant,* by yours truly.

Digital Files

I don't know of any industry more transformed by the digital revolution than photography, and for those of us who've survived, it's been a time of constant change. During the late-nineties, there was constant hype that everything was going to the Internet. The crash of 2000 demonstrated that some of this enthusiasm was unwarranted. Once the investment has been made to get an online library running, it's the best way to show and sell photography. Buyers get to view lots of imagery and you can quickly download a high-resolution file or send just the film they need. The days of sending out large film submissions with the hope the viewer may use a photo are largely gone.

Digital files can't be lost or damaged like a piece of film. Photographers have been awarded up to $1,500, and sometimes more, for each lost or damage piece of film. That's a major concern for clients. From the photographer's view, digital files don't need to be returned and refiled. The task of filing several hundred slides is daunting.

Digital also keeps the photo buyer honest. Most usage fees (prices) are determined by how the photo is used. If someone states an image will be reproduced at 2 × 3 inches, you send a small file. To reproduce an image in print, you a need a resolution of 300 pixels per inch at the size the photo will be reproduced. Therefore to reproduce an image 2 × 3 inches, a magazine needs a file measuring 600 × 900 pixels, quite small.

FILE SIZE
Before you can send the right digital file, you need to know something about file size. A client might say they need a 3 MB (megabyte)

file. This provides some information, but doesn't really tell me what I need to know. I prefer knowing what dimensions (in pixels) they need. This might be 2000 × 3000 pixels, or perhaps they tell me how large they plan to reproduce the image. Let's say 2 × 3 inches at 300 dpi for a magazine.

File size is confusing, because a file measuring 2000 × 3000 pixels isn't always the same size in megabytes. When I save that image as a Photoshop file it's 17 MB. Saved as a TIFF, it's 18 MB. Saved as a maximum-quality JPEG, it's 5 MB. Saved as a lower-quality JPEG, it's only 300 KB.

All four files still measure 2000 × 3000 pixels, but TIFF and Photoshop have the best quality. The maximum JPEG is a very close second, and will be the easiest for the client to download. The 300 KB JPEG format will look pixilated, but it's the better choice for your Web site, because it loads quickly and there's less quality to steal.

FILE FORMATS

Let's begin with a piece of film that has been scanned, or an image captured digitally. Scanners and digital cameras may provide a common file format, like JPEG or their own proprietary file format. Whatever you start with, save it in a file format that's best for its intended use.

Open the file while in a photo management software, such as Photoshop. Next do *File > Save As* to change file format, while retaining the original file. You're given a host of options like JPEG (.jpg), Photoshop (.psd), and TIFF (.tif). Adding the proper extensions (suffixes) to the end of a file name helps ensure the file is transferred properly and can be opened later. For example the same photo could be saved as "Alpine Lake 6.psd" or "Alpine Lake 6.jpg."

Photoshop Files (.psd)

This is a common file format, because Photoshop software is the standard. When you open up a file from your scanner or digital camera, save it as a Photoshop file and keep this as a master or archival file. Now you can do image manipulation, resizing, and changing file formats. Photoshop is great, but it's usually not the final file format. Non-professionals may not own Photoshop, and these files are also too large for Web applications and e-mail, so use JPEGs. Some industries, like four-color printing, have standardized on TIFF.

TIFF (.tif)

It's probably more important to know about TIFFs than to use them. Designers use QuarkXPress® software, and to a lesser extent Adobe InDesign®, to layout print ads and brochures. Designers import TIFF images (Tag Image File Format) into these programs because it's the standard file format when the job is printed on a four-color offset press. I send designers either a maximum-quality JPEG or Photoshop file, both in RGB Mode, and let them convert the file to TIFF. Ultimately, the graphic designer is responsible for how the end product looks, so let her handle it.

If you want to create a TIFF, use the *File > Save As* command. However, TIFFs must be saved for either a Macintosh or a PC. These days, you can't assume a client is on a Mac. I often send "TIFF saved for Macintosh" and a "TIFF saved for IBM-PC." If the image is going to be printed on a four-color press, which uses four different inks to print the different colors, save the TIFF in CMYK Mode, not RGB Mode. CMYK stands for cyan, magenta, yellow, and black. In Photoshop use the command *Image > Mode > CMYK Mode*. TIFFs are large files and LZW Image Compression is a useful option. This reduces the file size with little loss of data.

JPEG (.jpg)

The JPEG file format is mentioned throughout the book because it's so useful and familiar due to the Internet. Its greatest asset is reducing, or compressing, large files into small ones, while retaining an amazing amount of quality. When you want to send an image (digital file), you often begin with a large, high-resolution file. Then you resize the image and save it as a JPEG.

Open the original file and save it as a JPEG (*File > Save As*). You're given a range of *Image Options* regarding how much quality you want to retain. Smaller files means lower quality. Start with saving at the "maximum level" JPEG. Afterwards close the file and check its new file size in megabytes. If it's still too big, open up the original file again, and save as "medium level" JPEG. Check file size.

QUESTION: A CD-ROM can store 660 MB of information. How does a royalty-free CD-ROM hold 100 high-resolution files that are 20 MB each? (100 files × 20 MB = 2000 MB)

ANSWER: The original scan is saved as a 20 MB TIFF or Photoshop file. This is then saved again as a Maximum JPEG and the file size is reduced to 6 MB. You buy the CD-ROM and open

the 6 MB JPEG file, and then save it as a TIFF or Photoshop file. Voilà, it's 20 MB in these file formats.

Ultimately, I choose a file that's a good balance between file size and image quality for the particular application. For example, consider who's on the receiving end. You don't want to overload their e-mail with a 5 MB file. For Web applications, Photoshop 7.0 shows how long a certain-sized JPEG takes to load at various speeds (baud rates).

JPEG FORMAT OPTIONS

There are also two *Format Options* regarding the file's use on the Internet. *Progressive* means the entire image will be blurry when it comes up on the monitor. It refreshes three to five times before it's sharp. *Baseline Optimized* means the image is displayed one line at a time and is preferred for photographs.

PDFs (.pdf) and Adobe Acrobat Software

When a designer sends me a layout of an ad to review, it's usually as a PDF (Portable Document Format) file. This is the primary format for Adobe Illustrator and Adobe Acrobat software. This isn't a rough layout. It shows the precise placement of every photo, along with the text in the proper font. Generally, your job is to review how the image is being used to quote a usage fee and to send a proper scan.

An exact layout is particularly helpful when the designer is only using a portion or "cropping" the image. Often, there's no need to send the entire scan. This makes the file smaller and easier to send, while reducing unauthorized use. Always provide the image a little larger than what they requested, so they have some leeway, but don't give away the store. To open PDFs you need Adobe Acrobat or Photoshop 7.0 (*www.adobe.com*). On Mac, select *File > Open* and choose *Show: All Documents*. On Windows (PCs) select *File > Open* and choose *All Formats*.

RESOLUTION

Resolution is the number of dots, or pixels, per inch (*dpi* equals *ppi*). A higher-resolution file is analogous to using a finer-grained film—there's more information in any given area. It's usually worth the investment to get a high-resolution scan, which can be resized for use in different applications. Important: Your first task is to know the how the image is to be used and then change the file to the appropriate resolution. Next, you resize the image to fit into the appropriate spot on the Web site or magazine.

Practical Example

An image (scan) has the dimensions 2000 × 3000 pixels, but it can be saved at different resolutions, like 72 dpi and 300 dpi. You want to match the resolution with the application. For example, you want 72 dpi for Web uses and 300 dpi for four-color presses. This means the 2000 × 3000 pixel scan at 72 dpi measures roughly 27 × 42 inches on your computer monitor. Therefore, after changing to the proper resolution (72 dpi), you resize it.

The same 2000 × 3000 pixel image at 300 dpi resolution can be reproduced up to 6.67 × 10 inches, if printed on a four-color press. When you want to print a smaller image, you resize it, while keeping the resolution at 300 dpi.

To change the resolution use: *Image > Image Size*. (Warning: *don't* check the box "Resample Image.") Now you can change the resolution from 300 to 72 dpi, without changing the total number of pixels in the image (pixel dimensions).

RESIZING A FILE

Once you have selected the right resolution (dpi) for the application, you resize the original image, let's say from 2000 × 3000 pixels to 300 × 450 pixels. Again use *Image > Image Size*. Now check the box "Resample Image" and change the pixel dimensions (length and width), to the size you want.

To resize an image, the software uses a formula to decide which pixels to delete or add. Unlike changing resolution, every time you resize an image, some quality is lost. Ideally, you want to resize only once, starting with the largest dimensions and resizing to the smaller dimensions, so you're eliminating, rather than adding, pixels. This is important when you want your images to look their best.

RGB AND CMYK MODES (COLOR SPACE)

It's amazing that such a spectrum of colors can be produced from so few. Computer monitors use red, green, and blue light; printers use cyan, magenta, yellow, and black ink (and sometimes several versions of a particular color). Keep files in *RGB Mode* when they're going to be outputted to an ink-jet printer or viewed on the Web. In Photoshop use: *Image > Mode > RGB Mode*. Mode is also referred to as a file's *color space*.

As you now know, the four-color printing process utilizes CMYK. In Photoshop use *Image > Mode > CMYK Mode*. Use *Image > Mode > Grayscale* to convert a color image to black and white.

SCANNING FILM

In simple terms, a scanner converts a film's image to a digital file. I don't know if you can be a professional photographer today without a scanner. I'll concentrate on scanning color transparency (slide) film, since it's the industry standard. You can get by with an inexpensive flatbed scanner when you only need low-resolution files for the Web or multimedia applications. When a scan is used for printing on a four-color offset press, or to make a fine-art print, the need for quality and higher resolution increases (See chapter 28, Photographic Prints).

GENERAL SCANNING CONSIDERATIONS

- Review your work environment, especially the natural and artificial lighting. Scans look dramatically different as ambient light changes. Screen glare can be a particular problem. Consider taping a "hood" around your monitor made of black cardboard.

- Calibrate your monitor. There are some simple procedures to make sure it's the right brightness and contrast. Look at some professional scans of your film. If they look properly exposed and have the right color balance, your monitor isn't too far out of range. This is not the same as color management. (See the section on color management in chapter 28)

- Carefully clean your film and scanner. This saves time retouching the scan. Skies are notorious for showing dust.

- Invest the time or money to make one high-resolution master scan (archive) and burn it to a CD-ROM. Resize this master scan to the desired size when needed, but only resize once.

- If you must produce a larger image (upscale) from a smaller one, use the software Genuine Fractals or Extensis pxl Smart Scale.

- Experiment and learn by scanning film that's well exposed and has a range of colors. Take notes. Scanner software controls such as "White & Black Points" and "Density Range" are worth learning. Import the scan into Photoshop to do your sharpening and color balancing.

- It can be difficult to decide if a scan's color is a little off; maybe it's just a little too red or green. In Photoshop, use *Image > Adjustments > Hue/Saturation* and crank the saturation to the max. If you thought it might have been too green before, it will be obvious now. Then use *Image > Adjustments > Color Balance* to correct it.

- Become familiar with Photoshop's sharpening tool: *Filter > Sharpen > Unsharp Mask.* Try these Unsharp Mask settings as a starting point:

–Amount 15 percent; Radius 50 pixels; Threshold 0

–Amount 500 percent; Radius .3 pixels (that's point 3); Threshold 3

USING CD-ROMS

Our small agency, Kieffer Nature Stock, released our first CD-ROM stock-photo catalog in January 1998. Printed stock-photo catalogs were still popular, but they cost a small fortune to print and distribute. The CD allowed us to show many photos at an affordable price, and aggressively pursue specific local and national markets. Back then the decision was more obvious, because the Internet was too slow for photography. Producing CD-ROM photo catalogs was probably the best business decision I ever made. Although the Web now overshadows them, CD-ROMs are still a very viable marketing tool. Here are some basics you might consider to see if CDs, and increasingly DVDs, have any value to you.

CD-ROMs are great for archiving high-resolution files, but maybe they can help you sell photography. CDs have several advantages over a Web site. First, people don't have to be online to view your photography. Also file size and load time are less of an issue, so you can use more graphics and larger-sized images (72 dpi, JPEG) to make a powerful presentation.

People tend to hold onto CDs, if they're useful. Theft is less worrisome, because you know who you sent the CDs to, and relatively few people have access to them compared to the Internet. Hopefully, a local art director is going to think twice about stealing a local photographer's work for an ad. Still, state clearly on the label and inside the CD: "This is NOT Royalty-Free Photography." A final thought—make sure you have a clean, virus-free computer so you don't infect your CDs. People won't be interested in your services if you give their computer a virus.

STOCK PHOTO CATALOGS

Stock Photo catalogs usually have hundreds of images and are best suited for experienced photographers with in-depth coverage and quality imagery. If you don't feel you have adequate photography to justify an entire catalog, consider networking with like-minded and complementary photographers. For instance, a landscape photographer

might form alliances with wildlife or adventure sports photographers. Some niche catalogs that we've produced for individuals cover New York City, California, Colorado & the West, Hawaii, Cars, Health Care, Pacific Northwest Nature, Adventure Travel. Resources you might bring to a partnership are money, motivation, business and sales experience, excellent photography, technology, and a client database. (See CD-ROM: Marketing > CD-ROMs > CD-ROM1.jpg and CD-ROM2.jpg)

ROYALTY-FREE PHOTO CD-ROMS
Royalty-free collections on CD-ROM contain up to 100 high-resolution images and cost from $300 to $450. Files measure at least 2000 × 3000 pixels, at 300 dpi (JPEG format). This means they can be printed up to 6.67 × 10 inches in a magazine or four-color ad. Images are usually organized into a handful of folders. Consider providing a low and a high-resolution file for each image. Low-res files load quickly for easy evaluation, yet they're large enough to be used in a layout *for position only* or "FPO." You can also place small thumbnail images on an index page—simple but effective. Most royalty-free CDs have a certain theme, such as water, lifestyles, a specific state, wildlife, backgrounds, mountains, patterns, and skies. (See CD-ROM: Marketing > Print Media > Postcard.jpg)

RECORDING TO CD-ROM
Today's CD-ROM recorders, also called writers or burners, are inexpensive, fast, and easy to use. Generally, a CD will exhibit fewer problems when it's recorded at slower speeds, like 4X. Also, write to the CD only once: Multi-session disks are more prone to problems. It's also important that each JPEG file has its proper suffix, or extension (.jpg). Whenever you abort the recording process, start over with a new CD. Finally, verify that each CD works. As far as longevity, who cares? A stock catalog doesn't need to last forever, and it's better if a royalty-free CD lasts only so long. The most common software for recording to CD-ROM is Roxio's Toast.

CD-ROM DESIGN CONSIDERATIONS
CD-ROMs are most successful when mailed to carefully selected prospects. You might send a postcard announcing your free catalog, and those interested can e-mail you with their requests. This limits the number of catalogs ending up in the trash, plus you get a valuable

e-mail address for your database. However, once clients have your CD, you still have to get them to open it up and use it.

Packaging

Have you ever noticed that the packaging often seems more important than the product? It plays an important role, so convey what's inside using thoughtfully selected photography and concise text. If you've brought a good, useful product into the marketplace, buyers will find a need for it. You can design a beautiful package in Photoshop and print it on almost any printer. This lets you experiment before committing to a big print run, if you ever do.

I still favor the plastic jewel case. It has a certain desk presence and can be kept in a storage rack as a constant reminder. The jewel case spine, the skinny edge that sticks out of a CD rack, should catch the eye and clearly state what's inside. How about red text on yellow? If you're a local nature photographer, you want local art directors to know that this CD has 300 local nature photos. When they need a nature shot, how can they not look at your CD-ROM?

Jewel cases cost more to produce and mail, but I'm still amazed at how many are held onto and passed around—if they're useful. It's very easy to print a beautiful cover and back page (tray card insert), but they're not essential. The label that sticks to the CD-ROM is visible through the jewel case. I've had thousand of CDs replicated en masse by a reputable company, but I also use a do-it-yourself model for labels (*www.cdstomper.com*). It comes with templates and precut paper. I don't shrink wrap my CDs, because it's a barrier to their being opened and used. (Visit *.DiscMakers.com* for technical information and useful CD-ROM and DVD design templates.)

Software

Options for presentation of photos range from creating a simple collection of folders to developing a one-of-a-kind interface using powerful multimedia development tools. Your decision depends on your computer skills, goals, and pocketbook. MacroMedia Director is probably the most powerful of the lot. Next in line is Matchware's Mediator 7. HindSight's Stock View, an image-management program, can also be downloaded to a CD-ROM (*www.HSLtd.us*). Visit the Web site *www.GraphicsSoft.about.com*. It provides numerous links to software products for slide shows and photo viewers.

Extensis Portfolio, PowerPoint, Adobe's Photoshop/ImageReady, and QuickTime also produce a variety of slide shows and presentations. Still, the person receiving the CD must be able to view it. Often times a player or viewer can be supplied with the CD-ROM, and some of these programs are commonly installed when you buy a computer, anyway. Unfortunately, these programs are usually for either a Mac (Apple) or PC (Windows) system, not both. Therefore, you must make sure you can build a dual platform CD—one that works on both Mac and PCs. You can't gamble on a PC platform, because the photo and graphic arts industry is one of the few that continues to be a Mac stronghold.

HTML Viewers

HTML (Hypertext Markup Language) is the basic software language of the Internet. Perhaps the best solution is to use an HTML-based viewer that runs on the Internet, but can also be placed on a CD-ROM. The CD-ROM is opened and viewed through your Web browser, like Internet Explorer, Netscape, or AOL. These browsers run programs written in HTML, and everyone has a Web browser on their computer. The images on the CD-ROM included with this book can be viewed in a HTML-based browser.

Marketing Approaches: Old and New

Although traditional approaches my seem outdated or ineffective, they are not. I bet you get your share of junk mail and when done right, it works. Traditional marketing generally consists of printed material in one form or another. There are two basic approaches: First is direct mail, like postcards or a promotional (promo) piece, often designed and printed right at home. Second, you buy advertising space in printed directories, such as the telephone yellow pages or a local creative directory, which are then distributed for you to potential photo buyers.

But in our advanced technological age, we cannot escape from the omnipresent Internet, which, when used correctly, can be an enormously effective marketing tool in your promotional arsenal.

LOGOS AND IDENTITY

An important part of any marketing strategy is your logo and business identity. In some ways, a nice logo and an accompanying short phrase (tag line or slogan) are the culmination of all your hard research and self-reflection. Using simple design elements and a few well-chosen words, you try to sum up who you are or what your company is all about. Before committing to anything, think of your immediate and long-term goals. I don't think you can avoid changing your company name or identity over the years—it's all part of growth and evolution—but you might want to keep it to a minimum.

Photographers have a habit of tacking the word "Photography" after their name and that's their business. In late eighties, I used "Large-Format Photography," after my name. I thought using

221

a 4 × 5 inch view camera would help differentiate me from other nature photographers. When I began representing other photographers, I switched to "Kieffer Nature Stock." I still wanted my name in the title, since that's all a photographer has over the years. Our emphasis remained nature, and we're primarily a stock agency. I'll probably get rid of the Kieffer. It's too hard to spell for a Web site and e-mail. Plus, the Internet allows us to meet a greater diversity photo buyers and many don't know what "Stock" means. Presently, I want to convey that we represent nature and people enjoying nature. I just haven't figured out a way to say it.

PRINTED MATERIAL

Not too long ago, the glossy printed stock catalogs and creative directories would have taken center stage when discussing marketing and selling photography, but not anymore. These staples of advertising met their demise, prematurely perhaps, with the rush to do everything on the Internet. However, there are many very effective ways to use the printed medium. In fact, these more conventional methods may still the best way to drive quality traffic to your Web site, elicit e-mail, or entice someone to give you a call. Before you get too far into this endeavor, you should estimate your total costs. When you need to buy labels, shipping containers, and extra postage costs quickly escalate. (See CD-ROM: Marketing > Print Media)

General Design Considerations

When creating a promotional piece, you should use a clever design, so people will hold onto it. My guess is that a promo piece resembling a calendar photo will work better than one that is cluttered with copy. A great photo with your logo, brief company description, and Web address is about all that can fit on the front. The back can take care of the specifics. Make it enjoyable to look at; hopefully people will tape it to their wall for a month or two, just until your next mailing arrives. For more ideas, examine the direct mail you receive.

Consider designing three different promo pieces or postcards that have some continuity and identity. Send one every couple of months. This can be particularly important if you're just getting started, and you want to establish a presence. You might consider a seasonal approach—summer, fall, and then a winter image, maybe at

Christmas. If it's not a Christmas card, wait until after the new year. From Thanksgiving to Christmas, you compete against way too much other mail.

Choose imagery that's most useful to your audience. When mailing to ad agencies, convey that you know what the commercial stock industry is all about and that you can satisfy its photo needs. Do you want an art director to think "that's a great image, but I'll never need it"? Again the grand landscape far outsells close-ups or still-lifes, no matter how good they are. If you're going after Seattle ad agencies, you'd better have Mt. Rainier.

Try to elicit a response; this can be invaluable. Plus it can motivate you, knowing someone got your card and might call you some day. For example, request that recipients visit your Web site. If they e-mail you from there, they'll receive a 25 percent discount in the next six months. You'll not only get some idea as to whether you've reached anyone, you'll get an e-mail address. Do you have a CD-ROM stock photo catalog you can send them? Do you offer a royalty-free photo CD?

Postcards

Postcards have been used by all kinds of photographers for many years. They're one of the cheapest forms of advertisement and are appropriate for anyone you'd like to sell to or who might send business your way. We still send out Christmas (Holiday) cards and postcards to announce our updated Web site. Have you sold any photos that were used on postcards, greeting, or Christmas cards? The photographer can usually buy these from the publisher for a discount and you'll have photo credit. These can be used as a direct-mail piece or an easy way to send a personalized note, perhaps to congratulate an art director for winning an award mentioned in a local trade publication. (See CD-ROM: Marketing > Print Media > Postcard.jpg)

Postcards can also be sent to photo editors at magazines and to book publishers, especially if you can refer them to a useful Web site. If not, print a modified stock list on the back. Ask that your e-mail address to be added to their database of photographers, so you'll receive regular photo requests.

There's so much direct mail, I wonder if my postcard is lost in the shuffle. I've decided the 6 × 9 jumbo postcards are better than the standard size (4 × 6 inches). In fact, they've become the norm. Even junk mail is being super-sized. Be sure to check current postal rates: When you go beyond 4 × 6 inches, there will likely be a rate increase.

When evaluating postcards and related marketing materials, consider using a national printing company specializing in postcards and direct mail. You can send your mailing list to them and they'll do the mailing at bulk rates. You won't believe how much work and even money this saves. Try *www.CopyCraft.com*, Express Color (call 800-388-8831), and read the book *Direct Mail for Dummies*.

In-House Promo Pieces

A whole range of promotional material can be produced on a desktop printer, especially when using specialty paper. However, there are some drawbacks to consider. Photo-quality paper and ink are expensive, so investigate your local commercial copy center when making more than a couple of dozen color prints. Unlike professionally printed postcards, you can only print on one side. You must also determine how you'll mail it. Sending an 8.5×11 promo piece in an envelope is both expensive and labor intensive.

The do-it-yourself approach can work for magazines, and also to request submission guidelines for stock agencies or book publishers, because there are relatively few out there. You might try a combination of photos, coupled with a detailed subject list and professional credits. I've also mailed discount coupons. I've printed tri-fold brochures discussing my favorite photo spots for viewing alpine wildflowers. Later, I sent one for the fall aspen leaves.

PRESS RELEASES

You can send press releases to the business section of your local newspaper, to a professional organization's newsletter, and to local trade publications. Be sure to contact the publication for submission guidelines. You might announce launching your Web site, a new CD-ROM catalog, or supplying the cover photo for the state's tourism guide. Try to answer journalism's five basic questions: who, what, when, where, and why. Be sure to include your Web and e-mail addresses, along with other contact information.

THE YELLOW PAGES

Most photographers and stock agencies have only a simple listing in the telephone yellow pages. I think this is because most photographers put their limited financial resources in Internet services or their Web sites. I'm having more and more success with the yellow pages. Perhaps with the advent of desktop publishing and Web sites, smaller

businesses of all kinds need photography. Many aren't familiar with the big stock agencies or don't want to pay their prices.

Another reason might be our Web address. Potential clients go directly to our online stock catalog, and then call us. Checking the Denver 2003 yellow pages, I saw very few commercial and stock photographers listing their Web address. This is a mistake. A Web listing would also prove valuable for fine-art photographers, especially those with a nice online photo gallery.

YOUR WEB SITE AS A MARKETING TOOL

Your Web site should be the culmination of soul searching, market research, and a rational look at the facts. To get information on to how to utilize the Internet and get your Web site up and running, use your browser's Help section or pull-down menu. Also become familiar with Adobe Photoshop and ImageReady to work with scans and produce a Web photo gallery. Here are some general considerations for your Web site:

- Although the Internet has a worldwide reach, it's more practical marketing to, and serving the needs of, a local audience. Even though I've photographed much of the Western United States, I attract local photo users to my site by advertising in regional directories and sending out postcards or CD-ROM catalogs.

- Images that may not appeal to your local audience are better promoted by paying a fee for a Web service to host them *(www.WorkbookStock.com)*. These portals and communal sites are better able to advertise to the national and international market.

- Visitors come to your site to find photography, so use photo ID numbers. The simpler the navigation, the better. If your site hangs up or visitors get lost, you've lost them.

- Carefully consider the need for sophisticated graphics and other elements that increase load time, reduce reliability, and possibly subtract from your message. Are you a stock photographer or a Web developer?

- Remember that art directors and graphic designers usually have powerful computers, high-speed Internet connections, and the know-how to use them. If you intend to go after art galleries or the consumer (retail) market instead, your customers might be lacking these tools and knowledge.

- Expect the design process to be an invaluable learning experience. You'll find that some of your favorite photos are just plain difficult to use, or you might be missing certain subjects. Take what you learn to the field next time.

- Not all photos translate equally well to the Web, especially when small. A common Web feature is to click a small photo to view a larger version. Crop the small image to emphasize its best features. Place the 35mm slide on a light box and stand back: If it's vibrant, it will probably do well as a small image.

- Visit other stock photo Web sites to see how they're designed and what kind of photography they show. Visit *www.google.com* and enter: "photographs, stock." When you find one with a particularly nice search engine, send an e-mail complimenting the photographer and ask for the details about the search function.

- View your competition; visit *www.ASMP.org, www.NANPA.org, www.WorkbookStock.com, www.AgPix.com, www.DirectStock.com,* and *www.MIRA.com.*

- Many computers come with software that can be used for Web applications. Microsoft's Publisher is supplied on Windows systems and lets you make print brochures and mailers; just about anything you can do in Publisher is readily placed on your Web site. Macintosh has a similar program called AppleWorks. High-end software programs include Photoshop's ImageReady, Macromedia Dreamweaver MX and Flash MX, and Adobe GoLive.

- Use your home page to send the person viewing your site to the major sections. Someone wanting to buy a nice print is more comfortable viewing a "Fine-Art Gallery" versus your general "Stock Photo Catalog." You might consider a "Portfolio" to solicit assignment work.

- Have others navigate your site without your help. If they're confused about your message or how to get around, chances are others will be too.

PRELIMINARY DECISIONS

Your Web site is great for showing photography, but it can convey so much more. To utilize the Web's full potential, plan to invest some time and effort. There are two basic choices regarding building a Web site: You can either do it yourself using packaged software, or

you can hire a Web developer. Even when you have the help of computer-savvy individual, realize that the vast majority of the decisions and work will still be left to you. You have to choose the photos, and scan and resize them. You must write the words (copy) describing your business. The average Web developer knows very little about the real workings of the photo industry!

Be a Graphic Designer

Many so-called Web developers have little formal education in graphic design or even computers. This means if you have reasonably good taste, you can do a nice job after a little time with Photoshop or Extensis PhotoFrame. Writing copy, experimenting with layouts and fonts, and even making "buttons" to help visitors navigate your site broaden your marketable skills.

Being involved in the design process will even help make you a better photographer. I've had photos that I've liked, but found them difficult to use in a design. I've learned to appreciate a solid blue sky, which let's me use white or black text; I can also inset photos or crop it anywhere. If you must use a Web developer, have them link together the pages, text, and buttons *you* design. Otherwise you might pay a small fortune for a Web site you find impossible to modify, and with little monetary payoff.

ORGANIZING YOUR WEB SITE

It's often better to begin the design process on paper. This allows you to collect your thoughts, list possible images, and do some basic page layout. When viewing other sites, you can cut and paste a page's address for reference. A flow chart or diagram helps give an overview of how the site flows from section to section. Don't size your photos and make buttons until you've made some decisions. It's like carpentry—"measure twice, cut once."

The most common screen size setting is 1024 pixels wide by 768 pixels high, so your Web pages should fit well within this width. However, it easy to increase page height and let the viewer scroll down. Remember, you'll always be working at a resolution of 72 pixels per inch and using the JPEG format.

PARTS OF YOUR WEB SITE

Care should be taken to make your Web site clearly show the viewer what you have to offer, while being easy to navigate. Below are some

main parts of most photographic Web sites. To facilitate navigating your site, place links at the top and the bottom of each page to get to all major sections. These could be: *Home Page, Fine-Art Gallery, Stock Photo Catalog, Stock List, Photo Workshops, Contact Us, About the Photographer.* (For additional insights about organizing your imagery, see chapter 23, under Organizing Your Photography and Your Stock Business)

Your Home Page

The home page is the first page of your Web site and serves several functions. It should convey who you are and what you offer by using a combination of photos, the names on your buttons, and descriptive text. It's important, because if this page doesn't do its job, everything that follows may not matter. Always think of your audience. An art director must get the impression you know what the stock industry is all about. Do you offer digital fulfillment and same-day service? This is important to an ad agency, but means nothing to someone wanting a fine-art print. These people have no idea what a stock photo agency is or why you'd mention digital fulfillment.

TIP: The top left corner of your home page will load or come up first. This is a good location for your name, logo, and a concise message.

Navigation Center

Your home page is also the epicenter to navigating your site, by linking viewers to the major sections. If someone gets lost or wants to see what else you have to offer, they often return to your home page to start over. There are two basic ways to go to another page. You can have a button and a link embedded in text. For example, to direct someone to your photography section, you might have a button labeled *Gallery* or *Stock Photo Catalog.* You can also include descriptive text with links to the same page. This gives the viewer two ways to get to an important section of your site.

TIP: Many people are more comfortable sending an e-mail than making a phone call, so include an e-mail link called "Contact Us" at the bottom of all pages.

The "About" Section

This is your online resume, so consider the market and what's important to those buyers. In sales, we use the terms "features" and

"benefits." A product has many features, but only a few are real benefits to a particular user. Present the benefits.

The *About* section is a good place to provide contact information. Some people and companies are leery of providing a phone number or physical address, but I'm leery if they don't. I live in Boulder, Colorado, so I feel my address is an asset. Callers think we're in the middle of the mountains and always ask about the weather. On the other hand, if you photograph the western landscape while on vacation from New York, then an 800 number might be smart. Consider what person you write in. Use first person singular—"I photograph using a view camera"—when you want to add a personal touch. Use first person plural—"*We* can download a digital file at a moments notice"—for a "larger" and business-like tone.

Search Engines

Your home-page design helps search engines find your Web site, and also to ascertain if your site is important enough to be listed by them. The parameters used to rate Web sites change from time to time, but many search engines still look for text and keywords, not photos. A photo without keywords is invisible. You can also pay an e-commerce company to make you more visible to search engines, which might be worth a try if you have a quality site.

A title and block of text loaded with carefully selected words will help search engines find you. Web sites are written in HTML. Two important portions of the code are *<Keywords>* and *<Title>*. Software programs for designing Web sites usually have the ability to include words in these two *<Head>* portions of the code. Many photographers make the mistake of not having text on their home page (or for that matter throughout their site). If possible, attach carefully chosen keywords to photos. A mountain scene in Colorado might include: *stock photograph, mountains, photographic prints, Colorado, nature, Rocky Mountains, forests, national forest.*

When viewing a Web site, select *View > Source* from the task bar. The HTML (and any other programming language) will appear in a new window right in front of you. On the next page is just some of the HTML you would see in the source window of my Web site *www.kieffernaturestock.com:*

<HEAD>

<META NAME = "Keywords" CONTENT= "nature, john kieffer, john keefer, john keifer, kieffernaturestock, colorado, american west, stock, images, creative design, advertising, editorial, publishing, web, photography, photos, colorado photographers, stock photography, photographs, lifestyles, recreation, business">

<TITLE> Kieffer Nature Stock Photographs, Nature, Lifestyles, Recreation, Business for Advertising, Publishing…</TITLE>

</HEAD>

Search engines will look for the keywords (the lowercase, descriptive words under the <META NAME> tag) and the searchable words under the <TITLE> tag. There is no limit to the number of words you can have under these tags, so be as thorough as possible.

LINKS AND SEARCH ENGINES

Connecting or linking your site to other Web sites can move you up some search lists. I'm often approached by photographers and organizations to exchange links. I'm hesitant, because visitors are hard to come by and I don't want to send someone to another site, particularly that of a competitor or a listing of other photographers. There are, clearly, many other successful ways to market your Web site on the Internet.

SHOWING YOUR PHOTOGRAPHY

While a home page can make a great first impression, the heart of your Web site is your photography. It generally boils down to how much imagery you intend to show and to whom.

On a simpler Web site, the photography section often consists of a dozen portfolio pieces or maybe thirty to forty images offered as fine-art prints. Although this approach is ultimately limiting, it's intuitive and therefore easy to navigate. You can still show hundreds of images—just increase the number of sections and subsections. Other major photo sections accessed from your home page might be: *Landscapes, Magazine Assignments, Wildlife, Stock Photo Library, Stock List, New Photography,* or *Recent Photo Trips.*

Navigation

One of the most common ways to navigate through a large section, say *Landscapes,* is to display a list of keywords or a collection of "photo buttons" which link to subsections. This is similar to the design used in this book's accompanying CD-ROM: Major subsections are Mountains, Skies, Patterns, etc. Clicking on "Skies" brings up a page of thumbnails. Click a thumbnail to see a "full-screen" photo. Mountains are divided even further, but it's still easy and effective.

Make full-screen photos about 300 × 450 pixels in size. Photos must look their best and include a photo ID number or a unique caption. Many photographers don't even take the time to crop the black border found on raw scans; neglecting this small task is a mistake. The decision to add a drop shadow, frame, descriptive caption, or colored background depends on your audience and how many images you show. However, these are nice touches and should be seriously considered.

If you'd like to add an editorial aspect to the various sections of your site, photos can be aesthetically arranged on a page to resemble a magazine story, photo essay, or self-assignment. Text is easily added in Photoshop. For example, the home-page button called *Magazine Assignments* might link to a second page with five buttons. Each of the five buttons could represent a photo essay, such as "Backpacking the Pacific Crest Trail" or "Slot Canyons of the Colorado Plateau." "Slot Canyons . . ." links to a page designed with a title, some text, and a pleasing arrangement of images. Use Photoshop to design a page measuring 800 × 700 pixels.

SUBJECT LIST OR INDEX

When you have unique or comprehensive files in a certain area, you should consider using a subject list, stock list, or geographic index. Let's say you have extensive files of wildflowers. It may not be wise to show every species on your Web site. A detailed list is easier and possibly more useful for a book publisher, magazine, or someone printing a seed catalog. Invite interested photo buyers to phone or e-mail you about your specialty. Consider sending them a custom e-mail submission.

PROTECTING YOUR PHOTOGRAPHY

When an image leaves your office, whether it's a piece of film or a digital file, it's out there for someone to take and use. Legally, the

photographer is the copyright owner, and everyone else must have your permission to use the image. However, there are people ignorant of copyright law or those who just ignore it. As you show more and better photography, especially on the Web, your concern increases. Here are some things to try (See also the copyright section in chapter 23):

- Whenever and wherever possible, state that your photography is copyrighted and cannot be used without your express written permission. State that it's not royalty-free and it's not in the public domain. A standard copyright notice is "Copyright © John Kieffer 2004, All Rights Reserved." Register it with the U.S. Copyright Office.
- Imbed an identifying mark when sending digital images for review. Use the "Text" function in Photoshop to place your name, copyright symbol, and photo ID number on the image or along the outside edge.

- When sending photo files on CD-ROM, include a file titled "Copyright". This can be written in Photoshop and saved as a JPEG, so it's easy to open. Include all contact and copyright information.
- For Web site images, reduce the opacity of your name or logo, and position it discretely in the photo's corner. Don't go overboard—you want your photos to look good. In Photoshop, you can reduce the opacity by using the opacity setting found in the upper right corner of the Layers palette (if you don't have the Layers palette open, go to *Window > Show Layers* in the task bar).
- Before showing the photography section of your Web site, display an intermediate page that educates the viewer about copyright law or requires them to agree with a copyright statement. Every little bit helps.
- The smaller the photo and the greater the JPEG compression, the lower the image quality, and hence the reduced value to steal.
- There are electronic copyright communication services that digitally embed information into your photo file with an imperceptible digital watermark. This unique code identifies the image owner and has the ability to be tracked by a Web crawler. The photo's location is then reported to the copyright owner and provides the photographers a way to find unauthorized digital use and recover lost revenue (Go to *www.digimarc.com* for details).

- Join and become active in photographers' organizations, such as the American Society of Media Photographers (ASMP) and the North American Nature Photography Association (NANPA).

E-MAIL

Today e-mail might be the most productive part of your computer. It's also a big money saver. You can use e-mail to send photos, mail active links to clients, and invite contact by Web visitors. When people contact you through your Web Site, the most serious inquiries about pricing include some company information—a sign that they're real and that I should respond. When given minimal information about the company and intended usage, I usually respond with some basic pricing information and then lower my expectations. Whoever it is, ask how they found the Web site. This can be particularly important, if you've mailed a postcard announcing your site or you include a Web address with your yellow pages listing.

I realize that e-mail is supposed to be casual and brief. I agree with brief—or perhaps succinct is a better word. When writing a business e-mail, take the time to reread your message and always use spell check. There are also ways to help make your message stand out. Your browser has a priority selector, so you can set your e-mail's subject heading to arrive in red. Use a specific subject, so your e-mail isn't mistaken for spam. You can also change font size, make it bold, or add a variety of colors. At first, send the e-mail to yourself to see how it looks. Often fancy formatting doesn't hold up from browser to browser and isn't worth the effort.

E-mail Attachments

You can send an image file by attaching it to a text message. Visit your browser's Help section for details, but here are a few photo-related tips. Make sure the attachment has the proper suffix. For JPEGs, it's "filename.jpg." You can send multiple attachments, but larger files take longer to send and download. A one-megabyte attachment is large by e-mail standards, and you don't want to overload the recipient's mailbox. Instead of sending four different attachments, while in Photoshop, drag four small photos onto one page (file) measuring about 800 × 800 pixels. (See CD-ROM image: Marketing > Local > G_of_Gods3.jpg)

To open an attachment, select the icon or file name. Hold down the mouse, until a pop-up menu appears. Look for a command such as "Save Link As" or "Save Image As." Selecting one should send you to a *Save File* dialog box. After saving, open the file from within the software application, like Photoshop.

Sending an Active Link to Your Web Site

Unsolicited attachments are being more frowned upon with every new virus. A better way to make viewing your photography effortless and safe is to e-mail an active link to your Web site. Type your entire Web address on a separate line in your e-mail message. Get it exact by going to your Web site's home page, copying the address, and pasting it in the e-mail message.

Now find the command *Insert > Link,* at the top of your browser. Insert your Web address in the 'Link To' window. When you do it right, the address is underlined and has that characteristic blue text. Test by sending it to yourself. You can send someone to any page. For instance, you might download or "FTP" a file (see below) to a *hidden* or *remote* Web page. One that isn't accessible (linked) to any page on your site. Once the file is downloaded, send the photo buyer an active link to the Web page.

E-mail Photo Services

Photographers can also subscribe to e-mail services that act as clearing-houses for photo requests. Requests are *very* specific and come mostly from magazines and book publishers. The usage fee paid is often stated along with the request, and the photographer sends images via e-mail (See *www.AgPix.com, www.PhotographersDirect.com,* and *www.PhotoSource.com*).

FTP OR FILE TRANSFER PROTOCOL

Besides e-mail, there's another way to send images, especially those with large file sizes. You upload the file or "FTP" it to a remote page, typically called a "pub," on your Web site. A buyer goes there and downloads the file. It's the same procedure used to upload your Web site to get it online: You collect all your Web pages in one place or folder, and then copy or "FTP" them to the server.

The software for Mac (Apple) is called Fetch. For PCs (Windows), it's WS_FTP. Use Google and search: "ftp programs." You can get general information from your browser's Help menu or

the Web site *www.hostingsupport.com*. You must work through your Web host to configure an FTP site or remote Web page. Visit your Web host's site for specific information. You'll need three basic pieces of information: a host name, user ID, and password.

The Stock Photography Industry 26

Since stock photography is such a big part of the business, I'll begin by explaining how an established stock photo agency works and how the photographer fits into the picture. Agencies have been selling pictures (licensing imagery) for a long time, and you can learn from knowing how they do business.

STOCK PHOTO AGENCIES

A stock photo agency represents many photographers and takes on an array of responsibilities, all centered on the job of licensing or "selling" the photographers' work. Agencies range in size from large corporations with international reach to small mom and pop companies that might service a metropolitan area or certain niche markets, such as nature, adventure sports, New York City, or editorial. Even solo photographers often run their own stock agency.

A Stock Agency's Responsibilities

You may not think a stock agency has a lot to do to sell your work, but there's plenty involved to get the job done. First, most agencies are approached by quite a few photographers, and they have to continually review new imagery, a time-consuming process. New photography has to be placed in a library or filing system. This used to mean someone would place a photo ID number and caption on a slide and put it in a file cabinet. Most agencies have been eliminating film for some time. Today the process involves working with scans, keywording, and making images available on the agency's Web site.

237

After all the prep work, the stock agency can finally begin the job of trying to sell images. Marketing strategies include catalogs, Web sites, direct mail, e-mail, magazine ads, and a sales force. Again, it all costs money and takes time. A photo buyer used to call up and ask if I had a certain kind of photo; I'd pull the film and send out a submission. Today, most of our marketing efforts are directed toward getting potential photo buyers to visit our Web site and select an image online.

Benefits to the Photographer

The biggest advantage of a good stock agency is its ability to market your work to many more photo users, particularly in the advertising industry, in national and international markets. Without distribution, your photography is invisible to the world. Even with a good Web site, it's difficult for the individual photographer to reach photo users.

A stock agency reduces the day-to-day aspects of trying to run a business, like answering the phone and e-mail. Most photo users in the magazine and advertising industry want the transparency or digital file immediately. Overnight delivery has already been overtaken by the faster process of downloading images from the Web site.

To some extent, the challenge of connecting with photo buyers has been exacerbated by the mass success of the Internet. Today, there are many photo-orientated Web sites, and most are bad—bad photography, poorly designed, and with a part-time photographer behind the scenes. Due to past frustrations, high-end photo buyers are leery about searching the Web, and they tend to go to the few remaining trusted names.

EDUCATION

Stock agencies need to work with professionals; don't expect them to educate you in all the basics. That's what this book and professional organizations (ASMP and NANPA) are for. However, they can offer some worthwhile information and advice, particularly due to their contact with photo users and by tracking industry trends. This is often sent out through newsletters, but hopefully you'll feel comfortable sending an e-mail or making a phone call to your agency now and then.

MOTIVATION

Photographers usually greet the news that they have been selected by a good stock agency with optimism and the hope that steady

commission checks are just around the corner. If you are given this opportunity, it should motivate you not only to photograph more, but to raise your standards. You know that ultimately your photos will go in front of someone to be judged and likely rejected if they're not excellent.

EVOLUTION

When I began in the stock photo business in the mid-eighties, I'd get a call from a graphic designer or art director asking for a certain kind of photo. They might fax a layout to help out. After pulling the film, I'd often meet with them to go over the film. It was a great way to build relationships and learn what clients wanted. This interaction began to wane when stock agencies proliferated, even more so when printed stock photo catalogs became the rage. Eventually most buyers ordered photography by the catalog number, and you just sent out a piece of film. The online photo catalog or database increases the amount of viewable photography, but distances you even further from potential photo users. When customers don't find what they want, they just search elsewhere. Now, most photo buyers have made their decision before they call. Unfortunately, if it's not you they're calling, you'll never hear from them or learn from them.

The Money Trail, or Why Does It Take so Long to Get Paid?

One of the biggest hopes and misconceptions photographers have is that you sign a contract with an agency, send it a couple hundred photos, and suddenly start collecting commission checks. Signing and the initial submission are just the beginning of the relationship. To make consistent income, you have to regularly submit good, salable work. Your 200 images may be among one million. Perhaps the greatest barrier faced by photographers at this early stage is to continue to invest in shooting, before any money comes in.

So, what's the delay? First, after the agency selects your images, it can take months before they're keyworded and placed in the file cabinets or online. Even after a photo buyer sees your image, there are often months between her decision to use your photo and your finally getting paid. Generally, the advertising industry has the fastest turnaround, usually just a couple of months between selecting the photo and actually paying the agency. Calendar and greeting card companies often pay on publication, and it's common to submit photos a year or more in advance.

Once the agency is paid, it may pay the photographer only every three months (quarterly). Now consider *subagents*—foreign agencies working with your agency to represent their imagery overseas. Besides adding months to the payment process, subagents take a hefty 50 percent right off the top. Then your agency takes its share. Ultimately you might get 20 to 25 percent of the gross sale, about nine months later. Now do you get the picture?

FINDING A COMPATIBLE STOCK AGENCY

Your success in finding a suitable stock agency and developing a successful relationship depends on many factors. First, it's not easy getting accepted by any agency, and nearly impossible to get into the top two—Corbis and Getty Images. There are a lot of photographers approaching relatively few agencies. This is why you must diversify your marketing efforts and plan on selling your photography yourself.

Second, don't plan on making lots of money, maybe just some reasonable income after three years of dedicated work with the agency. Finally, it's better not to be accepted by an agency that is incompatible with your imagery or if your work isn't good enough to consistently sell. This doesn't benefit anyone.

Niche Agencies

Finding an agency that's a good match for your imagery is critical. A niche agency emphasizes a particular subject or geographic area, and won't be able to effectively market your work if it's not compatible with the agency's niche. Several years ago, I signed on an excellent fine-art photographer. His unique style yielded exquisite images of flowers. His prints regularly sold in high-end art galleries. I thought that since our agency emphasized nature, we might be a good fit. We placed fifteen abstract flower images on our CD catalog and Web site, plus one rather cliché shot of a windmill at sunset. The only shot to sell was the windmill. In the long run, the stock business is a game of probability, and you have to play the odds.

Since compatibility is vital, learn something about prospective agencies. (Web sites can be particularly useful for this.) Besides subject matter, determine where the agencies are located. Even with the Internet, smaller agencies sell a large proportion of their work in their own backyard, so serving a large metropolitan area is important. Try to determine what markets they go after. There's a difference in photographic style between the advertising and the editorial (magazine) market.

Niche agencies are smaller and more approachable. They also may be the only option for newcomers. A particular agency's Web site may not be the most sophisticated, but if there's potential, call or e-mail with specific questions or request the agency's submission guidelines. As you become more interested, try to determine how they advertise. Do they have a useful Web site, CD-ROM catalogs, postcards, or contribute to online photo libraries or portals?

General Stock Agencies

Your alternative to a niche agency is the general agency. To be able to effectively sell a broad range of imagery, an agency has to be fairly large and well known. It's the only way to manage all the photographers and imagery, while marketing on an international scale. To get accepted, you'll need high-quality photography and lots of it. If you can shoot a variety of subjects, or you travel internationally, a general stock agency may be your best option.

Since the mid-nineties, there's been considerable consolidation in the stock photo industry. As many smaller agencies came into the fold of a general agency, the resulting agencies had a glut of photographers and images. It's been more of a process of weeding out photographers and returning images than adding new ones.

Before approaching a large agency, you must realistically consider the quality, quantity, and marketability of your work. You need to be pretty good to outperform the entrenched competition.

Resources

Here are some ways to find stock photo agencies. One of your first avenues is the yellow pages. Look under "Photographs, Stock." If you shoot local material, try a local agency. When you have material from other geographic areas, try the online yellow pages, such as Yahoo! or Verizon SuperPages. If the yellow pages don't list a Web site for the agency you are interested in, try entering their name as their Web address and hope it works, or use an Internet search engine like Google.

You can also use the search engines for a generic search; try "stock photo agency." You'll get a long list and links to various agency sites. Now you'll appreciate what photo buyers are up against when they do a Web search! There are also sites or "portals" that host individual photographers. Try *www.AgPix.com, www.WorkbookStock.com,* and *www.StockIndexOnline.com.* (These are also discussed in chapter 25 under Your Web Site as a Marketing Tool.)

PACA (Picture Archive Council of America) is the trade association for stock photo agencies in North America. Go to *www.pacaoffice.org* and visit the "Membership" section. You can find agencies by geography and subject, plus a link to agency Web sites. Also visit *www.ASPP.com*, the American Society of Picture Professionals. Perhaps the best professional photo magazine is *Photo District News*; its annual stock issue can be very informative. Also check the magazine's Web site (*www.pdnonline.com*) and follow the link to the stock photo section to find agencies.

The book *The Photographer's Market* is updated annually and provides descriptions and contact information not only for stock agencies, but also ad agencies, galleries, and publishers of calendars and postcards. Always keep an eye out for photo credits, usually placed next to photographs in newspapers, magazines, and books; as often as not, the photo credit goes to the stock agency, not the photographer.

SUBMISSION GUIDELINES

When an agency looks promising, usually you request the agency's submission guidelines. These provide ways to proceed further. Many agencies state they're closed to new photographers, which usually means they're extremely selective. Besides the task of adding new photographers, good agencies already have top photographers. When an agency dilutes productive photographers' work, their income decreases. When it finally decreases enough, they can't afford to produce. Ultimately the agency suffers.

How Many Images Should I Send?

Bigger agencies want to see a couple of hundred high-quality images, and if you don't have this number, you're probably aren't professional enough to consider. Smaller agencies tend to be more flexible. The number can be influenced by film format. It's much more difficult to build files using a 4×5 inch view camera than a 35mm SLR or digital camera, and the larger film size may be more desirable to some agencies. However, this large-format advantage is disappearing, as all imagery is being reviewed and sold online. Calendars are a notable exception. The agency will also bend the rules for unique images that might require a lot of digital manipulation, time in the studio, or are in especially high demand at the moment.

In many ways, the initial submission is more like a portfolio review: If you pique the agency's interest, you can send more. Be

selective, and organize your submission, usually by subject. When I go through submissions of slides or digital files, I want to be able to quickly compare similar photos side by side and select the one I feel is the best.

What to Send

Unless specified in the guidelines, it's possible to send anything from film to digital files—and digital can mean CD-ROM/DVD, e-mail attachments, or a link to your Web site. Since digital is disposable, many photographers bypass asking for submission guidelines and just send something. Whatever you do, you want your photography to look its best. It may be your one chance with an agency.

If your Web site is slow to load, the photos are small, or they don't have photo ID numbers, sending a link to your site isn't always the best solution. Also, the photos you have up may not be *exactly* what you'd like to show to a specific agency. Frankly I find most Web sites tedious, and it's too easy to visit even a nice one and forget about it.

Consider placing a better-organized selection of files onto a CD. They can have larger dimensions and be saved as higher quality JPEGs, for greater impact. Make sure each image has your name along its edge or a ghosted logo in one corner. Send a self-addressed stamped envelope (SASE) if you want anything back.

Film should always be sent and returned via a commercial carrier at the photographer's expense. You can usually tell an agency is more serious when it wants to look at your film, instead of low-resolution digital files. Agencies often have their own scanning operations, to ensure quality and consistency in their digital library.

WORKING WITH YOUR STOCK AGENCY

You should go into your relationship with your stock agency(ies) with an attitude of cooperation. You supply the proper photography and they make a concerted effort to sell it. In general, they supply the marketplace with a product. They won't invent a new market for your work. Consequently, there should be an open line of communication, but you don't want to become a pest. To some extent, you've determined some of their needs before you signed a contract. Now, it's more refinement.

Even if the stock agency *were* all knowing and could tell you exactly what it needed, you must balance the agency's needs with

your short- and long-term goals. Just like a stock agency, your photography is your product line; if it becomes too diverse because you're running around trying to satisfy a stock agency's every whim, you may not be able to effectively market yourself. Once, I made a point to photograph a pair of satellite dishes under a variety of nice conditions. I had a good agency, and one of the photos made it into an internationally distributed print catalog. Fortunately I made some good bucks, but now I have little use for the photos. I've found that I get calls for cityscapes and roads because these subjects can be viewed as landscapes—but satellite dishes? Remember, a stock agency is only one of many outlets you might have for your work. Also, if you spread yourself too thin, you won't build up a high-quality body of work. (See CD-ROM: Marketing > Subjects > Hi-tech.jpg)

STOCK AGENCY CONTRACTS

Virtually all agencies have an agency-photographer agreement or contract. In simple terms, it gives the agency the right to license your imagery, and states when and what you'll be paid. Of course no legal contract is simple, so for greater detail and a host of legal forms, such as model releases, I suggest *Business and Legal Forms for Photographers* by Tad Crawford (Allworth Press). Here, I'll mention some especially important issues. Perhaps the most important terms are: *non-exclusive rights* and *exclusive rights*. Contracts are one or the other, and there's a big difference.

Non-exclusive Rights

The term *non-exclusive rights* means the agency can license your photos, but it's not the *only* agency that can. You can send the exact same images to other non-exclusive stock agencies for them to license. You can also license them yourself. Some agencies have *limited exclusivity*. Most commonly, this lets the photographer license the same images, but those specific images can't be sent to other stock agencies.

Exclusivity or Exclusive Rights

Exclusivity gives the stock agency the *sole right* to license the selected images. Neither the photographer nor any other agency can license the images. Exclusivity is a scary word to stock photographers, but unfortunately a common one in contracts from the top agencies. The agency controls your work and if they don't sell it, you have no

alternatives. Established photographers can often live with this, because the bigger agencies make them good money. Better photographers often have such large files, that they keep different photos to license themselves. I signed an exclusive agreement with my first stock agency and it was a mistake. I made some money, but I found I often returned to the better areas and re-photographed them, so I'd have them in my files. This cost me time and money.

Agencies say they need exclusivity to supply the lucrative advertising market. Their clients may want to know how an image has been used. Ford doesn't want the same image Toyota used. A client might buy exclusivity for the image, so they can build a product's identity around it. In reality, few buyers need exclusivity or will pay for it. All top advertising agencies and big companies use a considerable amount of royalty-free photography, so exclusivity and knowing a photo's history usually means very little.

Another reason for image exclusivity is to help agencies build a unique product line. In the early days many of the best stock photographers had half a dozen agencies, often more. The photographers made 35mm dupes and sent every agency the same thing. From the stock agencies point of view, this wasn't good for the industry and they put a stop to it. Whether photographers like it or not, exclusivity is here to stay.

Similars

Now here's a tricky term and one that can really hurt photographers. When an agency has exclusivity for an image, this exclusivity also applies to any and all "similars." Similar images are any images that look like, or are similar to, the exclusive photo. Exactly what is similar is not defined and it would be open to endless legal debate.

Advertising and Commercial Usage 27

When I discuss photographing specific subjects, I emphasize what to consider when shooting for certain markets, particularly for advertising and commercial uses. This is because this is where the action is for so many stock photographers. Yes, it might be more satisfying to see your photo in a book, magazine, or calendar than in a brochure, but you'll get over it when the check arrives. Remember, your marketing approach is to sell to many carefully selected markets, and one of the best is found locally.

THE ADVERTISING INDUSTRY

Regular purchasers of photography for advertising consist mostly of advertising agencies, graphic designers, and larger companies with in-house marketing departments. One reason this market is so worthwhile is that there is some form of advertising industry no matter where you live.

Advertising Agencies

An ad agency is hired by a company to perform a wide range of tasks, from designing simple brochures to developing a whole branding identity, like Charlie the Tuna. To do the job, even smaller agencies have at least a half dozen people, whereas the big New York agencies can have as many as 100 art directors. The photographer typically deals with the art director, and it is to this person that I send most of my promo pieces. At medium-sized agencies, art directors are involved in the entire process, including choosing the imagery and negotiating price.

In larger agencies, once an art director decides to use an image, the photographer (vendor) deals with the art buyer (purchasing agent). Art buyers issue purchase orders and pay you. I often send them promo pieces and ask if they could direct these to the appropriate individual or place them in the department's creative library. A phone call from an art buyer is always welcome. The traffic controller/coordinator is an office manager, and oversees many tasks—also a good contact. While I work with many individual graphic designers, I do not generally work with those at larger ad agencies.

Graphic Designers

Graphic designers do the mechanical layout of the ad, like selecting fonts, sizing artwork, and getting all digital files ready for the printer. Many graphic designers run their own small design firms; then they diversify and do some advertising. I send them my promotional pieces, but I find it's less productive. Just about all ad agencies buy photography at some time or another, while maybe half of the designers do; just a guess. And because graphic designers often run a one-person operation, they're more likely than a big ad agency to be out of business after a few years.

FINDING AD AGENCIES AND GRAPHIC DESIGNERS

Set your sights on the local market. A quick check of the Denver yellow pages shows 300 advertising agencies, but a paltry dozen ads. Amazing, most ad agencies don't advertise and or even list a Web address. Visit your library's magazine section and look for business publications. Seek out any publication with advertising, marketing, or your city's name in the title. Nationally there's *Advertising Age,* and locally, try a business journal, such as *The Denver Business Journal.* These magazines often rank the top local businesses, like agencies.

Most cities have trade publications for the locals, like Denver's *Advertising and Marketing Review.* These are a great source of individual names and new businesses. A good library has many resources, so talk to the reference librarian. Try contacting the American Advertising Federation (*www.aaf.org* or call 800-999-2231) for a local chapter (i.e., Denver Advertising Federation). Someone may be able to provide a membership list or know about local trade publications.

I have success with local ad agencies of all sizes. When approaching smaller agencies, I direct my mailing to art director or photo buyer. If I know it's a larger agency, I call and request they fax

or e-mail me their *creative list.* This gives the names and positions of their creative staff. Most graphic designers are sole proprietorships and named after the designer.

National advertising agencies are more difficult to go after. You need excellent photography, or more specialized photography, to compete, because most bigger ad agencies are used to buying high-quality imagery from the top stock houses. It's also critical to determine which agencies are most likely to need your imagery, because there are so many. The most useful national resource I've used is an annual publication called *The Blue Book: Directory of Creative Services and Print Buyers* (*www.gabb.com*), which costs about $250. It lists the creative staff and many of the accounts for larger ad agencies, corporations, graphic designers, and publishers.

LARGER COMPANIES AND CORPORATIONS

Many companies have an in-house ad agency, but finding them and the appropriate contact within them can be difficult. However, the professional organizations that publish the resources used to locate ad agencies often list many of these companies. This is because the employees of those companies are also members of the professional organizations.

Often your best bet is to regularly read the local newspaper and magazines. For instance, Colorado has many outdoor-oriented companies. When one comes to my attention, I find out if I should send something. Receptionists are very helpful. Begin by introducing yourself and asking if they might be able to direct you to the right person.

WEB DESIGNERS AND MULTIMEDIA DEVELOPERS

These are a new and worthwhile source of business. Most usages are small files (72 dpi) for computer monitors or kiosks. This means scans from most scanners and digital cameras can do the job. Plus, files can be sent by e-mail. However, these companies often expect to pay relatively little ($40 to $100) for many Web uses, and they're very familiar with royalty-free photography. On the other hand, Web sites can use lots of imagery. Get the name and Web address of the end user, and limit length of use. You might make some easy money in a year or two with just a phone call by charging a reuse fee.

MISCELLANEOUS COMMERCIAL CONTACTS

Trade magazines often publish an annual directory of creative services, which lists ad agencies and many related services. These have led me

to several worthwhile contacts. One is the trade show industry. Many companies make a considerable investment in a sophisticated booth, including imagery. Look under "Displays" in the annual directory. Another worthwhile service is decals. These companies make signs for commercial vehicles, vending machines, and banners. They have in-house designers.

Creative directories and the yellow pages are also a source for specialized mailing lists; see "Direct Mail Services." Some industries that have *not* proved worthwhile are public relations (PR), marketing research, and printers.

COMMERCIAL CALENDARS

Many calendar sales are made to ad agencies or directly to companies that print their own calendars, which are then given to clients or customers. Relatively few photographers approach these companies—everyone sends photos to the big calendar companies. They also have a comparatively short process regarding choosing photography and paying for it. You can often make more selling photos to a major company than for, say, a Sierra Club calendar. Plus, there are more potential buyers. See the yellow pages. Look under "Calendars" and also "Advertising, Promotional Products." Local companies often want local photography. If you happen to live on the East Coast, but you shoot the West, use the online yellow pages.

MAILING LISTS AND DIRECT MAIL

Purchasing the rights to a mailing list eliminates much of the work regarding direct mail by providing contact information, usually for specific industries. I've purchased these for national ad agencies and found them to be accurate and useful, especially the ones that break down the agencies into industries, such as automotive and healthcare. Generally, bigger agencies in big cities are best represented, while agencies in a medium-sized city like Denver are represented hardly at all. For local mailing lists, see "Advertising, Direct Mail" in the yellow pages. See also *www.infoUSA.net, www.AdBase.com,* and the book *Direct Mail for Dummies.*

Purchasing mailing lists can be expensive, from $600 to $1000, and you're allowed to use the names for only a period of time. This being so, it's usually best to develop your own local list. If you're sending out thousands of pieces, use a printing company specializing in direct mail. (See chapter 25, under Printed Material, and the CD-ROM: Marketing > Print Media)

PRICING

The advertising industry has more variability in usage fees than any other part of the industry. Magazines, calendar companies, and book publishers pretty much tell photographers what they pay and most photographers accept it. When I get a call from an ad agency, they ask me what I charge—that's quite a difference. The basic premise of stock photo pricing is that the more the clients use a photo, the more they pay. Begin by asking questions. Often, the questions you ask to determine a usage fee help you send out the best digital file (To ask the right questions, see CD-ROM: Marketing > Forms > Call Report).

CALCULATING A USAGE FEE

To determine a fair usage fee, you need to know how the image will be used. Ultimately this information is spelled out in a quote or invoice. Is it for a Web site, product label, postcard? How large will it be? The bigger the reproduction, the higher the usage fee. Is it on the cover or inside? The more prominent or important the photo, the more is charged. Will it be distributed locally or nationally? The wider the distribution, the higher the fee. Closely related to distribution is the *print run* or *press run*. Another part of the equation is, how long will it be used? One magazine ad or two years on a Web site? You must place a time limit on the length any image can be used (See chapter 23, under Pricing Aids).

251

Sample Usage Fees

Here's a review of some of my commercial sales for the year 2003. Figures are the usage fee for one image and may reflect the current (very soft) advertising climate: large display prints for use at trade shows ($400 to $1200); calendar photos ($150 to $700); label for a local company's detergent bottle ($500); advertising use for ice cream ($1,200); point of purchase (POP) display for beer sales ($1,500); brochures ($100 to $800); automobile advertisements ($375 to $1650); cover photos for trade publications ($400 to $800); Web site uses ($40 to $275); several signs/logos for commercial vehicles ($175 to $450); software packaging, exclusive rights to one industry, ($3500); fine-art prints (profit: $75 to $350 per print); company ads in the telephone yellow pages ($225 to $400); postcards for advertisements ($175 to $360); front of vending machines ($435); label for applesauce jars ($1500).

QUOTING A PRICE AND CLOSING A DEAL

I can't imagine the range of prices photo buyers get from photographers. Since nothing is set in stone (or even whipped cream), here is some advice on pricing and negotiation. One of the frustrations in this business is getting off the phone, knowing I could've gotten more if only I'd asked. Unfortunately it's too late, unless the buyers want to increase their usage, or you claim to have misunderstood what they really meant. One of the best ways to avoid this sinking feeling is to ask if you can call them back, especially until you're more experienced.

During this time you can check some pricing books or software, or better yet, call fellow photographers. I've found that if you quote too high a price, the only way you know is that they never call back. Therefore, try to elicit a response or leave the door open to negotiation without blatantly saying, "Of course I'll take less, if you only tell me what you're willing to pay." Ask, "Is my price within your budget?" They'll usually tell you. They might respond with, "I'm still working on the budget" or "I need to talk it over with the client." Tell them you'd like to work with them on this project, and if price becomes a stumbling block to call back. With so many strange uses out there, I even plead ignorance, "I've never priced that usage, what do you usually pay?" This works amazingly well. Realize the person on the other end of the phone is not an adversary, but like you, just trying to do her job. (For your protection, see chapter 23, under Getting Paid: Invoices and Credit Cards)

Reuse Fees

A real benefit to precisely defining usage is that the photo buyer often calls back and wants to print more brochures or use it in a new ad campaign. You have every right to increase the fee or calculate a reuse fee. A big concern from photo buyers is if they want to reuse an image—and I assume because it's been successful—that I'll raise my price. Most worries can be handled by stating some reasonable reuse fees in the initial contract. For instance, when the duration of use is three years, you might include a reuse fee of 35 percent for each additional year. When the initial print run is 10,000 brochures, add a 25 percent reuse fee for an additional 5,000 copies.

Calendars and Book Publishers 28

Although calendar companies and book publishers might seem like different industries, there's quite a bit of overlap in their products and, consequently, in how you approach them. Once a company has a good distribution network, it makes sense for it to diversify into related products. For example, book publishers sell books to bookstores, so why not calendars? The publisher has the network of photographers, printers, and bookstores in place, plus bookstores sell lots of calendars. Often calendar companies extend their reach into products related to tourism, like regional travel guides, postcards, and greeting cards.

CALENDARS

Calendars might be the most obvious use of nature photography, but the calendar market is divided into two distinct markets, commercial and retail. The commercial calendar market was discussed in the previous chapter. Ad agencies or companies producing promotional materials design those calendars. They're for advertising, not for sale in retail stores.

The Retail Market

This is one of the more satisfying photo markets. The photographer deals with a calendar company or publisher, which often also prints postcards, travel books, posters, greeting cards, and various souvenirs, such as placemats and screensavers. Photographers of all levels approach these companies. The competition is pretty stiff and the final product is very good. National calendar companies put out

dozens of titles, most fairly specific in subject, like lighthouses or a particular state. When a title sells well, it comes out year after year with much the same kind of imagery.

Many of the chapters in Part III describe subjects that tend to be best for calendars. For example, an Arizona nature calendar will always include the Grand Canyon, Monument Valley, desert flowers, and the saguaro cactus—year after year. These locales are padded with a few less familiar spots. Lesson one: shoot the popular areas. Lesson two: photograph the grand landscape, which far outsells intimate scenes or still-lifes. Lesson three: most photo buyers choose evenly exposed images. Photograph more often in daylight than at sunset. Blue skies sell—add some great clouds and it's even better. Finally, shoot horizontal (landscape) format.

FINDING CALENDAR COMPANIES AND PUBLISHERS

Look for calendar and greeting card companies at bookstores, office supply stores, grocery stores, gift shops, and when visiting tourist/resort towns. Search the Web, use Google and try "calendars, nature," and also go to *www.amazon.com*. When you get to a company's Web site, look for a link to "Photographer's Information" or "Submission Guidelines." Commercial contacts can be found in both the online and telephone yellow pages under "Calendars" and also "Advertising, Promotional Products."

I search for these companies literally nonstop, not because they go out of business, but because I run out of fresh imagery to send them. Let's say I send a national calendar company my best landscape photos for its Washington state calendar. It took me two productive summers to accumulate these images. Whether I sell something or not, the next year I have nothing new to send them. I have to find a new company to send my Washington images. Because of this constant juggle, I regularly have hundreds of calendar images that never get refiled. I am continually sending them to a new company. A good source for publishers and the names of their creative staff is *The Blue Book: Directory of Creative Services and Print Buyers* (*www.gabb.com*).

Submission Guidelines

Once you have a company name, you want its submission guidelines. Its Web site is your best bet. You can review the company's product line and usually print out its guidelines. For example, go to

www.metrobooks.com for Barnes & Noble Publishing and find the link "Current Needs." Photographers, many of questionable merit, are constantly approaching these companies, so it's really important to be professional and follow the guidelines exactly.

DEADLINES

The deadline for sending imagery is as important as the subject needs. Retail calendars and book publishers have a fairly long lead-time, anywhere from six to eighteen months before you'll see the product on the shelf, but they're usually adamant as to when they'll review photography. Many threaten to return packages unopened if received after the deadline. Some advantages to working with companies that produce calendars for commercial use is that they have a short turn-around time and pay much sooner. I often get calls in September for photography for next year's calendar.

SENDING IMAGERY

Color transparency film (slides) is still the norm when submitting imagery to calendar companies, so larger-format film is often an advantage. With that said, I've seen guidelines stating the company will also accept prints and digital files for review, and only request the film if an image is selected. The designers may feel they'll get higher quality if they scan the film, and retail calendars still stress quality.

Each image should have its own unique photo ID number and caption. Most books and calendars like to include caption information, such as the name of a lake or mountain. However, they rarely call to check details, so make sure the information is accurate and complete beforehand. Organize and clearly label your submission into the categories the company requested—anything to make the job easier. Check if you need to send return shipping (SASE). The industry is split on this, with the better companies tending to pick up the tab for returning film. If you intend to stay in the photo industry, set up a Federal Express account.

USAGE FEES

Usage fees paid to the photographer are usually spelled out in the publisher's guidelines, which also may limit liability for lost or damaged film. Unlike commercial stock sales for advertising, calendar companies and publishers state exactly what they pay. You acknowledge and

accept this fee by signing and returning their guidelines. However, book covers are often left open to negotiation because the cover is such an important image.

Retail calendar usage fees range from $125 to $400 for a photo used for one page (month). You often receive an additional 50 percent if the same image is also used on the cover. Contracts often state that the publisher can show a picture of the calendar or book in its product catalog, without paying additional fees. Most publishers pay on publication, meaning they mail the checks when they distribute the calendar or book.

Postcards, Christmas cards, and greeting cards pay anywhere from $100 to $250. Some of the better greeting card companies pay a royalty based on the number of cards sold, not a flat usage fee. This has always made me considerably more money, often after just a few checks.

Photo Credit

Providing photo credit is common for calendars and book publishers. When I return my signed submission guidelines or a delivery memo, I clearly state how I would like my photo credit to read, and then wait to see what happens. In addition to my name, I request that my Web-site address or company name follow it. I'm always pleasantly surprised by who contacts me after seeing my photos with the appropriate credit.

Magazines and Trade Publications

When I'm in the field, many people ask if I work for a magazine. I do sell to magazines, but there aren't many national consumer magazines regularly using nature photography. This also holds true for related subjects, such as adventure travel and skiing. I look at it this way—my database contains about 1,300 potential professional photo users in the Denver metro area, while there are only a dozen or so national consumer magazines to approach. You do the math. This doesn't mean there aren't some great opportunities out there, but you have to know where to look.

TRADE PUBLICATIONS

There's a vast array of magazines lurking in the shadows of mainstream America. They're trade publications and journals, but you won't see them in a magazine shop. In most fields, from petroleum engineering to manufacturing, there are several "trades" to keep professionals informed. You know of *Outdoor Photographer* magazine, but have you ever heard of *Photo District News, Digital Capture, Photo Electronic Imaging (PEI), Studio Photography and Design,* or *Digital Imaging*?

Unlike consumer magazines, I rarely sell a stock photo for use inside a trade magazine. Usually industry-specific images are needed. However, they regularly buy nice cover photos and nature is very generic. Their budget might be smaller ($150 to $400) because they have a small circulation. However, they can make up for it with repeat business, because like any magazine, they continually need cover art. Plus, they're rarely approached by photographers or stock agencies.

Find them by regularly visiting the periodical section of the library, both public and university. Be observant; the aerobics room at my YMCA is a collecting ground for esoteric magazines. Many have a nature shot on the cover. A magazine's *editorial* (as opposed to advertising/sales) masthead provides up-to-date contact information and is located near the table of contents. Individuals like the photo editor, art director, and articles editor are listed, so you have a specific person to address your inquiry to.

CONSUMER MAGAZINES

Consumer magazines cover popular subjects and are sold at bookstores, magazine shops, grocery stores, and by subscription. Getting your foot in the door at a good magazine isn't easy, but if you understand how magazines function, you'll increase your odds. First you have to examine your photographic style and the diversity of imagery in your files. Whereas a trade publication needs a generic landscape for its cover, most consumer magazines have very specific needs for every issue.

HOW MAGAZINES WORK

Most magazines decide on the articles first, then look for photos. Therefore, to regularly supply imagery, you need fairly large and diverse files, often of images that aren't appropriate for the advertising market. I recently received a call from a national travel magazine looking for photos of specific buildings in Boulder, Colorado. No doubt they were mentioned in an article. After living in Boulder for twenty-five years, I hadn't heard of most of these places. There's no (profitable) way a photographer could go out and document them with the hopes that some day, someone might need a photo.

Most magazines have a list of photographers they contact for imagery. In the past, the photo editor would phone established photographers and ask what they had in their files. If they couldn't find anything, some lucky photographer ended up with an assignment. The time and effort it took to contact photographers kept the list selective.

E-mail has made this process much easier for magazines and more democratic for photographers. The photo editor does a mass e-mailing with photo needs for the next issue. It's quick and easy. Photographers then e-mail any appropriate photos for consideration. This has helped stock photographers, but has taken another bite out of the assignment market.

CONTACTING MAGAZINES

Whether requesting guidelines by mail or the Internet, you need to convey you're a professional and you have photography that magazines need. Remember, this is a screening process. Include a stock photo list of general subjects, geographic locations, or a specialty. Magazines need specific subjects, and this shows you have diversity in your work. You might also send some promotional material, like a printed piece, a CD-ROM, or an e-mail attachment. Show your best and most appropriate photography.

Cover Letter

Write a cover letter specific to the magazine, no form letters. State that you'd like to be contacted with stock photo requests. List some photo credits and why your imagery is a good fit. Magazines often have tight schedules. Can you offer high-resolution files? Can you send photos or files the same day?

OFFER MORE THAN PHOTOGRAPHY

Another way to approach magazines is to write or propose an article that uses your photography. It makes the magazine's job easier, and you get paid for both the text and the photography. Unfortunately this adds considerable work to the endeavor, with no guarantee of success. You also have to be both a good photographer and a good writer—not an easy task. To reduce the risk of doing too much work, without any guarantee of a pay off, try writing a query letter.

259

This is a short, well-crafted proposal that describes your idea for an article. Basically, it's a sales pitch. If they don't bite, you get rejected before you invest any more time. Accompany the query letter with a few low-resolution photos on CD, or disposable prints. Magazines often take months to get back to you, so try to send the same query letter or proposal to several magazines. Another approach is to network with writers by supplying them with high-quality photography and good editorial ideas. Finally, magazines do *not* want unsolicited film, and if you want anything returned, enclose a SASE.

PRICING

Most magazines have established rates for photography and articles. Don't submit material if you don't accept them. You can always demand more and you might even get it, especially if it's for a great

cover shot or an uncommon image. However, if you become known as a pain in the you-know-what, they'll stop working with you.

A cover photo for a national consumer magazine can range from $450 to $1,200, depending on circulation. Inside photos range from $150 to $600, depending on size. Unlike trade publications, which often have reasonable advertising revenue to finance photography, smaller consumer magazines can't offer very much (zero to $150 for a cover). This can be better for your ego than your bank balance, but you'll gain experience and you've got to start somewhere. However, if you can sell an article with several photos, then the check begins to amount to something.

Photographic Prints 30

Selling photographic prints may be the first thing that comes to mind when people dream of directing their love of photography toward something more professional. There's a real joy and sense of satisfaction seeing your best work displayed, and it's a natural next step to consider selling prints.

In the not-so-distant past, this meant tediously creating a black-and-white print in your darkroom. The advent of digital cameras, low-cost scanners, Photoshop software, and color ink-jet printers has turned an esoteric craft into something available to anyone. So much so that I really wonder what the future holds. When most people feel they can make a fairly pleasing print, why buy one?

I'll address the black-and-white print briefly: I stopped using my darkroom and enlarger for black-and-white prints in 1988. It was a smart move. If you're going to be a successful nature photographer, just remember one thing: People love color. You'd be much better off converting color digital files to black-and-white. Making a profit selling color prints is tough enough.

THE MARKETPLACE

I don't intend to tell you how to make the perfect print. I want to discuss the marketplace for prints and explain several basic strategies. The print market can be divided into two broad categories. There's the art gallery market, also called the fine-art market (high end), and the mass consumer market (low to medium end). Both hold potential, but to succeed you must analyze what you can realistically pursue.

This means an honest evaluation of your photography, while determining who will buy your prints and where you'll sell them. Entering any market requires some business savvy, along with considerable investment of time and money. You must approach it as a serious undertaking. Making an occasional print for friends and acquaintances is one thing; making a profit in the print business is entirely different.

BUSINESS CONSIDERATIONS

A big consideration is the financial investment in making prints. In other markets, once you have the image, it's ready to be licensed. The print-selling business takes this several steps further. Now you're getting into manufacturing, distribution, and retail. This is where costs mount.

You'll soon find that there's very little profit to be gained once you have the courage to calculate the cost to make a custom print. Not to mention the cost of capturing the image. You must trim costs at every level.

THE SCAN AND PRINT-MAKING PROCESS

It begins with capturing an exceptional image. Then working with a scan (digital file) to make a print, which is usually mounted and displayed. It sounds pretty simple, but there are many small steps. Every part of the process involves time, decision-making, and money to make it work.

The Scan (or Digital File)

Unless you're using a digital camera, the first step is having your film scanned or converted to a digital file. Generally, making larger or better quality prints takes better quality scans and progressively larger (higher resolution) files. So invest in high-quality scans from the start. (Small files measuring 2000 × 3000 pixel are inexpensive and make up to an 8 × 10 print.)

Consider buying a scanner. Scanners for 35mm slides have 4000 dpi resolution (dots per inch) and are affordable. I've seen very nice 20 × 30 prints from their scans. Try Genuine Fractals software to enlarge (upsize) a file for even larger prints.

I have a fairly good scanner for my larger-format films (6 × 7 cm and 4 × 5 inches). At 1800 dpi, it meets 95 percent of my needs. Lower-price scanners are at their best when scanning a well-exposed,

high-quality piece of film. You'll also need a CD-ROM burner or some way to archive your files.

Once you have the initial or raw scan, your work starts. Examine it for sharpness, color balance, and dust marks (especially in skies). Make any fixes, such as eliminating power lines using image-manipulation software (like Photoshop). This takes considerable time, especially with larger files, but it's worth doing early in the process. Now you have a high quality master scan to archive.

Color Management

Over the years, I've looked at and worked with thousands of scans from every sort of scanner. I've been pleasantly surprised to find that even a poor-looking scan can be made to print fairly well. One stumbling block in the process is to have what appears on your computer's monitor resemble what you get from the digital printer. To get this repeatability from scan to scan and print to print, you need to calibrate your monitor to each printer you use. This is referred to as *color management.*

Color management isn't as critical when using your own printer. You basically use Photoshop (*Image > Adjustment > Color Balance*), and by trial and error, you produce a print you like. Stick with the same paper, printer, and ink, and things go pretty smoothly. Most nature photos can shift in color and still be quite pleasing to the eye.

When sending a scan out to be printed, your computer monitor must be calibrated to the provider's printer, so what you see on your monitor matches the print that is made for you. This is why many labs suggest you first buy a smaller test print. For the best working relationship, you'll want to acquire your favorite printer's color management software and then stick with that company. While learning, a local photo lab can be helpful. However, it will be relatively expensive, compared to high-volume printers.

The Print

If you intend to experiment with Photoshop and different papers, keep organized notes. You'll see patterns that will save you time and money. High-quality paper and ink are expensive, so work with smaller prints or a portion of the final print. View your prints under a variety of lighting conditions. You will find that *www.inkjetart.com* is an informative site.

Different surfaces, such as glossy, matte, watercolor, and canvas-like, have varying impacts on the final look. It seems most buyers (and photographers) prefer glossy paper. This surface provides the most vivid color and the sharpest image. However, these papers produce considerable glare, making it difficult to appreciate a print from certain positions. Matte and semi-gloss surfaces are unaffected by glare. Watercolor and canvas-like surfaces are particularly complementary to artistic or more abstract imagery.

Specialty papers and archival inks add considerable cost and may be difficult to justify unless you're getting a premium price. If a buyer is concerned that a print might fade, try offering a replacement print if the buyer sees an objectionable loss of quality. Be particularly leery of buying inexpensive, generic inks on the Internet. These are perfect for day-to-day office tasks, but they show fading in just months.

To Print or Not to Print

Consider a medium-sized printer for most of your printing needs, especially if you sell smaller prints. A good scanner or professional 6 megapixel camera can make a 16 × 20 inch print. Try Genuine Fractals or Extensis pxl Smart Scale to increase a file's size. Although making one print at a time isn't the best use of your time, avoid getting stuck with inventory that never sells.

When you need a larger print (thirty inches wide and above), send it out to the pros, at least until you've done some experimenting with different inks and papers (most users standardize on one kind of paper and ink). Big printers require space, money, and skill. Also, if you buy one and don't need it for six months, you often have an old, overpriced printer.

FOUR PRINT MARKETS

I've divided the print market into four categories. Although the goal is always to sell a print, the way you go about it is different.

Metropolitan Art Galleries

Art galleries in metropolitan areas are looking for photographers with a distinctive photographic style or technique. Clients tend to be collectors, wealthy homeowners, and a whole range of businesses. The photographer's name recognition and resume are very important, especially when the buyer is investing in photography as art. When a

gallery displays or represents your work, it needs prints on hand. The photographer must provide large archival prints, but not mattes or frames. Still, this is a real financial commitment. Since most galleries take 50 percent of the selling price, an unmounted 20 × 30 inch print must sell for at least $350 to make the photographer's investment worthwhile.

FINDING AN ART GALLERY

Just like a stock agency, an art gallery must be compatible with your imagery. Most are known for a certain style of artwork; if your style doesn't fit, the gallery probably won't be interested—that is, unless you have something that's quite exceptional. Start your search and education locally by checking the telephone yellow pages and online directories under "Art Galleries."

The relatively large number of art galleries can seem encouraging, but you must realize that art covers a wide spectrum. Most galleries don't represent photography, much less conventional nature photography. The real task is finding the few that might be interested in your work. Unfortunately, a gallery's name rarely reflects the kind of art it represents, plus most don't list a Web address in the yellow pages. Many galleries are run by individual artists or photographers, and they refer potential buyers to their personal Web site. Even when you strike out, ask if they know of a gallery or organization that might be helpful.

Like any businessperson, you have to keep a sharp eye out for opportunities. Check local shopping malls and art-orientated colleges, walk the art district, accumulate Web addresses and art-related newsletters. Most local newspapers have public service announcements that list upcoming art festivals and juried competitions. The book *The Photographer's Market,* updated annually, provides information on galleries.

CONTACTING A GALLERY

Before you begin in earnest, be prepared to collect names and results, even if it's as simple as "not interested," in an organized way. Lots of artists approach galleries, so to sound professional, be prepared with what you're going to say. Begin with a phone call. Tell them you're a fine-art photographer and ask if they have a Web site. This quick question tells you if they have any interest in photography, while their site will show subject matter and provide an e-mail address.

There's considerable variability as to how galleries initially review a photographer's work. However, gallery owners tend to be less fluent with the Internet than, say, stock agencies. The owner may want to see a resume or actual prints, and may not appreciate a portfolio via e-mail. Shipping any portfolio is expensive, so be sure it's really worth your time and effort.

Don't expect a gallery to drop everything and get right back to you, even if there's potential. Gallery employees and their photographers come and go, so there may still be opportunity. Commit to a long-term approach. After several months, call back or send another e-mail. They'll have more respect for individuals who can follow up with an additional promo piece or e-mail.

GALLERY CONTRACTS

Usually the photographer supplies an unmounted print and the gallery receives a commission of 40 to 50 percent of the selling price. Exclusivity is an important point. A good gallery wants to have the exclusive right to represent an artist in geographic area. This protects the gallery and maintains the value of the artist's work by eliminating the possibility of a pricing war.

Prints for Tourist Towns and Resorts

Tourist towns and resorts are another source of galleries, plus a variety of other sales opportunities. New York City is America's top tourist destination; plan a visit to Time Square and you'll find numerous people selling matted and framed prints right on the sidewalks. Most tourist towns are associated with national parks, a notable history (Boston), entertainment centers (Las Vegas), and ski areas (Vail). If you live in a one, you'll know it.

Most galleries and souvenir shops are the efforts of an individual trying to make a living in a place they love. They almost always sell imagery and artwork from the area, so you better have it. Larger communities distribute tourist-related publications, which are also very informative. Be advised, many of these businesses come and go, and are best found by visiting the area and pounding the pavement.

MAKING CONTACT

You should be making any business connections well before the peak tourist season(s). The more time you can give your suppliers, the lower your costs. Tourist-related businesses make nearly all their

income during a relatively short period, so it's best to approach them off-season, or in high season during off hours. Before you approach someone, see if you can offer something more than, "Do you want to sell my prints?" Besides your photography, what else do you bring to the table: money, reputation, business or sales experience, computer skills?

PHOTOGRAPHIC PRINTS

When you set your sights on the average tourist, there's far more variability when it comes to quality. There are some high-class galleries in most upscale tourist towns, but there's also an opportunity to sell more affordable prints to a larger audience. Smaller, matted prints are sold in many souvenir shops, bookstores, and restaurants. Besides being priced right, small prints are portable.

Art Festivals

Tourist towns have found that festivals are big draws, and so they stage events for wine, mountain biking, film, music, and art. Art festivals vary greatly in the quality of their artists, and the better ones may want to review your work or otherwise evaluate your credentials. Imagery in these shows can range from good to incredible.

The photographer usually pays for a booth, often a 10×10 foot piece of real estate. At first glance, your initial investment may seem quite reasonable; $400 to $600 for a middle-of-the-road art fair and you're in business. But not so fast: Here are some expenses to consider and pitfalls to avoid.

Most buyers at art fairs want a matted print and possibly a frame, especially for smaller sizes. These extras often cost more than the print itself. You must buy materials in volume, via the Internet or mail-order catalogs. Stick to standard sizes, like 8×10, 11×14, and 16×20 inches. Those committed to the art show circuit often cut their own glass, mats, framing materials, and even invest in their own a shrink-wrap machine (For starters see *www.lightimpressionsdirect.com*).

DISPLAYING YOUR WARES

You may have great imagery, but you have to display and sell it. At best you'll be provided a tent, but more likely a table. You're responsible for transforming this void into a pleasant viewing environment. Visit some art festivals with an eye toward what goes on behind the prints. Photographers often start with a minimal investment in plastic crates

and pegboard. Store unsightly supplies under a table, covered with a colorful sheet. Industrious do-it-yourselfers often build their own display units. Keep in mind that you're likely to evolve and change over time, so have some flexibility in your system.

Display materials need to be easily transported, set up, and taken down. In the long run, investing in used commercial display units may be your best bet. The art-festival circuit is hard work, even if you're well prepared. Setting up will certainly take most of your morning. Don't forget a company sign, price lists, and a chair. Eight hours standing on concrete is hard on the body. And how do you get all this stuff to and from the show? It's a combination of back-breaking work, a handcart, and a large SUV pulling a trailer. Have you noticed you're hardly a nature photographer anymore?

You need to display your prints to look their best. Don't forget, your success depends on heavy foot traffic. Try arranging the booth to invite people to come in and get off the busy main aisle. This not only makes the viewing experience more enjoyable, but you can employ some sales technique. Also, inquire about overnight security.

INVENTORY

Having good inventory is a real gamble, because you can't sell what you don't have, but you pay for everything, even things that never sell. I guess it's possible to print more in your motel room, if you have a great day. That reminds me, don't forget to budget for a couple nights in an overpriced motel room. Most festivals are on weekends, so you can get your feet wet while working a traditional job. (You'll also get an idea as to how it feels to work seven days a week.)

MAKING THE SALE

Car salesmen put on the pressure because they know once you leave, they've probably lost you. Selling prints is the same. Plan on visiting with your customers. If they're eying a specific print, come up with an interesting anecdote. Try to make a connection. Ask where they're from; can you send them to one of your favorite spots?

Consider handing out something—candy from a bowl is a favorite. Design a business card or printed promo piece, so people can go to your Web site. Try placing an additional selection of photos on a CD-ROM and have a laptop computer on hand. You can show more photography to interested individuals. Do you offer other services, like photo workshops or seminars?

EXPECT TO LEARN AND EVOLVE

No one stays in business without constantly evaluating everything they do and trying to figure out how to do it better. Listen to your visitors to learn what they want. Then photograph these subjects. Visit other photographers' booths. Check their photography, how it's displayed, and how they interact with prospective buyers. Also, check their prices. If they have good imagery at a lower price, you may not sell much. Ask how long they've been at it. Believe me, some photographers literally price themselves out of business. Good riddance.

Online Print Galleries and Photo Catalog

Attracting legitimate print buyers and stock photo users to your site is difficult, but the Internet is *the place* to send prospective buyers to review your work. You'll find that no matter how you advertise, inquiries range from an individual expecting to find a cheap 8 × 10, to someone responsible for decorating new corporate offices. With such variety, the question becomes, which of these people can you deal with and make a fair profit? Selling more expensive prints doesn't always mean more profit.

INTERNET PRINT SERVICES

Perhaps one of the best solutions to lower budgets is to work with an Internet printmaking (or fulfillment) service. These companies don't just make a good print at an affordable price. They're Web sites and portals designed to connect print buyers with fine-art photographs. At the Web site, the buyer can view your photography, along with work by other photographers. Generally, you supply these companies with a collection of high-resolution files (about 55 MB). They make and ship the print directly to the purchaser, and send you a commission. Exact details vary from site to site, but you want to remove yourself from the selling process. One disappointment with print inquiries is that many people only want to pay $75. It's impossible to do the job yourself, but these companies seem to be able to make a profit (Visit *www.pictopia.com* and *www.artemisimages.com*).

APPEAL TO PRINT BUYERS, NOT STOCK PHOTO BUYERS

Stock photographers and agencies need an online stock photo catalog, where buyers can search for photography. However, having countless images available as fine-art prints is problematic,

not to mention the extra time and cost incurred when every print is custom. It's too much selection for most buyers— they're overwhelmed.

YOUR ONLINE FINE-ART GALLERY

It's better for most stock photographers to put together an online selection specifically for print buyers. This gives the online buyer confidence that you really are in the print business. Call it something like *Fine-Art Gallery*, and have it separate from the Web pages showing your stock files. You might use a separate button on your home page or a different Web address.

You can still offer all of your stock images as custom prints, but specify that it might cost more to sell a custom print rather than a stock image. We recently made a nice sale to a mining company, a print of a potash mine. Although quite stunning, I'd never have selected it for a fine-art gallery.

Consider a separate name for your print business. The general public doesn't know what a stock photo agency is. For listings in the yellow pages under "Art Galleries," use a descriptive name that reflects your photography. "Art Galleries" encompasses considerable diversity. When someone is looking for a nature photo, your company name should tell him you're the one to call. Seriously consider an additional listing for your company's Web address.

PRICING

Two questions people often ask are, "How much does a print cost?" and "Do you have a price list on your Web site?" I tell them, "I don't have a price list at the moment, but if you hold on I'll make one up." I check my caller ID and start asking questions. Is it for a home or office? Companies hold far more promise.

Have they chosen an image from our Web site yet? When they haven't, price is probably their top concern. When they've picked an image, I know they've invested some time and are somewhat serious. My confidence goes up. Why did they choose a particular image? Is it special to them? Is it one of a kind? When the client has an emotional attachment to an image, the price goes up. I know what it costs me to make a print, but I want to know what they're willing to pay. Call it custom pricing, with a minimum.

If a print costs me $100 to produce, why do I want to sell it for $400 for a couple's mountain cabin but $750 for a corporate office?

Simple, I guess. When I sense deeper pockets, I dig in. It also draws on my experience with commercial stock photography. A client pays more for an image, if they "use" it more. A beautiful print in a corporate lobby is being used more than the same print in a house. It's used to impress visitors, vendors, and prospective clients. Consequently, it's worth more.

When you give a price, listen. Has their jaw hit the floor? If you hear "That's a little out of my budget," ask them what they had hoped to pay. It's blunt, and it gets the job done.

You need to know if there's any chance of working within their budget. That's why you must know what it costs to produce and ship a print. Before making any print, you must feel confident you're going to get paid. If you don't get paid for a stock photo usage, you lose time. If you make a print and don't get paid, you lose hard earned cash and a lot of time. Credit cards are the safest bet.

Index

Entries in bold refer to the accompanying CD. This contains nearly 650 images, each with an instructional caption, location, date, and time.

276

Books from Allworth Press

Allworth Press is an imprint of Allworth Communications, Inc. Selected titles are listed below.

ASMP Professional Business Practices in Photography, Sixth Edition
by the American Society of Media Photographers (paperback, 6¾ × 9⅞, 432 pages, $29.95)

Photography: Focus on Profit
by Tom Zimberoff (paperback, with CD-ROM, 8 × 10, 432 pages, $35.00)

Business and Legal Forms for Photographers, Third Edition
by Tad Crawford (paperback, with CD-ROM, 8½ × 11, 192 pages, $29.95)

The Photographer's Guide to Marketing and Self-Promotion, Third Edition
by Maria Piscopo (paperback, 6¾ × 9⅞, 208 pages, $19.95)

Creative Canine Photography
by Larry Allan (paperback, 8 × 10, 160 pages, $24.95)

How to Shoot Stock Photos That Sell, Third Edition
by Michal Heron (paperback, 8 × 10, 224 pages, $19.95)

Pricing Photography: The Complete Guide to Assignment and Stock Prices, Third Edition
by Michal Heron and David MacTavish (paperback, 11 × 8½, 160 pages, $24.95)

The Business of Studio Photography, Revised Edition
by Edward R. Lilley (paperback, 6¾ × 9⅞, 336 pages, $21.95)

Photography Your Way: A Career Guide to Satisfaction and Success
by Chuck DeLaney (paperback, 6 × 9, 304 pages, $18.95)

Starting Your Career as a Freelance Photographer
by Tad Crawford (paperback, 6 × 9, 256 pages, $24.95)

Please write to request our free catalog. To order by credit card, call 1-800-491-2808 or send a check or money order to Allworth Press, 10 East 23rd Street, Suite 510, New York, NY 10010. Include $5 for shipping and handling for the first book ordered and $1 for each additional book. Ten dollars plus $1 for each additional book if ordering from Canada. New York State residents must add sales tax.

To see our complete catalog on the World Wide Web, or to order online, you can find us at *www.allworth.com.*